HELMUT NEWTON – PORTRAITS

Helmut Newton began compiling his magnificent portrait collection of the beautiful people from the world of international film, art and fashion in 1974 for renowned magazines such as *Vogue*, *Vanity Fair*, *Harper's Bazaar*, and also for elite art journals such as *Egoïste* and *Wolkenkratzer*. We were the first to publish this collection of portraits and are pleased to release this special paperback edition.

In his photographs of top film stars, fashion designers, actors, artists, writers, pop musicians and photographers, Newton has revealed the discrete charm of the bourgeoisie with the impudence of an Italian paparazzo. With ultimate technical perfection, audacity and his own inimitable style, he has captured in masterful photographs the psychological tension between the glamour of show business and the self-image his models wished to project. The volume contains portraits of Paloma Picasso, Catherine Deneuve, Hanna Schygulla, Romy Schneider, Yves Saint Laurent, Karl Lagerfeld, Andy Warhol, Sophia Loren, Liz Taylor, Mick Jagger, Kim Basinger, Jack Nicholson, Rainer Werner Fassbinder, Nastassja Kinski and many others.

248 pages, 179 duotone and 20 colour plates

HELMUT NEWTON
P O R T R A I T S

PHOTOGRAPHS FROM EUROPE AND AMERICA

WITH AN INTRODUCTION BY CAROL SQUIERS

A Schirmer/Mosel Book
Distributed by

te Neues Publishing Company
New York

Acknowledgements

The author and publishers thank all the following people and magazines for their helpful co-operation: Marion Harding, Monique Kouznetzoff, Marc Picot; Les Editions Condé Nast, Paris; *New York Times Color Magazine*; *Le Nouvel Observateur*; American *Playboy* Magazine; *Stern*; *Texas Monthly*; *US* Magazine; *Vanity Fair*, New York; American *Vogue*.

Design: June Newton and Lothar Schirmer

ISBN 3-8238-1711-6
Printed in Germany
A Schirmer/Mosel Production

Once again, for June

Introduction by Carol Squiers

Opulence, fetishism, decadence, malaise, fantasy, haughtiness, aggression and chic: these terms are frequently deployed either to applaud or excoriate the photographs of Helmut Newton. For thirty-odd years, in fashion pictures, advertising, nudes and portraiture, Newton has planned and mapped out his lush, privileged and aberrant world. Often set in sumptuous villas and splendid hotels, his pictures present a rarified and intimidating look at Continental *luxe* and jet-set hauteur. His controversial combination of affluence, explicit sexuality and ambiguous psychological scenarios irrevocably marked fashion imagery from the mid-1970s on, permanently altering the terms and limits of the depiction of fashionable women.

In the 1980s he has become increasingly more involved with portraiture, doing much of it as commissioned editorial work for magazines. Unlike his fashion work, which was peopled with a fictional Newtonian tribe of imperious Amazons and seething style mavens, his portraits form a real-life roster of élite society's newsmakers, night-lifers and would-be transgressors. Still, they are as fictional and contrived as fashion itself.

Like any skilful portraitist, Newton makes himself an essential part of the expressive equation, doling out seduction and discipline in equal share. But he has a crucial advantage: he induces his subjects to fantasize themselves as *images* seen through *his* eyes. At that double remove his sitters project themselves as a Newtonian idea and help tailor their mundane and idiosyncratic beings into flawless, daunting avatars of notoriety, triumph and style.

Just as he has created his own private world of sex and chic, Newton has also created himself. His biography is a bare-bones summation with noticeable gaps. Born in Berlin in 1920, he was apprenticed in 1936 to Yva, a photographer of fashion, portraits and nudes. In 1938 he left Germany and lived in Singapore and Australia; in 1961 he moved to Paris. He remains adamantly secretive about the years between 1938 and 1956, when he first went to Paris to end his protracted exile from European culture. Since 1981 he has lived in Monte Carlo and Los Angeles.

[The following interview between Helmut Newton and Carol Squiers took place in New York in the spring of 1987.]

CS: In an earlier book, *World Without Men*, you wrote about how you lied to get in to photograph Jane Russell in 1972. You were so nervous that very few of the pictures turned out! Since then you've photographed many celebrities. Were you usually nervous around celebrities?

HN: No, I'm generally pretty good, especially if I like somebody very much. I've done two sittings with Elizabeth Taylor. During the first one I was very much in awe of her and she wasn't relaxed with me, either, but we did very good pictures. By the time we did the second sitting, for *Vanity Fair*, she had confidence in me and she said to the people at the magazine, I want Helmut to choose the make-up, the hair, the dresses—everything! She was very, very sweet and very funny. In one picture she holds an enormous emerald, and she said to me, Will you buy this for me, Helmut? I said, Of course! I will ruin myself with great pleasure for you!

CS: So it wasn't that Jane Russell was a celebrity that made you nervous.

HN: No, it was that I had seen many of her movies and I thought that she was physically very exciting. She was also very nice. I don't know whether she still is, but at that time she was very religious—she had candles burning everywhere and religious pictures all over her room.

CS: But some people do give you a hard time when you photograph them. What do they do?

HN: I just photographed a famous blonde actress. The first time was very good. Then I photographed her again and she wasn't well and she gave me a hard time. I always want more skin. And she'd say, Oh, I don't want to show that, and I'd say, But that's good! Actresses, especially Hollywood movie stars, are particularly obsessed with not showing a square inch of meat.

CS: Why?

HN: God knows! I don't know. They don't mind doing it in front of a movie camera! Americans are very prudish. Even in fashion photography, the parameters are so different.

CS: How would you feel about showing a little of your skin in a portrait?

HN: Well, a certain well-known woman photographer photographed me a couple of times. And the first time she wanted me to take my cock out of my pants! I said, No way! You must be crazy! I was really shocked! This was the first time I met her. Then she said, Well, put your camera down there, and I didn't mind doing that.

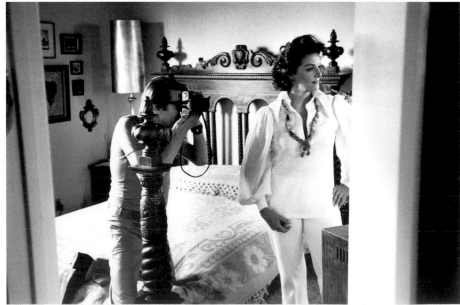

Jane Russell and I, Los Angeles 1972

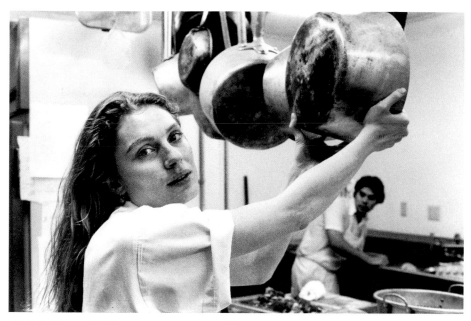

Cook in Texas, 1985

CS: But considering the way you photograph people, why did you think it was so outrageous that she asked you to expose yourself?

HN: But I don't ask anybody to do that. I hear that she always asks people to do crazy things. I think she sees herself as a latter-day Diane Arbus. I see myself as a latter-day Erich Salomon.

CS: What do you think of the whole notion of photographing celebrities?

HN: People don't want to see my Aunt Agatha, even if my Aunt Agatha has the most fascinating face in the world. And I'm fascinated to see what celebrities look like. They've all achieved something. But I also did a series of portraits for a large magazine. They said, We can't afford your prices. I said, You give me what you give everyone else, but I would like to do such and such a thing. They said OK and set up eight portraits of rich people and eight portraits of poor people—cooks, waitresses, engine drivers. Guess what happened? They published the rich and they never published the poor! I was furious! But I can't force them to publish them. I came to portraiture, and to nude photography, very late. I started nudes in 1980 and I started doing portraits a little bit before. In the beginning they were commercial assignments.

CS: What's your definition of a portrait versus any other kind of picture of a person?

HN: I think everything is a portrait. A fashion picture is not a portrait, but a portrait can be a fashion picture. In the business we call models 'models' and people like you and me 'real people'. Is it a real person or is it a model? A model is not a real person because we pay her x amount of money to be allowed to make her into whatever we want.

CS: What do you think the elements of a portrait are?

HN: The person's surroundings, the way the person behaves. I don't go through a great psychological process.

CS: You don't do anything different when you take a portrait than when you take a fashion picture?

HN: Yes, I do it differently. A fashion picture is much more *mise en scène*. I try and do a *mise en scène* for a portrait. For instance, when I photograph an actor or actress, I always give them the same spiel, which I believe in and which works. I say, I don't want an actual picture of you. To the actresses I say, Look, imagine you're playing a part. When I photograph I'm really not interested in actual pictures, because I'm too contrived. I find it boring. What is a natural picture? A snapshot. I like the person to play a part, to be somebody else—or be himself but more so. When I photographed Mel Brooks, I got an assignment sheet from Condé Nast—what time to be there, et cetera, et cetera. And it said on the sheet that Mr Brooks requests that I do no close-ups and only funny pictures. Isn't that hilarious? Every picture of him I've ever seen, he mugs, he pops his eyes out. He started doing the same thing with me. And I said, Please, Mr Brooks. I am very diffident in front of these people. I'm not like a lot of other photographers who have a power trip, who get behind the camera and see it as a weapon to violate a person. It's already a violation enough even when you're quiet—it's bad enough having a camera in front of you. I said, Please, if you don't mind, be serious. And then he was very good—every picture was serious and quite good.

CS: Sean Callahan, the photo editor, said recently that you 'became' Helmut Newton after your heart attack in 1971.

HN: He got that right. I changed my life totally. I had a heart attack right here in New York City and I almost kicked the bucket. That does change your life. I had a beautiful Bentley Continental car back home that I adored, and the first thing I did when I came out of hospital was to sell it. Time was too short. I just wanted to take pictures. I had quite a lot of houses—a house in the South of France, two apartments in Paris, one in Los Angeles—and I started getting rid of all that. I just wanted to rent. I got two Volkswagens, one for myself and one for my assistant. I rent an apartment in Monte Carlo. I like staying in good hotels.

CS: The heart attack seems to have changed your work, too. Where there were certain elements of perversity in your work before the heart attack, the work seems to have become much more intense and more perverse afterward.

HN: I'm truly not aware of that. But I hope it's perverse! I know my work has changed. My outlook has changed. The heart attack changed everything, but I don't know in what respect. I think it's better than it was. But whether it's less perverse or more perverse, I don't know.

CS: How did you get interested in violent subject matter in the 1970s?

HN: My pictures aren't violent. They're erotic, but they're not violent. Other people have put that label on me.

CS: Why do you think they did that?

HN: I'm buggered if I know. When they did *The Eyes of Laura Mars* they commissioned me to do the pictures that Laura Mars was supposed to have taken. When they saw the first pictures they called me back and said, Helmut, this is not what we want. These are erotic pictures. We want a general-release certificate. We want violence. I said, but I'm a sexy photographer, I'm not a violent photographer. You got the wrong guy.

CS: Did your association with them end at that point?

HN: No. I went on and surrounded myself with *True Detective* story pic-

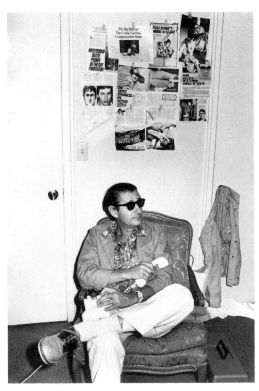

In my New York hotel room surrounded by True Detective, *1977*

tures—it's very funny. But I never produced any pictures. I don't like violence.

CS: You've said you're not capable of being anything other than a photographer. What's the difference between an artist and a photographer?

HN: Enormous difference. I say, and not for the first time, that art is a dirty word in photography. It'll kill photography. All this fine-art crap is killing it already. That's what I think. It's very serious.

CS: There seem to be many overt references and allusions to mortality in your work. The most obvious reference is the picture of the X ray of the skull and necklace with the quote from Shakespeare in the beginning of *Big Nudes*: 'Golden lads and girls all must, as chimney-sweepers, come to dust'. You're shaking your head. Do you disagree with this?

HN: Totally. I'm not at all interested in death. I'm not preoccupied by death. My wife, June, once said, Helmut, don't you want to discuss this subject? And I said, It doesn't interest me. I don't want to discuss it, it's a waste of time. She has a friend she discusses it with. But I don't want to know her opinions. I don't care about it. I'll spend a lot of time being dead, I'm sure, like most everybody. So there you are: I couldn't disagree more.

CS: Then what does that picture and quote mean?

HN: I love doctors.

CS: I've never heard anyone say that before.

HN: A lot of doctors that look after me have become very good friends of mine. There are four self-portraits in the book of me with doctors. I'm a hypochondriac. The moment I've got anything wrong with me, I run to the doctor for the simple reason, like a car, I want to be fixed quickly to go on with what I'm doing.

CS: Why did you put the pictures of you with the doctors in the front of the book?

HN: Because the beginning is the personal section. It's about my life. Pictures of my wife, including the first picture I ever took of her, with the dog. There are many more. I couldn't do a family album, but the doctors are part of the personal section.

CS: But there's your early life and then there's really nothing between 1936 and 1973 when we jump into the hospital.

HN: Well, a lot of it has been lost because I travelled a lot all over the world. I lived in Singapore for three years—that kind of thing.

CS: What did you do in Singapore?

HN: I'm not going to tell. It's nobody's concern.

CS: What part does your wife play in your picture-making?

HN: She's enormously important. When she was really sick, I truly didn't think I would take another picture. I wasn't interested any more. She got me back into it. I was in a very low state. Women are much stronger than men— in every possible way. I truly believe that. I'm a big admirer of women. After I did the first picture in the series of orthopaedic-corset pictures, I thought I'd gone too far. I was ready to give it up. And she said, You must go on with this, it's very important. But she is a very straight girl, not sexually perverted in any way or anything like that—real healthy. Not twisted like I am!

CS: How did you start doing the orthopaedic-corset photographs?

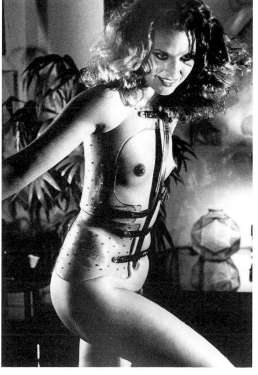

Orthopaedic corset, 1977

11

HN: I've always been an admirer of Erich von Stroheim. My father looked very much like him—he was in the Prussian army like Stroheim. And I always loved his movies the best. In *Grand Illusion* he wears a neck brace. I've always been crazy about that image. So I got the idea of putting women into orthopaedic corsets. I had a terrible time finding them. In the end, the most important French orthopaedic hospital opened its doors and the head surgeon let me come and choose whatever I wanted.

CS: What does the dedication 'Full immobilization in a cuirasse' in *Sleepless Nights* mean?

HN: I said to my doctor in Paris, Dr Dax, give me some medical writing on orthopaedic corsets. That's from a book that a doctor wrote. It said, 'full immobilization'—total restraint. Restraint is sexually very interesting.

CS: Was that what primarily interested you about the corsets?

HN: It's like bondage, in a way. When these pictures came out, I got a lot of mail—a lot of good response. Women wrote and said, I have been in a ski accident or I've been in a car accident and I found myself ugly and horrible, and then I saw your pictures and I realized I could be beautiful in this corset. They were all from Europeans. It was really very interesting—it was an encouragement to the women that they saw these beautiful women wearing them. It was not a matter of making fun of them, but it was something that made them feel desirable. I never thought it was a very sexually arousing thing to look at, to see a woman in one.

CS: And when you originally started these pictures, you thought you were on the wrong track?

HN: I thought it was sick. I don't mind being sick, but I don't like sick people. I hate going to hospital. I can't see blood. I mean, the idea of somebody really whipping a girl, if she'd really get whipped, I'd get *very* upset. I'd be very angry. The first one was taken in our apartment and June didn't feel in any way threatened—she thought it was great. I don't know why. I still don't know why. Maybe she doesn't know, either.

CS: You thought it was sick, like an illness?

HN: I thought it was sick in the head. I thought people would really hate them. I couldn't care less. I'm not here to be liked. I've taken lots of pictures of June in the hospital—the day after her operation, when she'd still got all the clamps in and everything. It's not that I'm squeamish, although I faint pretty readily at a sight like that. As a child I fainted a lot. My parents were used to it—in the middle of the dinner table I'd just fall off the bloody chair! I was a sort of delicate child. But I went on with those pictures because June encouraged me.

CS: I understand that you're interested in prostitution, too, aren't you?

HN: I know a lot about prostitution. I've known girls that have been with Madame Claude, the famous madame in Paris. I've always been fascinated by it, even when I was a kid in Berlin, where there was a lot of prostitution. My brother is ten years older than I am so when I was a little kid of nine or eight, my brother was eighteen—that would have been in 1928. There was a very famous whore on one of the main streets in Berlin, called Red Erna. She wore red boots and carried a whip. My brother showed her to me—my eyes were poppin' out of my head. Elder brothers are terrible to their young brothers! But

that was already something that fascinated me. I've visited many places of prostitution all over the world—in Haiti, Mexico, Singapore. Now I'm a bit bored with it. Really interesting bordellos are finished. There were bordellos in Paris until not long ago that were like very lush apartments—in Berlin, too. There was a big living room with a salon and there would be a bar—you could just go and have a drink. You weren't forced to book a girl. The girls were hanging around. In France they're called *pensionnaires*. A *pensionnaire* is a girl that lives in a boarding school. Even now some of the great hotels have *pensionnaires*. The girls sit in the bar in the lounge. They don't go around and solicit. Even in the hotel where I always stay when I'm in Paris, they tolerate certain *pensionnaires*. But unless you knew who they were, you wouldn't know. What is so interesting is the idea of their availability. It's the fact that a man can go into a place and choose a woman, like merchandise. It's quite extraordinary. The merchandise often can be very luxurious and most presentable. I'm not talking about streetwalkers. Also, AIDS has changed everything. I think it's changed the sexual mores of everybody, with a speed that's unbelievable.

CS: Didn't those big, old, posh bordellos start changing before AIDS became a problem?

HN: Yes, because the law clamped down. They were getting rarer and rarer. They were tolerated, absolutely, before that. In France there was an interior minister who managed to pass a law to close all the bordellos—it was after the war. There were some very famous bordellos. One was called the Sphinx, which was the most famous—*everybody* would go there, the choicest people dined there. You *dined* there, you didn't just go to fuck.

CS: It was an atmosphere of naughtiness, of being outside social norms.

HN: But it was within social norms in those days. It was not outside social norms, not in Paris. The customs in America, Australia, and in Britain in the Victorian days were just outrageous! I don't know what America was like in those days, but I think in the West it was pretty wild. But I think the Victorian days in Britain for prostitution were incredible—the German word for it is *Ausschweifung*, excesses! It is when the fantasies of the people become larger than life. They would go to great lengths for sexual pleasure.

CS: There are 'escort services' here rather than bordellos, like the one run by the so-called Mayflower Madam. Did you ever meet her?

HN: No, I was going to photograph her, but she wanted this and she wanted that and I said I couldn't care less, forget it. You've got to pay *me* to photograph her. I photographed Madame Claude for *Vanity Fair*. She's just come out of jail. She lived in Los Angeles, and when she went back to France, they clapped her in jail for seven months for income-tax evasion. She would like to exercise her profession because she does it very well. She's a very tough cookie. But where is she going to do it? She can't do it in France any more.

CS: You're interested in pornography, too, aren't you?

HN: I decided three or four years ago that I wanted to do some pornography. Through friends in Los Angeles I met two couples in the upper bourgeoisie, with money. Not great beauties but *very* nice-looking, both male and female. They were interested—they wanted me to photograph them in a very, very pornographic way. Really hard pornography.

CS: These people were friends?

HN: They live together. They love each other. I would never be interested in photographing people that don't know each other and don't care for each other.

CS: If the people love each other, then I don't see how what they do is pornographic. Is the pornography in your photographing them?

HN: If it happens with nobody around, it's not pornography. If you do something with your boyfriend that is not straight fucking, that is OK. There are not a thousand different ways—there may be five hundred different ways. Even the Marquis de Sade had his limitations. When you do it alone, it's sex. But the moment you have a witness to put it down on paper . . . Because I've been working for magazines for so long I have a kind of built-in safety valve that stops me. I try to make myself do things I would never have done before. So I started doing these pictures. And what's more, all these people signed releases. I've never published them, obviously, and I'm not going to because it would close too many doors for me—especially in America, but in Europe, too. I can't afford it. Later, not immediately, I showed them to June. And I said, In a way I'd like to go on with this, but what the hell, to me it's a waste of time because I can't ever use them, and I hate doing pictures that I put in a drawer and never use. It seems pointless. They've got to be seen by the world. And she said, You must go on with it—because you took pictures many, many years ago that were thought to be daring and now everybody's used to them. Fifteen years from now those pictures that are shocking to look at now may be looked at in another way. I don't think so, but she could be right. So I went on with it. But she is not interested in pornography—it's not her kind of thing. She admires, she likes the pictures because, although they are very hard, they have a lot of style. They're different from *Hustler* or the usual kind of pornography, but they're very hot. I mean, when I look at any of my sexy pictures, what I call my dirty pictures, I never get a hard-on. They don't excite me. Because I know the work that was involved. But those pornographic pictures—when I go back to them, they could possibly trigger off some kind of different sentiment, because they are pretty exciting.

CS: Do you think other people get excited when they look at your sexy pictures?

HN: I've been told they do, yes.

CS: Do you like that?

HN: Yes, very much.

CS: Do you want that response?

HN: I don't think of it. Obviously, I want a response to anything I do, whether it's a portrait or whatever. Very rarely are people indifferent to my photographs.

CS: One of your self-portraits shows you wearing a trench coat with a nude model, and your wife sitting off to one side. Does your wife sit in on photo sessions?

HN: Never. Ever. She had just come by for lunch that day.

CS: You've called yourself a voyeur.

HN: I *am* a voyeur! I think every photographer, whether he does pictures that are erotic or sexy or he does something else, is a voyeur. Your life goes by

looking through a little hole. If a photographer says he is not a voyeur, he is an idiot! I think he can't be much of a photographer. It has nothing to do with sex. With the advent of AIDS I wonder if there's not going to be a new renaissance of interest in pornography, in voyeurism. It's impossible now for young people. People like me—we've had our fun. I feel so sorry for young people. It's terrible. There are certain clubs here and in Paris where people just watch other people fuck and all that—but now there are only watchers. There are very few performers. And there will be fewer and fewer performers and more and more people who want to watch! What are they going to do if nobody wants to do it? So you get down to masturbation. You can't catch anything from masturbating. People have to get a high somewhere—or you don't do it at all, which would be totally unnatural. Or you marry a virgin and everybody's totally faithful, which is highly unlikely. It's not just the act that makes you unfaithful. The moment you desire somebody or you even say, I want to touch you, I want to see you . . . If I say to a person, I want to see you naked, and in my head I say, Well, I would like to fuck her but the reason I don't is because I'm scared to get AIDS or something, I'm still unfaithful, aren't I? I do it or I don't do it—it doesn't make much difference. Morally, you're already condemned, I think. I wonder where it's going to lead—sexual mores, AIDS. When we were very young in Berlin, we were all screwing around. The girls were all from good families. They were all very wild—at fourteen they were all fucking around. It wasn't like we went to whores, although we did that, too. But we were not interested in drugs. They didn't exist. We had one Scotch when we were fifteen and we felt we were really flying. We didn't like the taste of it, but we felt grown-up having a Scotch. We didn't even finish it.

CS: Why do you photograph so few men?

HN: I guess I just like photographing women.

CS: Do you find photographing men difficult?

HN: No, it's much easier than photographing women. Men are not so concerned . . . all men of my generation are concerned with *this* under their chins. I say I look like an old crocodile! But men are much easier. They can put up with bad light.

CS: When you photographed yourself nude in 1976, your clothes were very neatly folded on a chair in the picture. But when you photograph women who are nude, their clothes are scattered everywhere, in a kind of wild abandon.

HN: I'm quite a tidy person. I would hate to live in disorder and I can't work in disorder. But this is interesting—I create that disorder—I want the model to take all her clothes off and just dump them. That self-portrait was included in a European catalogue, and I said to June, Maybe I shouldn't put that in—it shows how small my prick is. It's not very impressive!

CS: You don't do editorial fashion anymore?

HN: No. I do it to make money. There are other things that interest me much more—like portraits and an exhibition I'm preparing now. When the portrait book was finished in December, it was like a chapter had been finished. I haven't taken any nudes since 1981. I've only done portraits and advertising. I've done maybe one nude a year. All of the sudden, I badly want to get back to nudes and I want them to be raunchy. Really raunchy.

CS: The portrait phase is over?

HN: No, I'll keep doing portraits. It's not something you can turn off. Taking raunchy pictures is very difficult. It's easier to take a portrait than a raunchy nude. I swear to you. You've got to have an idea. It can't be pornographic because then I couldn't use it for what I want to use if for. I've got an exhibition coming up and I want a lot of people to see it. To do real, hard pornography—I don't want people to see that. But I want it to be something that *is* raunchy but that has nothing to do with *Playboy* or anything like that. To do a portrait is difficult, but you can do it because the framework is so narrow.

CS: After you get the idea for the raunchy nude, then what?

HN: You've got to put it all together, like a fashion photograph—like a *mise en scène*. You have to find the place—they're not done in a studio. Sometimes you have to get a stylist. In what I'm doing now—in some of them I am myself an onlooker. Ever since I did the pictures of myself with the doctors and June and the models, I've been interested in putting myself in the picture.

CS: You sometimes do private portrait commissions in which people want to be portrayed in a very sexual way, don't you?

HN: Yes. One woman called and I said first I would have to see her picture. Very strange. I bet she was into some kind of bondage thing. She must have been about forty-five. I was interested in the fact that she was into bondage. We took the pictures and she was very gutsy, much more gutsy than I was. I was a little bit timid. But it was a real sitting—I had a make-up man and a hairdresser. She wanted to be photographed in a way very much like *White Women*, a little like a whore—very sexy, with boots and all that. And she was very difficult to photograph because she was already in her forties. I got some good pictures. They were for her husband as a present. She had two grown-up sons and it was their twenty-fifth wedding anniversary. I thought it was touching. Two years later she died of cancer. I wouldn't be surprised if she had known that and her husband didn't know and she wanted to leave him those pictures as a souvenir.

CS: How many private portraits do you do a year?

HN: Maybe two. They all want to look sexy and it's very hard to make them look sexy, especially when they're older. I don't get that many, but I love doing it.

CS: How many have you taken in which they wanted to take their clothes off?

HN: Three or four. But there's always a bit of eroticism, even when they don't take their clothes off. It's a very private thing—I'm sure it turns them on.

CS: When you photographed Nastassia Kinski—you wrote that you had to struggle to get her to pose.

HN: It was difficult to get her to take her clothes off. She's a very intelligent girl—very intense, very bright. Somebody else had done a sitting with her and they hadn't got her clothes off. The pictures were taken for *Playboy*, which pays a lot of money for it. The person who poses doesn't do it for nothing. And I get well paid. She chose a woman photographer who took some nice pictures of her, but she was dressed. They asked me if I would have a go at it. I said to her, It's no good. We're both working for *Playboy*. I'd rather you say straight off, I don't want to pose for *Playboy*. I'd understand that. It's like if I take a fashion photograph and I don't show the dress. You're a professional and you accept a job; you must do what you're supposed to be doing. What I

did—I used a ruse. She had just finished making a film with James Toback. I said, I would like to photograph you with your director. There's often a very strong relationship between an actress and her director. Even if they don't sleep together, there is a kind of sexuality or something—there *always* is. I wanted to use this relationship.

CS: The picture that's particularly strange is the one where she looks like she's about to nurse a Marlene Dietrich doll.

HN: That doll was given to me as a present. I've always been crazy about Marlene Dietrich and June saw the doll in an antique store in Los Angeles. It was about two thousand dollars, and she said, I'll buy it for you for Christmas. I told *Playboy* to go and hire it because I was going to dress Nastassia and the doll alike. They were so sweet at *Playboy*. They knew I wanted it, so they gave it to me as a present.

CS: How did you get Nastassia Kinski to pose as if she's nursing the doll?

HN: It wasn't nursing! I thought she was dancing—to me it was a dance. I never think about nursing. I'm not crazy about nursing mothers. It's rather disgusting. Ha-ha! I sort of faint dead away when I see it.

CS: Is Charlotte Rampling your favourite model?

HN: She's never been a model, but I've photographed her a lot—she's wonderful to photograph. Wonderful face, wonderful woman—all the attributes that I think a woman should have. Sexy, intelligent, very funny, beautiful voice. *Vanity Fair* asked me to do something with her and her husband, Jean-Michel Jarre, the son of the great film composer. I wanted to do something very raunchy with them, almost pornographic—and because they're married and they love each other, it would make sense. But then something happened: the Pope came to Lyons! Jean-Michel was commissioned to do a sound-and-light show for the Pope. The Pope sent a nice message to Jean-Michel that was printed in all the French papers. It was wonderful. And I said to June, I can't do pornographic pictures of those two after what the Pope said! It was just before the sitting.

CS: What did you do?

HN: I had another idea. I was going to do a photograph with them posed like a neo-Bolshevistic statue of peasants and workers going into the glorious dawn. I didn't tell *Vanity Fair*. I had a red light in the background and I put them on a podium. She was barefoot and wore a peasant skirt. He wore braces and they were looking into the light, going into the glorious dawn. They liked the idea. I sent the pictures off and I got a frantic call from *Vanity Fair* saying, What the hell has happened to you? We don't understand those pictures. I explained about the Pope. They said, Well, we're not interested in those pictures. Ha-ha! They got very upset, they thought I'd gone out of my mind. They said, But you were going to do something sexy—now what's this all about? In the old days it used to be the other way around!

CS: Could you talk about your years at *Vogue*?

HN: In the late fifties, we came from Australia and I got a contract for English *Vogue*. They paid me thirty pounds a week—it was barely enough to live on. We lived in a terrible little walk-up cold-water flat, but at least I was back in Europe. I took the worst pictures ever. I hated it and they treated me badly. One day I said to June, Fuck it, I'm going to leave. She said, You're

breaking your contract—you'll never work for Condé Nast again. I said, I don't give a shit—I can't make it. I had a beautiful white Porsche with red leather seats. We packed our few belongings into the car and we went to Paris. I went to four magazines and showed my book and got two offers, one from *Jardin des Modes*. I didn't even go to *Vogue* because I didn't think they wanted to know about me. *Jardin des Modes* at the time was the most interesting and avant-garde fashion magazine in Europe. It was marvellous and had a wonderful editor-in-chief—a great big lady who looked like a battleship. But she was very kind to me. In a very short time I learned about fashion. She used to say, Newton! Newton! *L'esprit de la mode! L'esprit de la mode!* It was 1957 and we were all young—the bright white hopes of fashion photography. June got a contract with the BBC and she had to go to London. We used to have meat one day a week, and the rest of the time we ate anything—we had *Vin de Postillon*—one litre for one franc. It was good! We never had much money, but we had a lot of fun.

CS: What did you do in Australia?

HN: I did whatever they gave me. I tried fashion, but I did everything—anything—mail-order catalogues. Anything just to make money. When I was in Paris the first time, I got a contract with Australian *Vogue*. June had a contract with the BBC—she loved acting. She was the first actress I ever met. I went ahead to Australia and she followed me. We made a pact—that two years from then we'd go back. And then exactly on the dot, in 1961, I went back to Europe. But June didn't want to leave Australia because she was doing very well—she worked a lot doing television and theatre. She came back to France anyway. I went back even though I had no contract, nothing. I immediately got work on French *Vogue* and have stayed with them forever. I did my most important fashion work for them. A marvellous woman called Edmonde Charles-Roux was the editor—she was probably one of the best editors French *Vogue* ever had. After that, Françoise de Langlade, who was married to Oscar de la Renta, became editor. Then I was thrown out of the magazine. I was working for *Queen* with Claire Rendlesham, who was a very good fashion editor. In the 1960s Courrèges made that enormous revolution with his space clothes and white boots. After she saw that collection, Claire had the idea just to do Courrèges in *Queen*. It was unheard-of—not to show any other couturier in a fashion report. When this came out, Françoise called me and said, Helmut, I'm very upset. You didn't tell me what you were doing. I said, I'm not going to tell you. It would be giving away confidences. She was furious and she threw me out.

CS: Did you get into hot water because of your pictures in the 1970s?

HN: The hot water was finished by then! It happened before—it was more difficult in the sixties. They let me do a lot of naughty things. Francine Crescent, French *Vogue*'s editor, did lay her job on the line quite often because we did a lot of naughty things and had a lot of fun. I know people were very upset at American *Vogue* about the pictures I did for French and Italian *Vogue*. And although I've been a regular contributor to American *Vogue*, it's few and far between. The seventies was a very exciting and wonderful period in fashion photography. We broke a lot of ground. We really whacked it down the throats of the readers at the time. We had a lot of battles—it wasn't easy going.

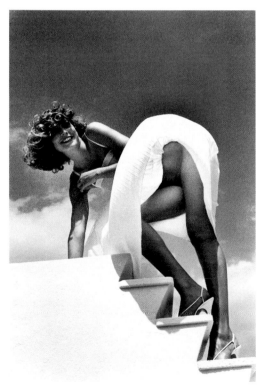

Daring fashion photo for French Vogue, *1978*

CS: A photographer, François Deschamps, once suggested that your work in the 1970s was influenced by the prevalence of terrorism in Europe.

HN: No, not by terrorism. What was influential was the revolution in sixty-eight in Paris, which really influenced fashion because of the kids who went out into the street with bandanas on their faces against tear gas. They were fucking right and left having a wonderful time, and they went to the Citroën factory and tried to get the workers into their cause. I wrote about it in *World Without Men*. Fashion certainly was influenced and I was influenced by it—I always get influenced by what happens around me.

CS: You did a portrait of Don McCullin, the famous war photographer. Are you at all influenced by war photography?

HN: Not at all. I admire him as a photographer enormously and he's a fascinating personality—the women are just mad about him. I don't like violence. I only like it on the movie screen when it's unreal. But I was really upset by *Platoon*. I walked out of it. I don't mind the violence in something like *Blue Velvet*, which I loved—the more outrageous, the more Grand Guignol—I adore it. But otherwise—I can't look, tell me when it's finished! June looked at *Platoon* the whole time, but I couldn't look because it's too real. I like it when it's all like a comic strip or a B-class movie, like *The Creature from the Black Lagoon*.

CS: Molly Haskell wrote about *World Without Men* that you 'go too far in taking the fun out of sex' in your pictures. What do you think of this?

HN: I don't think sex should be fun! Sex is deadly serious. Otherwise it's not sexy. If I laugh on my way, how can I do it? To me there's got to be a great element of sin to get people all excited. I don't see any fun. That's an American attitude, fun in sex. I don't know how it works. I haven't experienced it. It might be OK for some people.

CS: In *Sleepless Nights*, Edward Behr wrote that 'for all his hedonism, Helmut Newton is also a moralist'.

HN: I think he was right. I am very prudish. Terribly square. I get shocked easily.

CS: But you don't find your own pictures shocking?

HN: No, because I don't even get a hard-on from my own pictures!

CS: What do you want to show in your pictures?

HN: A lot of the pictures show the life-style of the women. This has nothing to do with moralism—I'm digressing. I talk about geography in my fashion pictures and even in my sex pictures. If I'm in America and I photograph a woman with a car, it would never be a Rolls-Royce or a Citroën. It would always be an American car, whichever describes the social class, whether it's a cheap car—it would be a Cadillac or a four-door Chevrolet. When I'm in France, it's always a big Citroën. In Germany it's a Mercedes 600, which is my favourite of all cars. The way the women are depicted is also as true as I can make it—the surroundings, the behaviour. They behave the way American women, I think, would like to behave. And the same goes for the French women I photograph.

CS: It's your idea of the way things should look?

HN: It's very expected.

CS: There are no surprises?

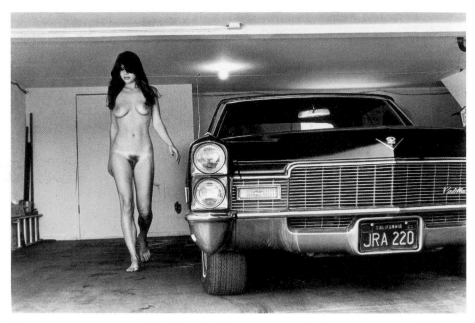

When in America, my models drive Cadillacs or have a Caddy in the garage, 1976 ·

HN: Yes, but I find that the most exotic things are surroundings that I know very well. I find mystery when I go out of my house in Monte Carlo at night—I photograph lots at night. Last year I did a lot of fashion at night for *Paris-Match*. I always loved night pictures—that mystique. I always work within a very short distance from where I live. My last apartment in Paris was on the Jardin du Luxembourg and all my pictures were taken there. I don't like going far away. Alex Liberman sent me to Maui for *Vogue* once—it was tied up with a promotion for the local tourist board. After three days I got a call from Alex's office and he said, Newton, get your ass out of the hotel. The tourist board rang up and said you haven't moved away from the pool! They want you to see a bit of Maui! Ha! When I'm in Los Angeles, I do the same thing. I go to the same places—Berlin, Monte Carlo, Paris, Los Angeles. That's where my life has been happening over many years now. They are the places I like.

CS: And they also tie up with your favourite photographers—Brassaï and Salomon.

HN: Well, the social scene ties up with them. Brassaï was plumbing the lower depths of the city—he is the great master. I love his night pictures of the prostitutes, the bars, but also the cityscapes at night. Not just the bordellos but the beauty of the city of Paris.

CS: And what about Erich Salomon? It seems to me there was always an element of the illicit about his work, even when it was done out in the open.

HN: Absolutely. What attracts me to him was that what he did was technically so difficult. I love the way he photographed at a time when nobody else could do it. There's a book about him in German and in the back are facsimiles of his letters—it's the most fascinating book I've ever seen on Salomon. He had a very short peak—maybe five years.

CS: You and Robert Hughes were talking during a portrait session, and you said, Oh, I don't believe all that psychological stuff in portraits. If you don't think a portrait is about psychology, what do you think the elements of a portrait are?

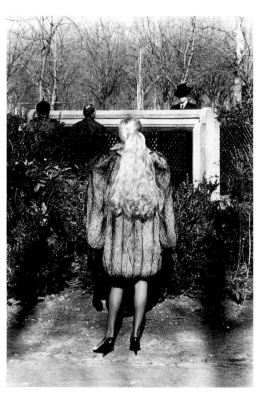

Pissoir in Jardin de Luxembourg, Paris, for French Vogue, *1980*

20

HN: Well, I don't know anything about people that I photograph. What do I know? It's only what I see. What can I know about a person? Robert Hughes—I've read his writing, but I don't know the guy! What do I know about this girl that I photographed recently? Nothing! I go, I meet them one day. I look at the clothes. I look at the apartment.

CS: You just look at everything that's there and then you construct a visual idea out of what's in front of you?

HN: Yes. I'm not a reporter. The antennas are up all the time, even if the reception is false or phony—it doesn't matter. Even if there's static that comes through. I don't know anything else. I couldn't say to that woman, What's happened in your life? I wasn't interested. I don't want to know! Why am I going to load myself with other people's lives? And what difference is it going to make for my picture? If I were a writer, that's different. If I were a painter, maybe I could put things in. But I can only photograph what my camera sees. I don't have a whole lot of symbols in these pictures. I see that a man like Robert Hughes is physically powerful, so I try to get his shirt off. But the moment he says no, I wouldn't press it because it's a waste of time. I'm not going to violate the person. If the person *wants* to be violated—that's different. Sometimes they ask for it! I know when they ask for it! When someone says to me, No way, I'm not going to make a fool of myself—it would be bad for our relationship.

CS: Why did you leave Berlin for Australia?

HN: Oh, it's a long story! We're not going to talk about that! It had nothing to do with anything. Everyone knows I'm Jewish. It had nothing to do with Australia. Australia was for other reasons and Singapore was for certain reasons that I'm not going into. I wasn't on my way to Singapore, I was on my way to somewhere else. That's why you've got to keep your antennas free and out. Life is full of surprises.

List of Plates

61. Diane Segard and the Countess Joy de Rohan-Chabot, Paris 1978.

62. Violetta Sánchez, Paris 1979.

63. Mary Ellen Mark at the Grand Hotel du Cap, Antibes 1977.

64. Betty Catroux at home, Paris 1980.

65. Nick Wilder, Los Angeles 1976.

66. My cousin, the poet Tessa, Paris 1975.

67. The Princess of Polignac, Paris 1979.

68. Isabelle Huppert, Hotel Carlton, Cannes 1976.

69. Romy Schneider, Paris 1974.

70. Mick Jagger, Paris 1977.

71. Marianne Faithfull, Paris 1979.

72. Jenny Kapitän, Paris 1978.

73. Xavier Moreau with girl friend, Paris 1974.

74. Volker Schlöndorff, Hollywood 1986.

75. Laurie Livingston, Beverly Hills 1981.

76. An unknown beauty, Monte Carlo 1979.

77. Raquel Welch, Los Angeles 1980.

78. Raquel Welch, Los Angeles 1980.

79. Xavier Moreau, Verona 1979.

80. A scene from Pina Bausch's ballet *Die Keuschheitslegende* (The Legend of Virginity), Wuppertal 1983.

81. Hanna Schygulla, Munich 1980.

82. Rainer Werner Fassbinder, Munich 1980.

83. Hanna Schygulla as Lili Marlen, Munich 1980.

84. Wim Wenders, Berlin 1980.

85. Thomas Brasch and Katharina Thalbach, Croix Valmer 1980.

86. Werner Herzog, Bavaria 1980.

87. Hanna Schygulla, Munich 1980.

88. Nastassia Kinski with Marlene Dietrich doll and movie director James Toback, Hollywood 1983.

89. Nastassia Kinski, Hollywood 1983.

90. David Lee Roth, Pasadena 1979.

91. David Bowie, Monte Carlo 1983.

92. Debra Winger, Los Angeles 1983.

93. Jenny Kapitän in my studio, Paris 1978.

94. Arielle after a haircut, Paris 1982.

95. Sigourney Weaver, Los Angeles 1983.

96. Sigourney Weaver, Los Angeles 1983.

97. Sigourney Weaver in drag, Los Angeles 1983.

98. Eiko Hosoe, Antibes 1983.

99. Don McCullin, Antibes 1983.

100. Stéphane Audran, Paris 1984.

101. Ralph Gibson, Antibes 1983.

102. Jakob Andersen and Helene Pikon, members of Pina Bausch's ballet company (on TV: Jakob Andersen and Josephine Ann Endicott), Wuppertal 1983.

103. Pina Bausch, Wuppertal 1983.

104. Larry Flynt, Beverly Hills 1986.

105. Tina and Michael Chow, Beverly Hills 1984.

106. Hugh Hefner and Carrie Leigh, Beverly Hills 1984.

107. Daryl Hannah, Los Angeles 1984.

108. Daryl Hannah with unidentified baby, Los Angeles 1984.

109. Teri Rojas and her sister Cheri Hamilton, Santa Barbara 1984.

110. Teri Rojas and her sister Cheri Hamilton, Santa Barbara 1984.

111.–112. Lisa Kitchen, Santa Monica 1984.

113. Lisa Kitchen, Santa Monica 1984.

114. Peter Beard with his portrait by Francis Bacon, Paris 1976.

115. Peter Beard, Hollywood 1984.

116. Helmut Berger, Beverly Hills 1984.

117. Helmut Berger, Beverly Hills 1984.

118. John Huston, Los Angeles 1984.

119. Anjelica Huston, Los Angeles 1986.

120. Serge Gainsbourg and Jane Birkin, Paris 1978.

121. The sculptor Robert Graham, Venice, California 1984.

122. Lisa Lyon in her studio, Venice, California 1981.

123. Jacqueline Bisset, Beverly Hills 1984.

124. Jacqueline Bisset and Alexander Godunov, Beverly Hills 1985.

125. Jeanne Moreau, Paris 1985.

126. Ava Gardner, London 1984.

127. Ava Gardner, London 1984.

128. Princess Diane von Fürstenberg and the writer Alain Elkann, Nice 1984.

129. Barbara Sukowa, Monte Carlo 1985.

130. Veroushka, Nice 1975.

131. Veroushka, Paris 1984.

132. Claude Montana, Paris 1982.

133. Steve Strange, friends, and bodyguard, Paris 1982.

134. Prince Rainier of Monaco with close friends, Monte Carlo 1984.

135. Princess Caroline of Monaco, Monte Carlo 1983.

136. Princess Caroline of Monaco, Monte Carlo 1983. Collage.

137. Baron and Baroness di Portanova with an unknown guest at the Hotel de Paris, Monte Carlo 1984.

138. Régine's cabana at the Beach Hotel in Monte Carlo, 1984.

139. Female train engineers and a policewoman (left), Houston, Texas 1985.

140. Gerald D. Hines, Houston 1985.

141. H. R. "Bum" Bright, Dallas 1985.

142. Former Governor John B. Connally, Dallas 1985.

143. Lynn Wyatt at an oilfield outside Houston, 1985.

144. Viscountess Patricia Rothermere at her home in London, 1985.

145. Julian Schnabel, Beverly Hills 1985.

146. The artist Julian Schnabel and his wife Jacqueline, Beverly Hills 1985.

147. Billy Wilder and his wife Audrey at their home in Los Angeles, 1985.

148. Timothy Leary and his wife Barbara, Beverly Hills 1986.

149. The writer Anna Stassinopoulos (left) and Françoise Gilot-Salk, Paloma Picasso's mother, Los Angeles 1985.

150. Dennis Hopper and Denise Crosby, granddaughter of Bing Crosby, at Hopper's studio in Venice, California 1985.

151. Jack Nicholson and Robert Evans, Los Angeles 1985.

152. Robert Evans in his garden in Beverly Hills 1985.

153. Xavier Moreau and his wife, Verona 1984.

154. Irving "Swifty" Lazar, Beverly Hills 1986.

155. Michael Caine and his wife Shakira at their home in Beverly Hills 1985.

156. Hanna Schygulla and costume designer Edith Head, Los Angeles 1980.

157. Anthony Burgess, Monte Carlo 1985.

158. Kim Basinger, Santa Monica 1986.

159. Arielle in my apartment, Monte Carlo 1983.

160. Grace Jones, Paris 1978.

161. The artist Arman and his wife Corise, Vence 1985.

162. Grace Jones and Dolph Lundgren, Los Angeles 1985.

163. Elizabeth Taylor, Los Angeles 1985.

164. Elizabeth Taylor, Los Angeles 1985.

165. Robert Evans and his son Joshua, Beverly Hills 1986.

166. Mrs. Winston Guest and her daughter Cornelia, Palm Beach 1986.

167. Mickey Rourke as private eye Angel Heart, New York 1986.

168. Michael Cimino and Mickey Rourke, Nice 1985.

169. Michael Cimino, Nice 1985.

170. The dancer Alexander Godunov, Beverly Hills 1984.

171. Claus von Bülow, New York 1985.

172. Prince Johannes and Princess Gloria von Thurn und Taxis on their yacht L'Aiglon off Ibiza, 1985.

173. Princess Gloria von Thurn und Taxis and her crew on the yacht off Ibiza, 1985.

174. Paloma Picasso with monocle, Nice 1983.

175. Julian Hipwood, captain of the English polo team, Palm Beach 1986.

176. Ornella Muti, Como 1986.

177. Jack Nicholson, Los Angeles 1985.

178. Madame Claude, Paris 1986.

179. Countess Marta Marzotto in her garden with her portrait by Renato Guttuso, Rome 1986.

180. Sting, Milan 1986.

181. Rudi Gernreich with the "pubikini," his last creation, a few days before his death, Los Angeles 1985.

182. The singer Sade, Beverly Hills 1985.

183. Pierre Klossowski and Roberte, Paris 1986.

184. Pierre Klossowski and Roberte, Paris 1986.

185. Pierre Klossowski and Roberte, Paris 1986.

186. Monica Vitti, Rome 1986.

187. Michelangelo Antonioni, the fashion designer Valentino, and Monica Vitti in the Café Greco, Rome 1985.

188. Monica Vitti, Café Greco, Rome 1985.

189. Mickey Rourke as private eye Angel Heart, New York 1986.

190. Charlotte Rampling and Jean-Michel Jarre, Paris 1986.

191. Salvador Dali, Figueras 1986.

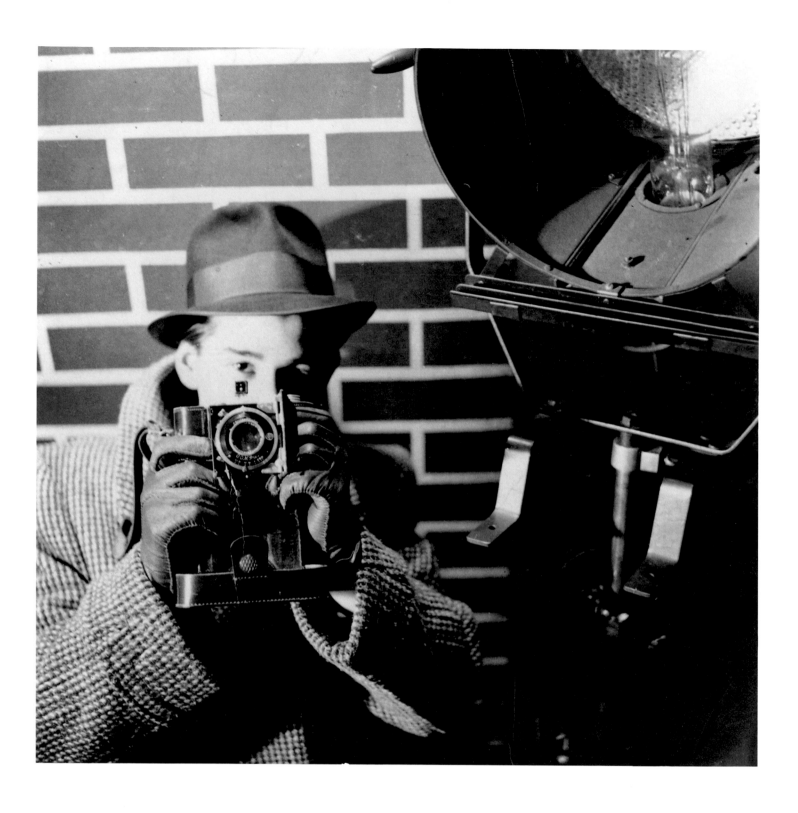

1. Self-portrait in Yva's studio, Berlin 1936.

2. Self-portrait, Halensee Beach, Berlin 1934.

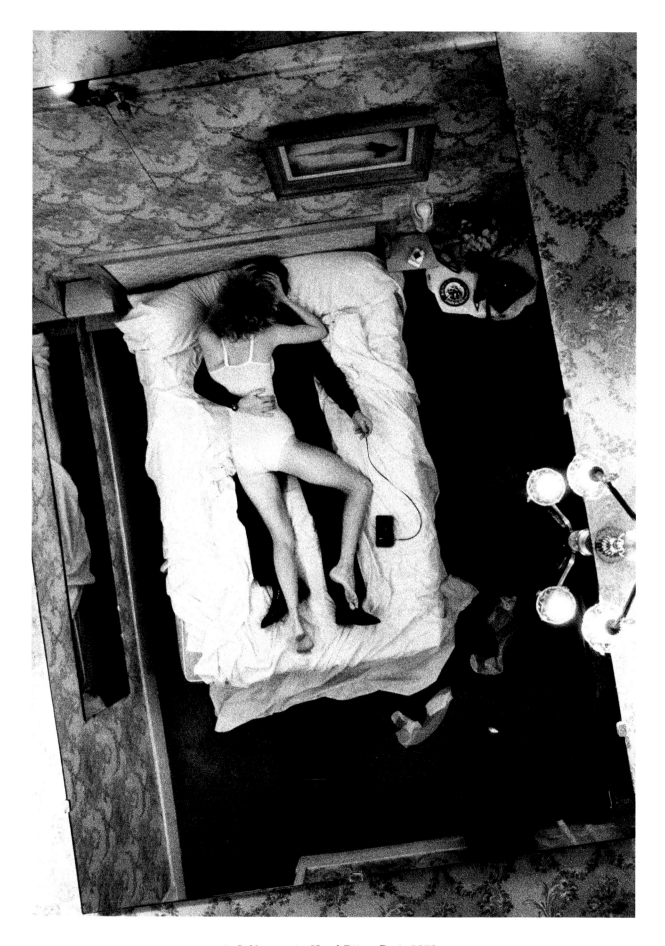

3. Self-portrait, Hotel Bijou, Paris 1973.

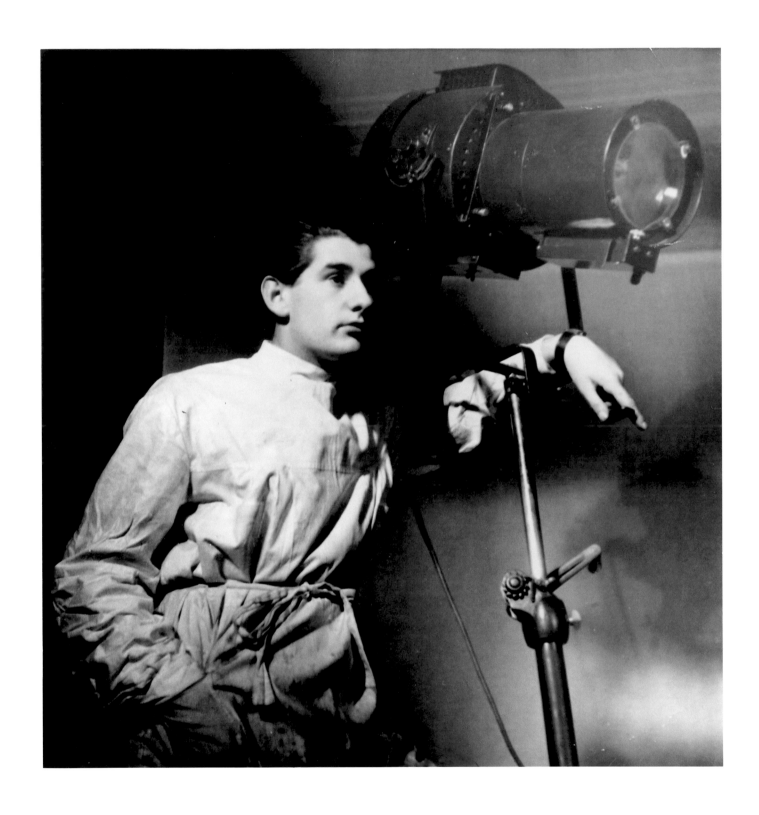

4. In Yva's studio, Berlin ca. 1936.

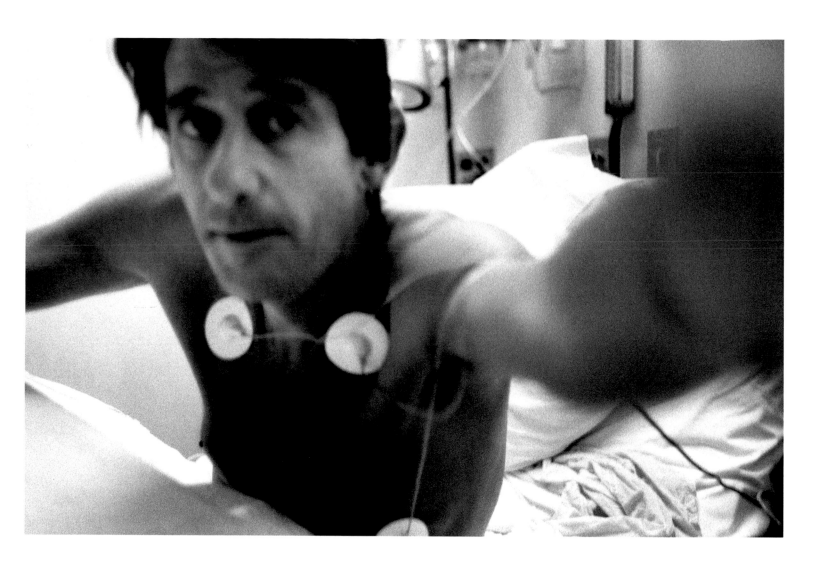

5. Self-portrait during an electrocardiogram, Lenox Hill Hospital, New York 1973.

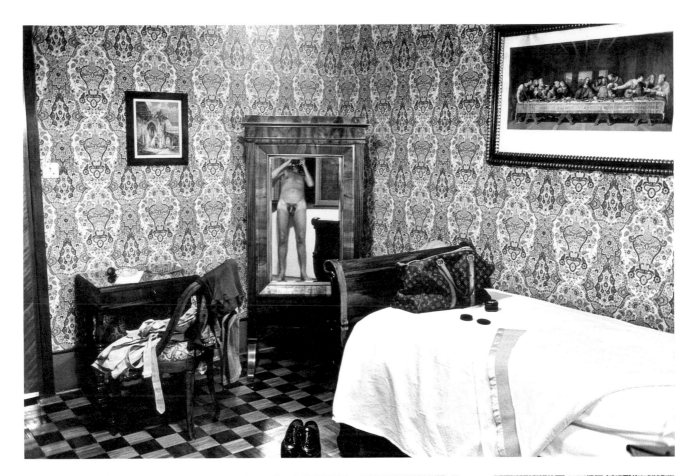

6. – 7. Self-portraits, Hotel Due Torri, Verona 1976.

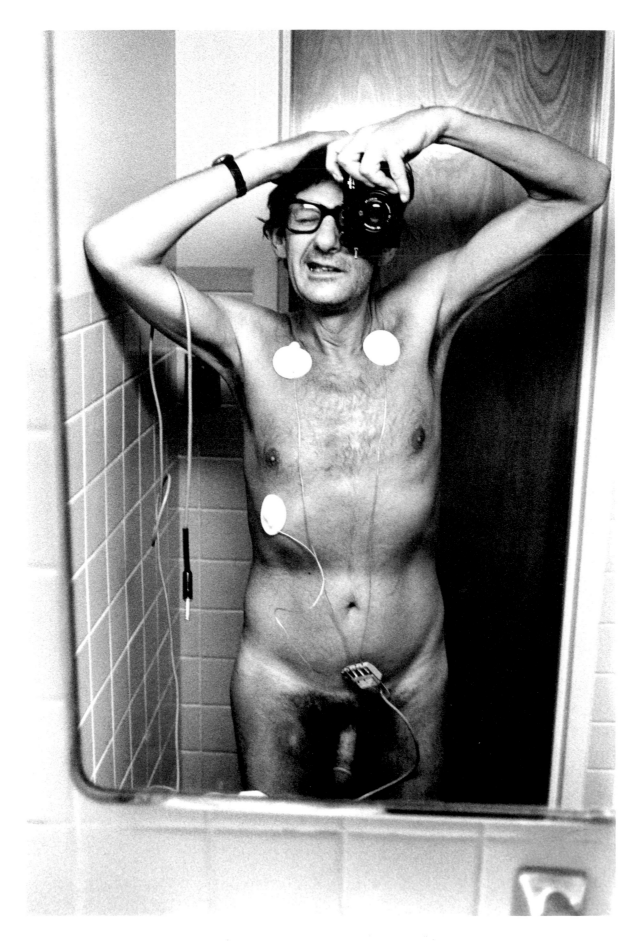

8. Self-portrait during an electrocardiogram, Lenox Hill Hospital, New York 1973.

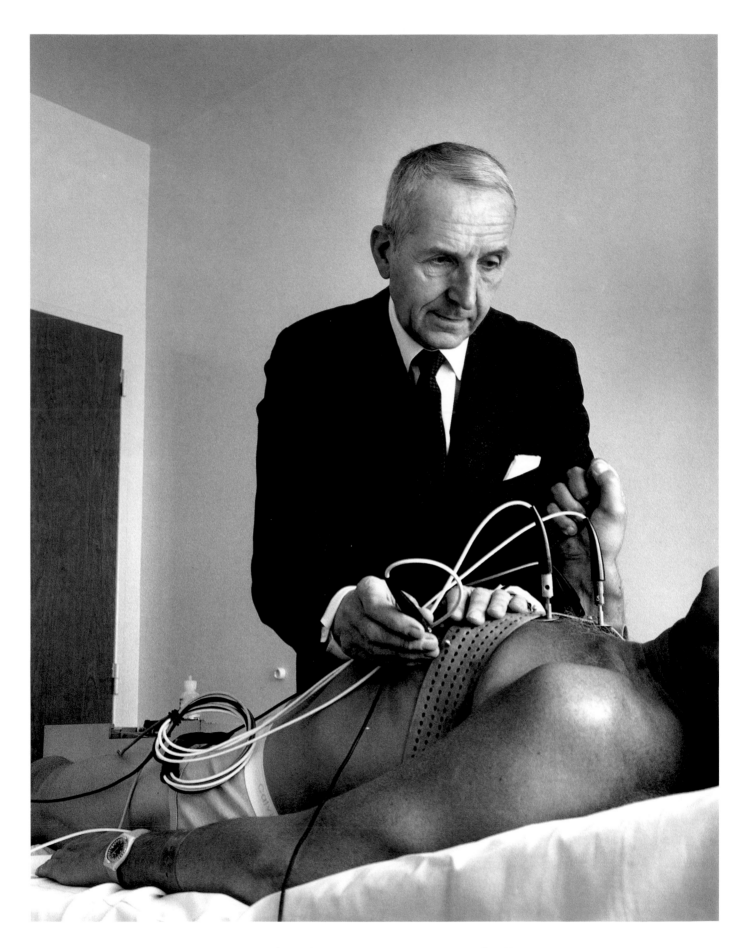

9. Helmut Newton with Dr. Simon Stertzer, Heart Institute, San Francisco 1986.

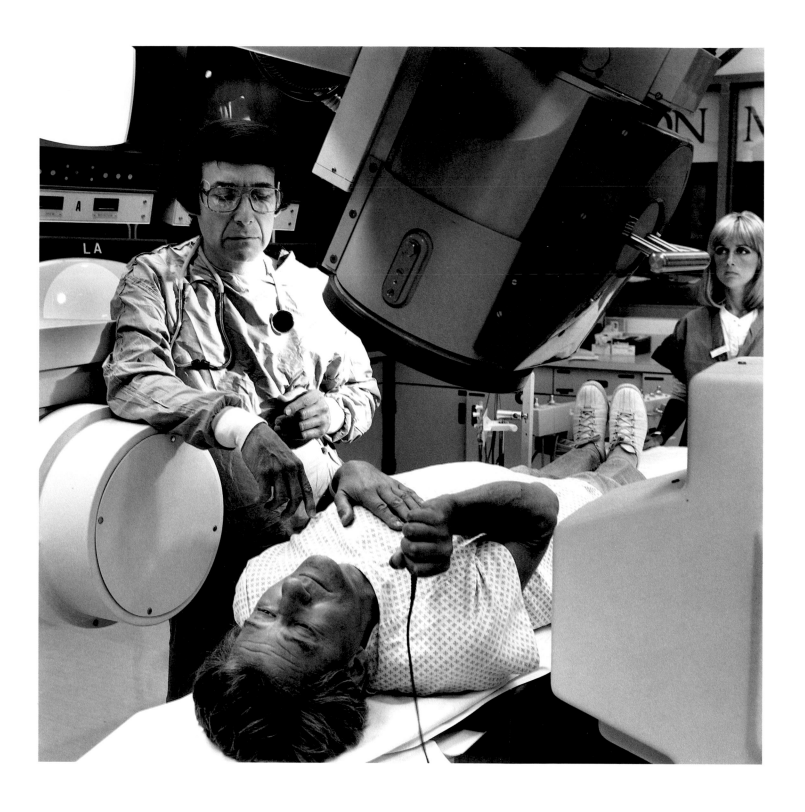

10. Helmut Newton with Dr. M. Degeorges, Hôpital Cochin, Paris 1986.

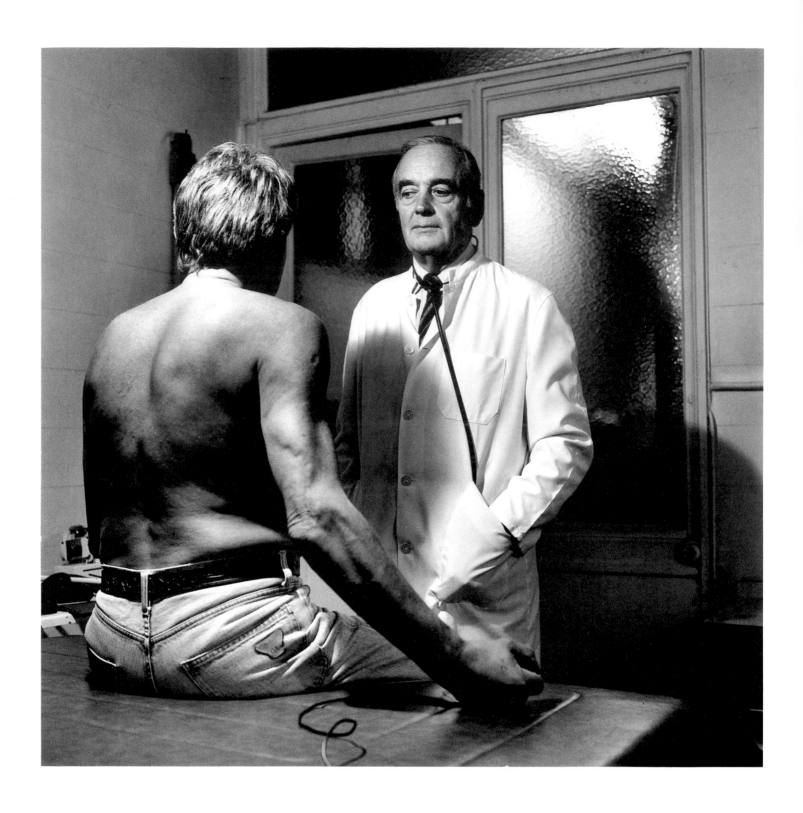

11. Helmut Newton with Dr. Jean Dax, Paris 1985.

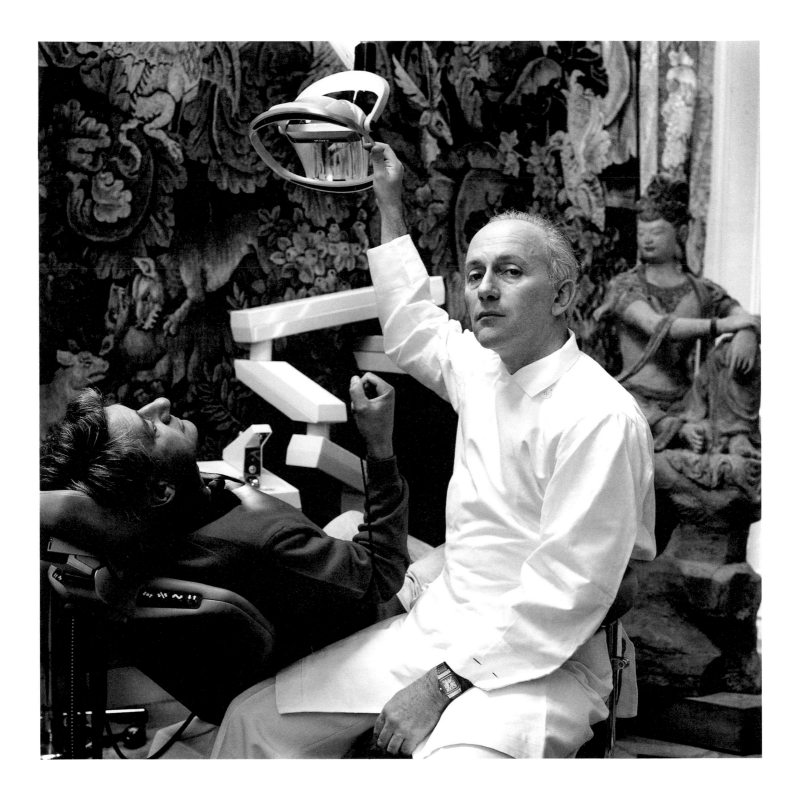

12. Helmut Newton with Dr. Jacques Vettier, Paris 1985.

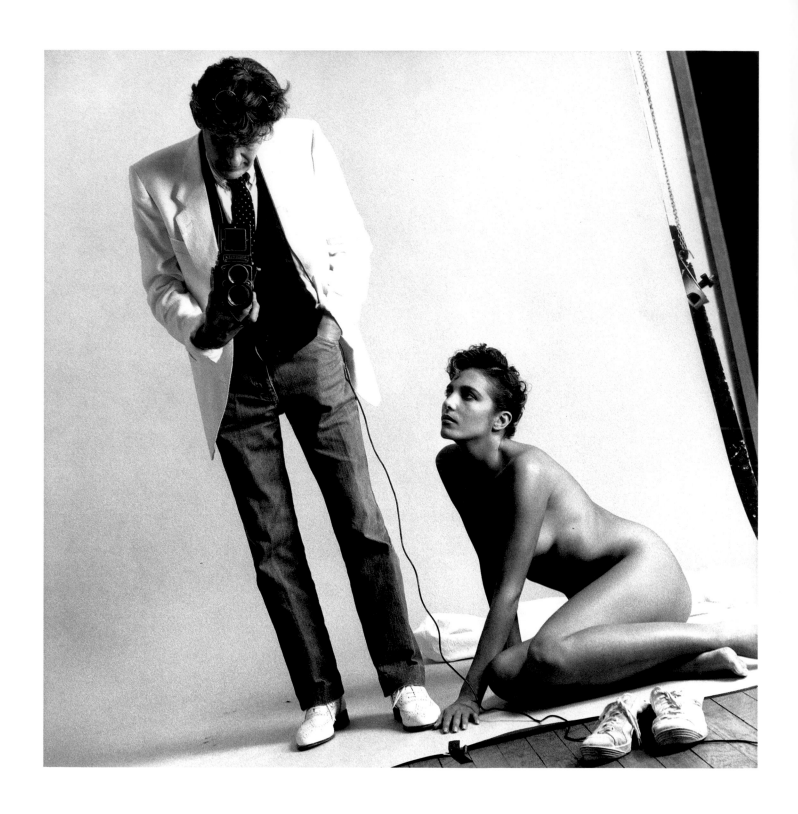

13. Vogue studio, Paris 1981.

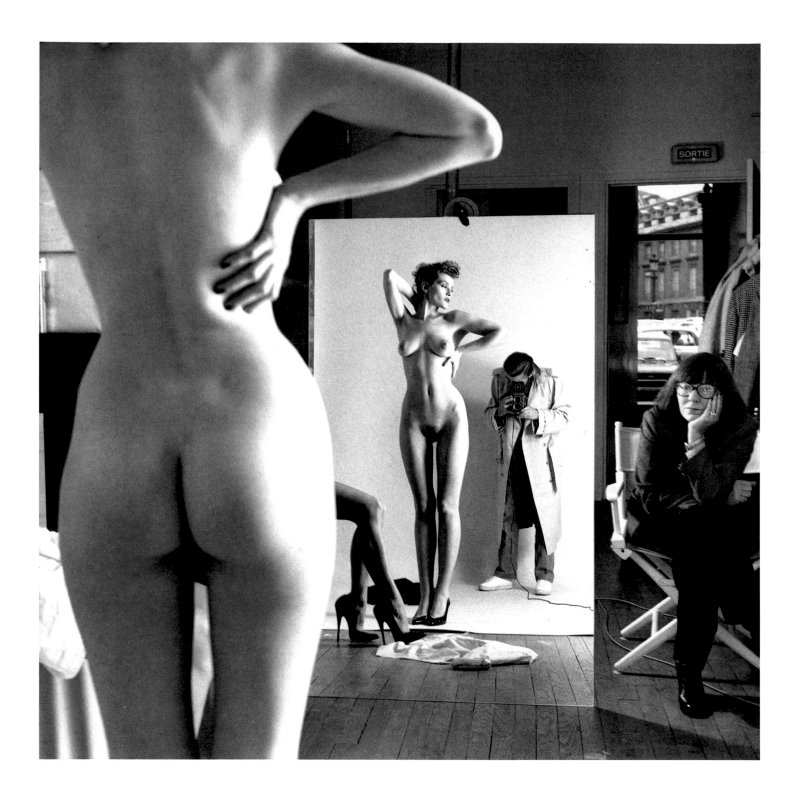

14. Self-portrait with wife June and models, Vogue studio, Paris 1981.

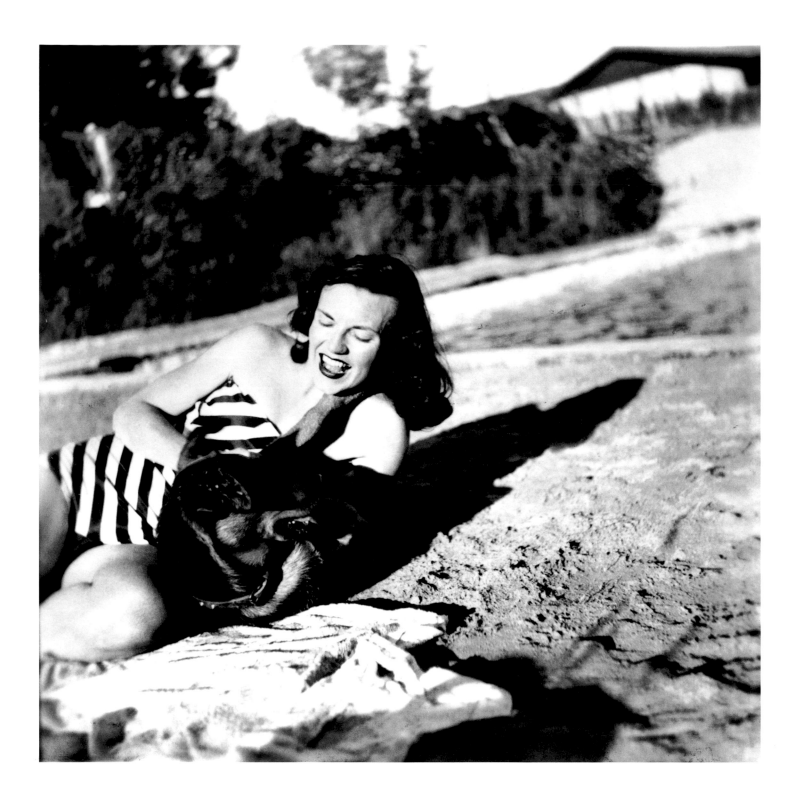

15. June Browne, Inverloch, Australia 1947.

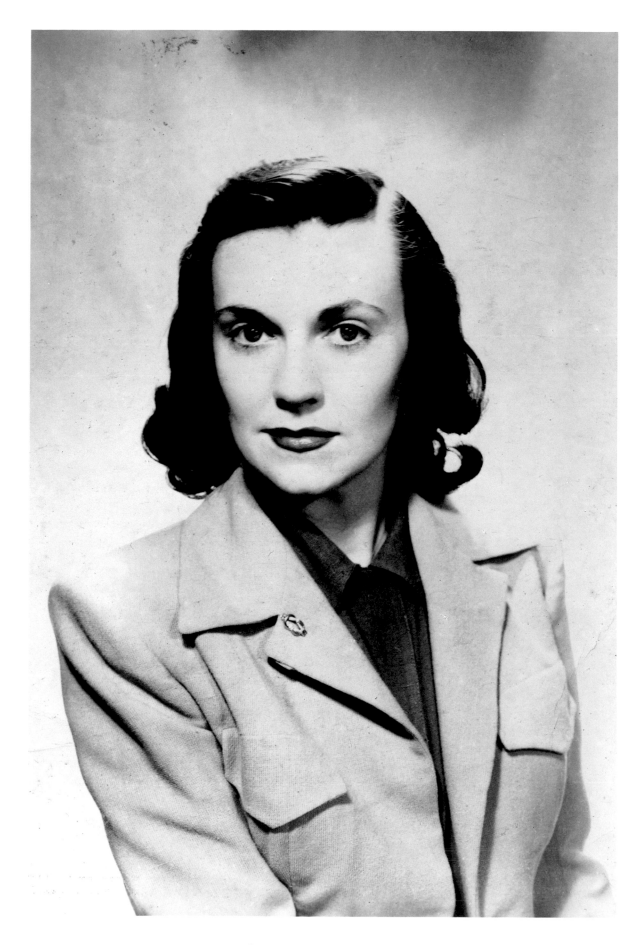

16. June Browne, Melbourne 1947.

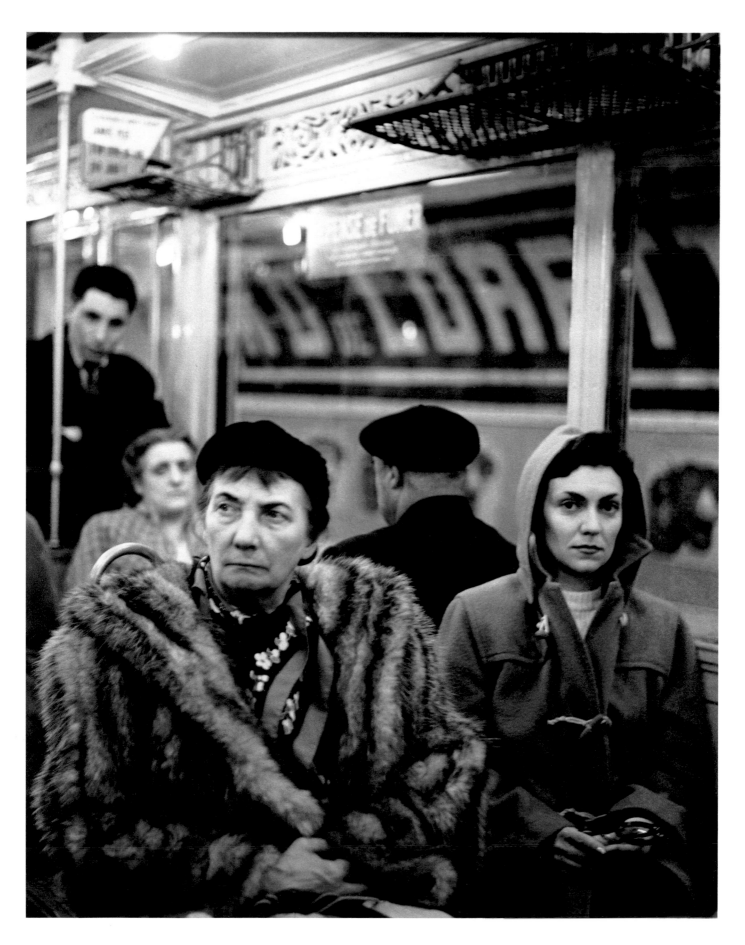

17. June Newton in the metro, Paris 1957.

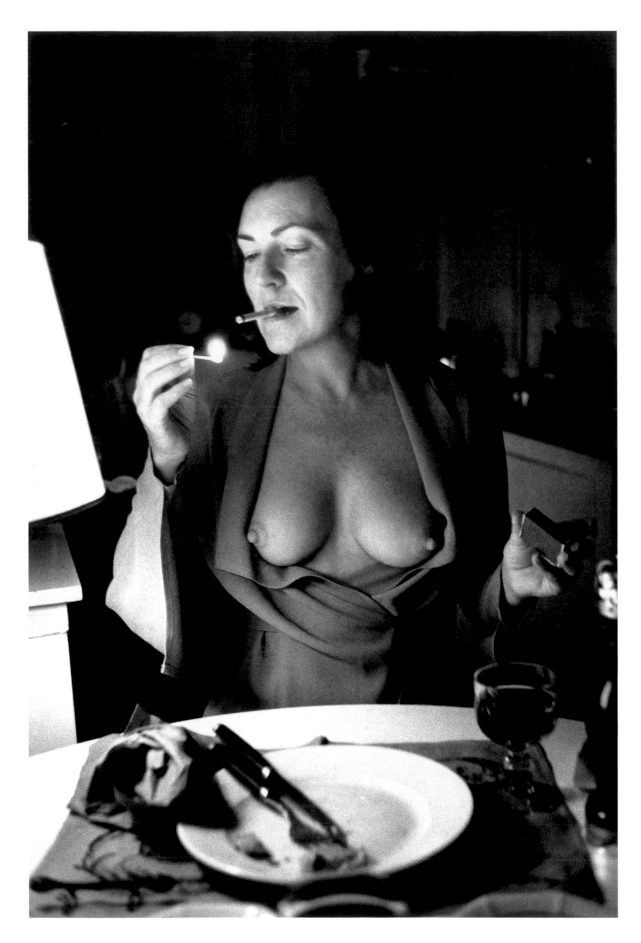

18. June, Paris 1972.

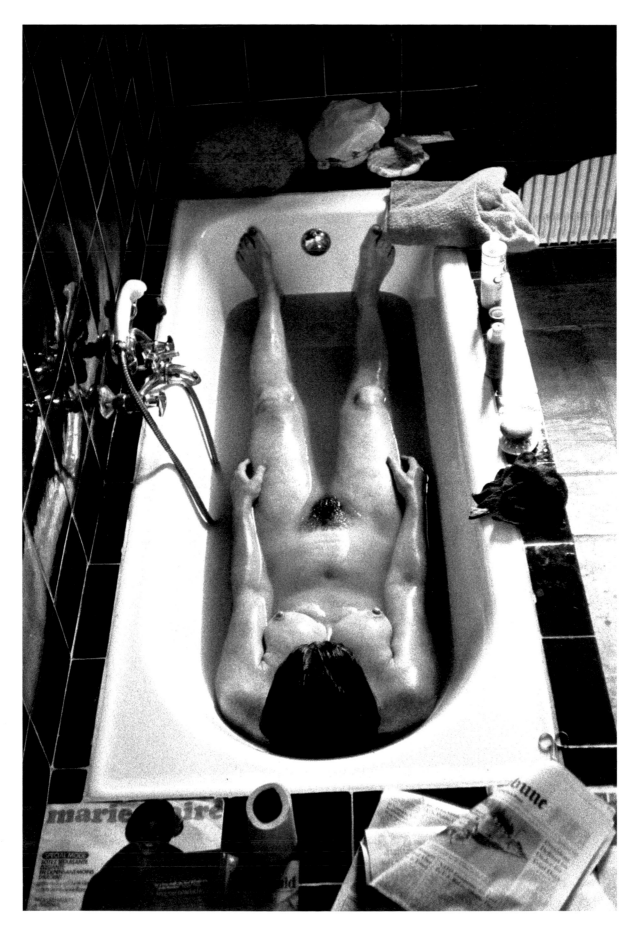

19. June, Ramatuelle 1974.

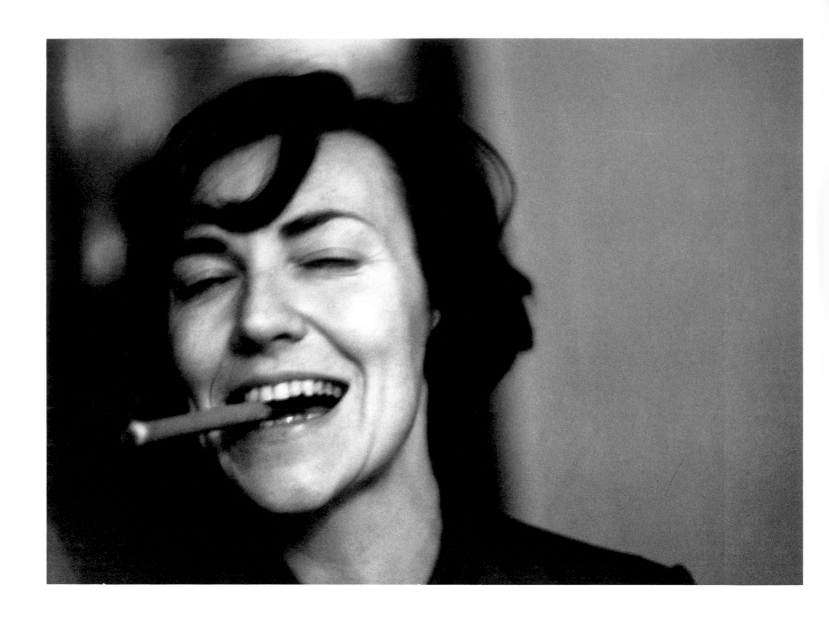

20. June with cigar, Paris 1962.

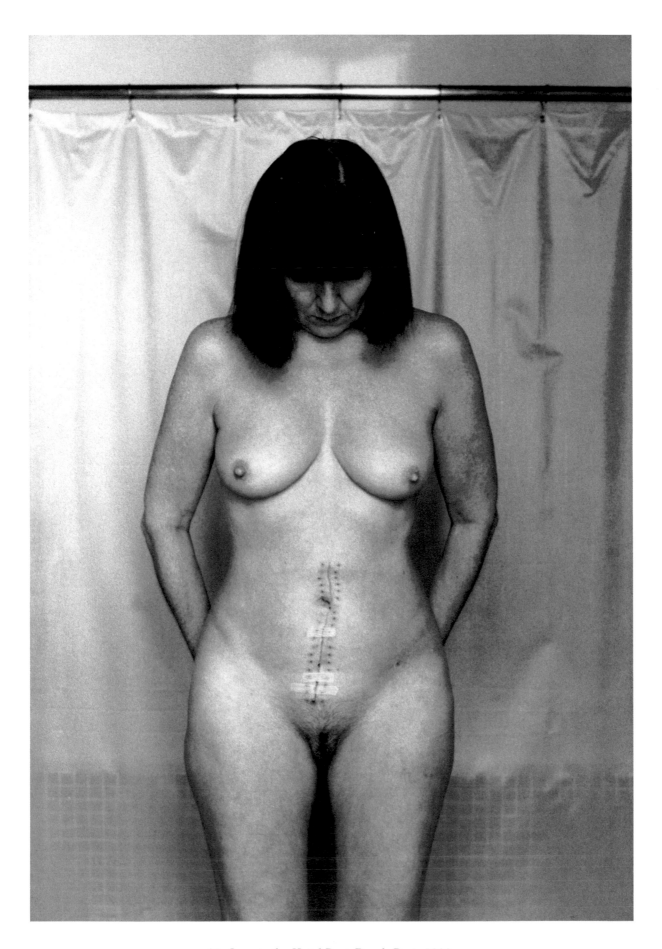

21. June in the Hotel Pont-Royal, Paris 1982.

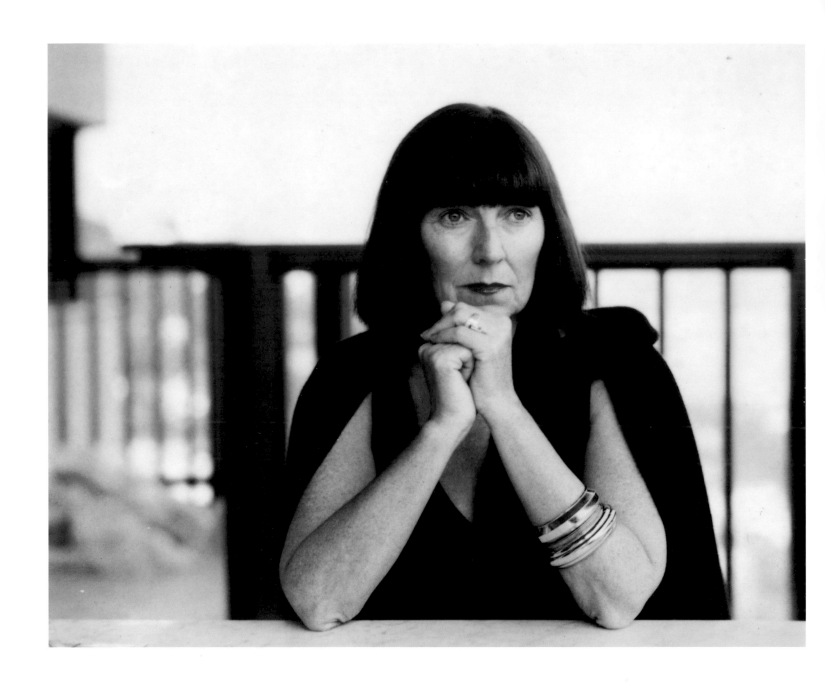

22. Polaroid color portrait of June, Monte Carlo 1982.

Helmut Newton's Photomachine

"... I had a photomachine built, a camera fitted with a motor and a timer, that can be adjusted by the model, who can decide whether to work fast or slow. A mirror behind the camera lets the model check the pose. Before every shot, a bell goes off, and then a strobe light flashes. The whole system is devised to heighten the tension of the modeling session, and catch the model at the peak of each pose."

(Two contact sheets of photographs taken with the photomachine are printed on the following pages)

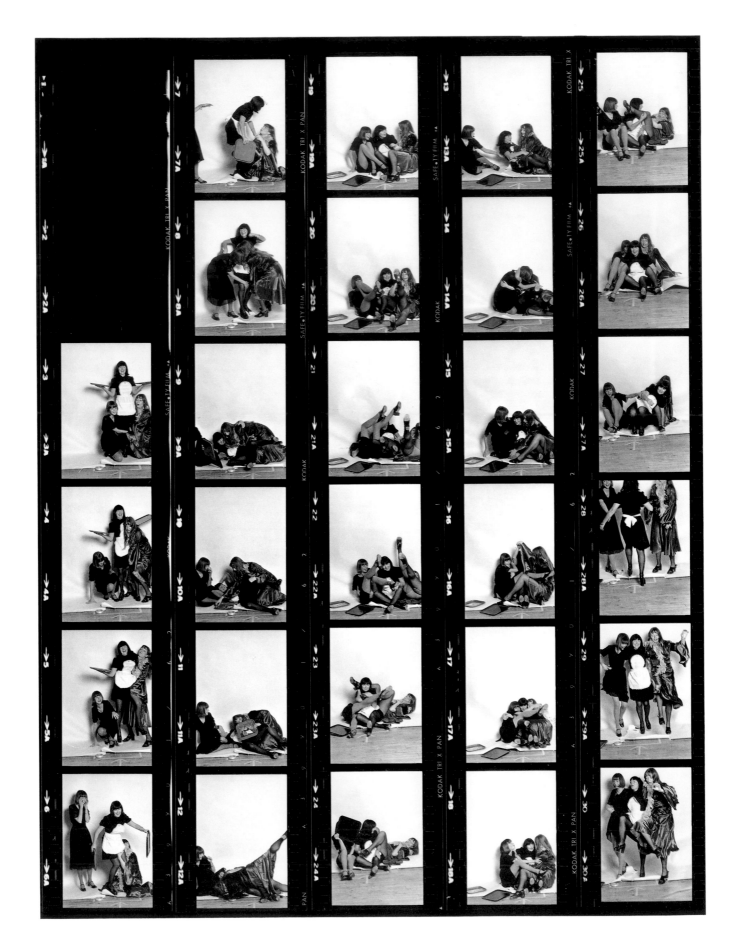

23. Newton's photo-machine: Désirée Hayter, Barbara Sieff, June Newton, Paris 1973.

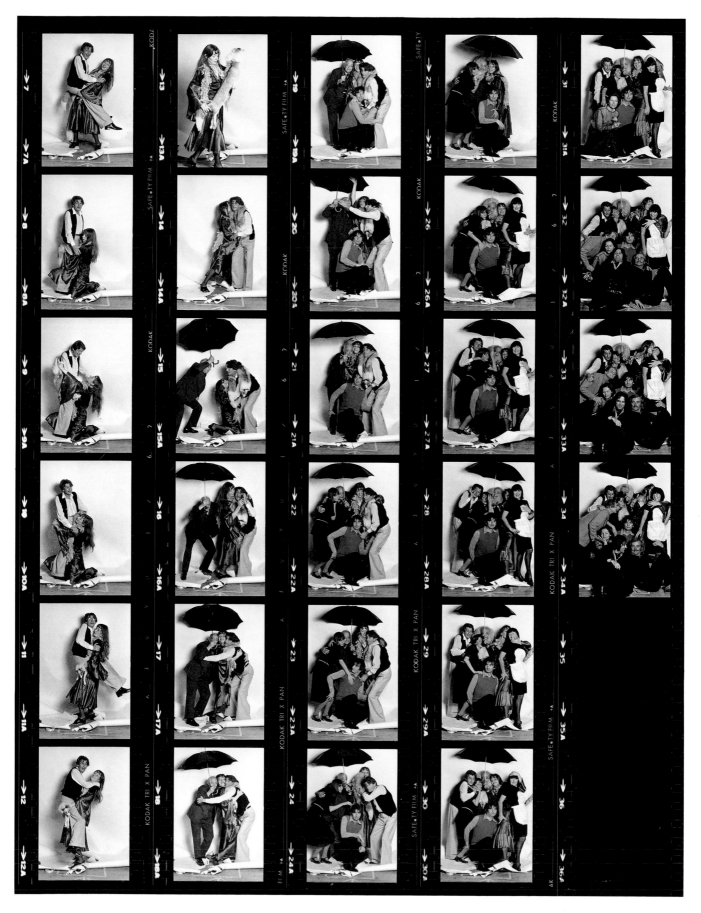

24. Newton's photo-machine: Brassaï, Gilberte Brassaï, Désirée and W. S. Hayter, June and Helmut Newton, Barbara and Jeanloup Sieff, Bob Smith, Eugenio Tellez, Paris 1973.

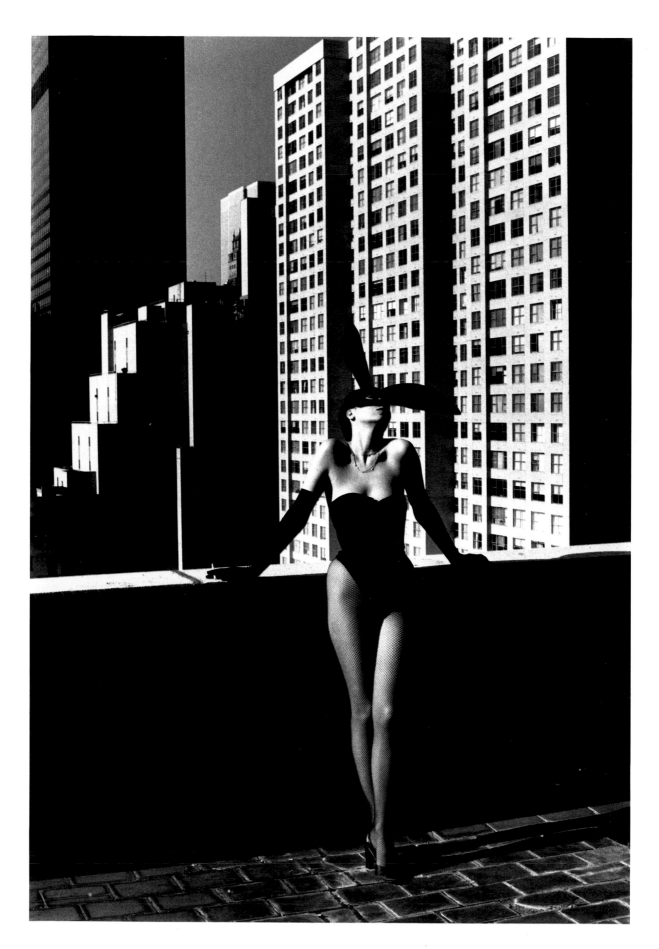

25. Elsa Peretti, New York 1975.

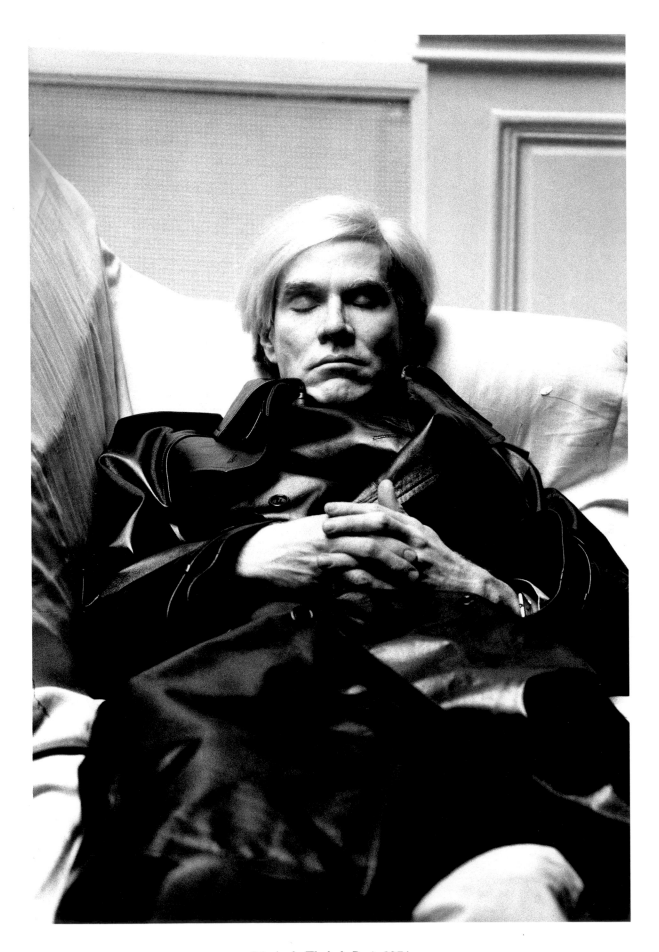

26. Andy Warhol, Paris 1974.

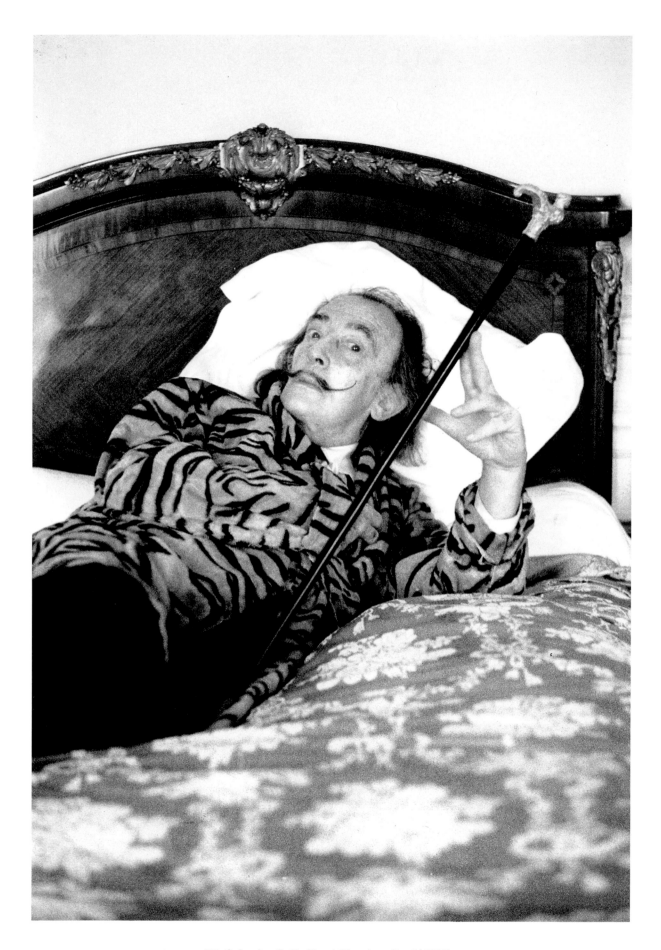

27. Salvador Dali, Hotel Meurice, Paris 1973.

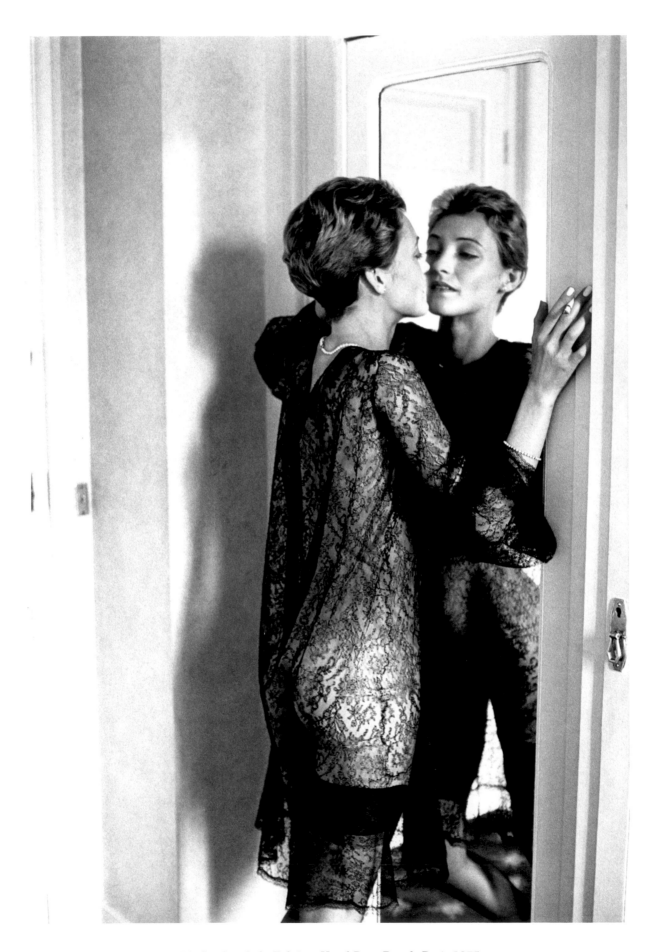

28. Loulou de la Falaise, Hotel Pont-Royal, Paris 1975.

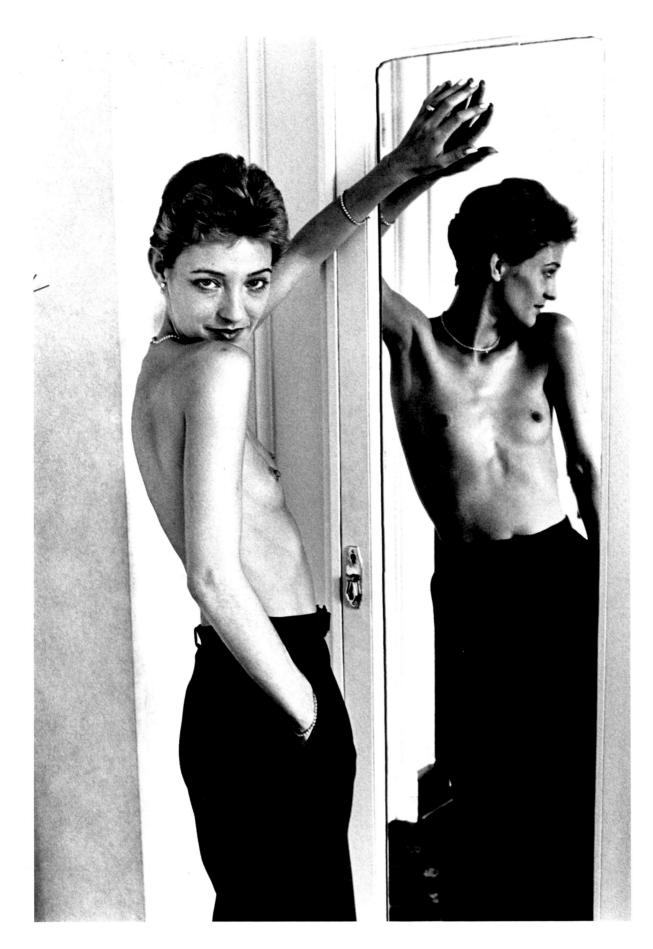

29. Loulou de la Falaise, Hotel Pont-Royal, Paris 1975.

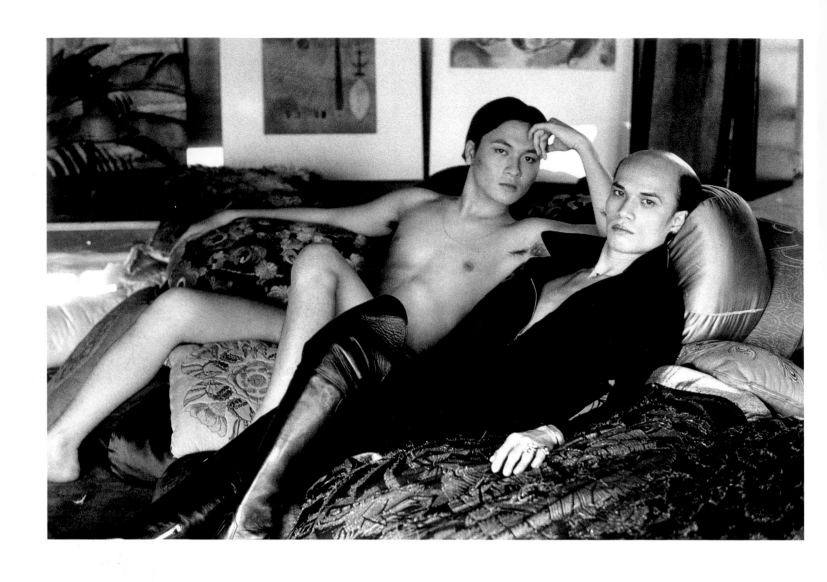

30. Tan Giudicelli and Tyen, Paris 1974.

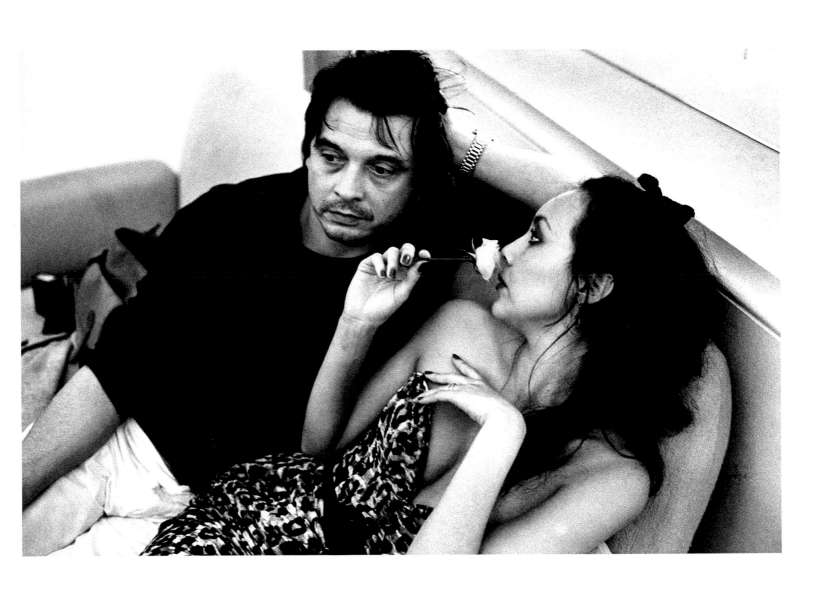

31. David Bailey and Marie Helvin at the Grand Hotel du Cap, Antibes 1977.

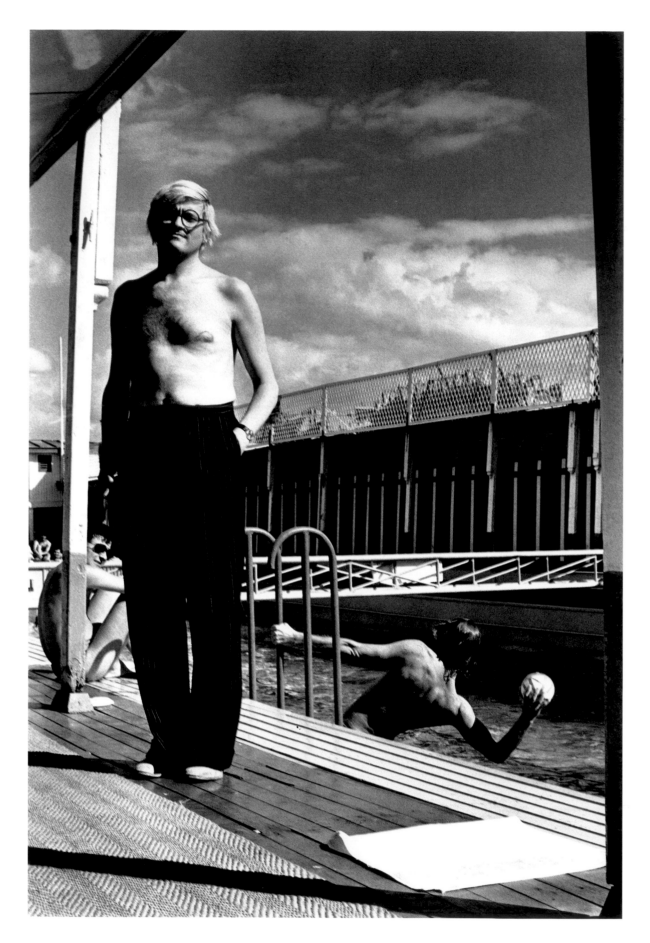

32. David Hockney, Piscine Royale, Paris 1975.

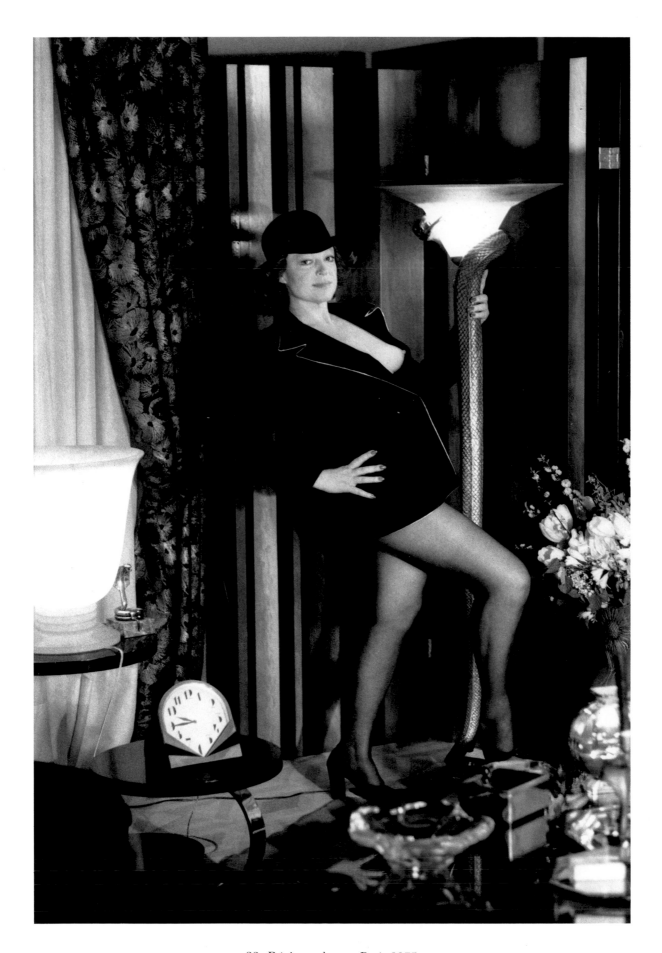

33. Régine at home, Paris 1975.

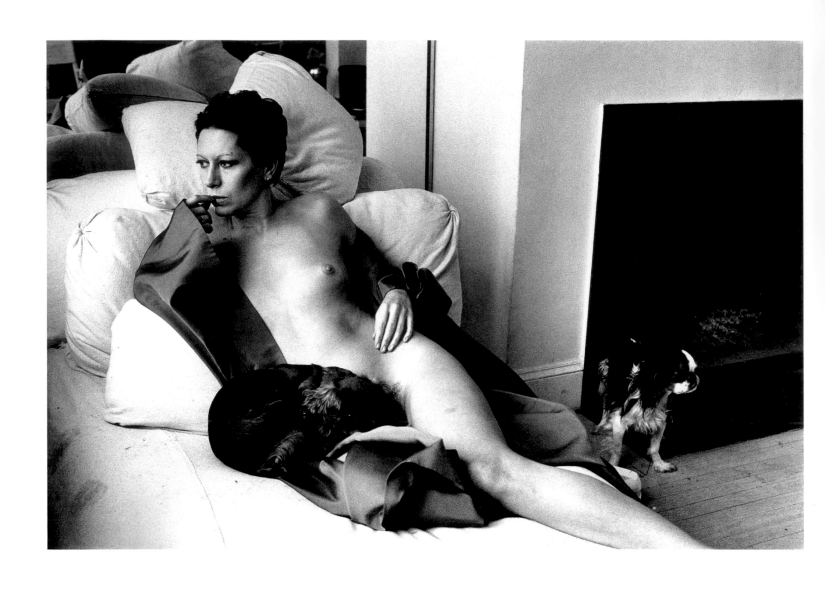

34. Elsa Peretti, New York 1975.

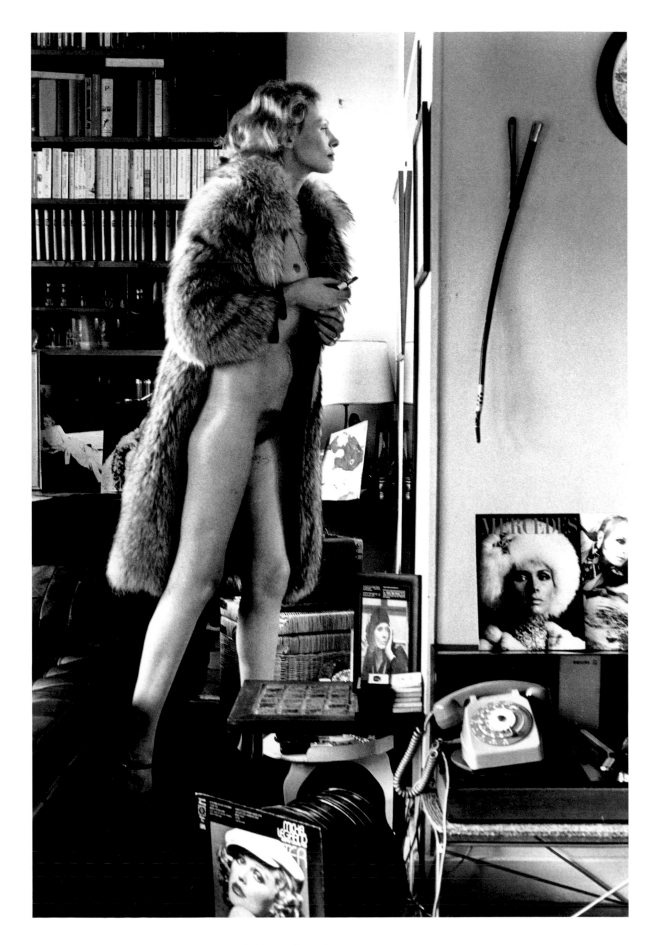

35. Mercedes at home, Paris 1975.

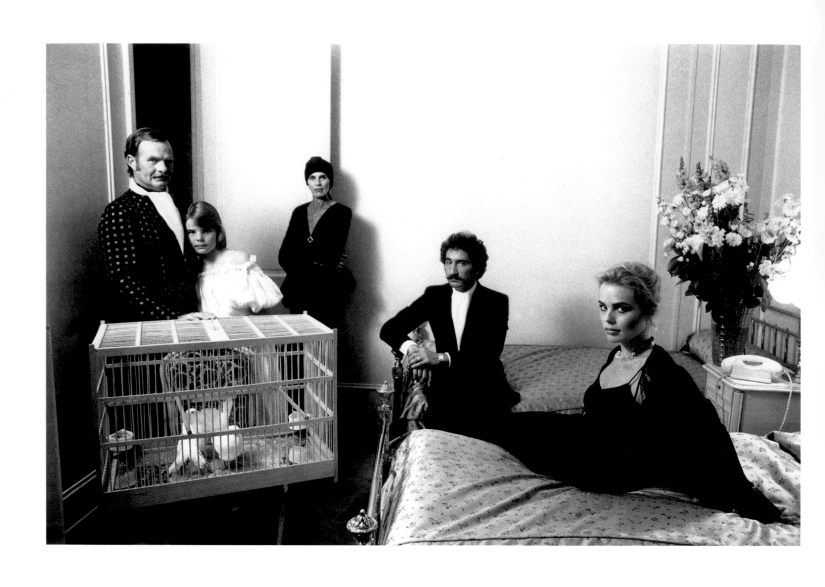

36. Margaux Hemingway with her family and her first husband at the Hotel Ritz, Paris 1975.

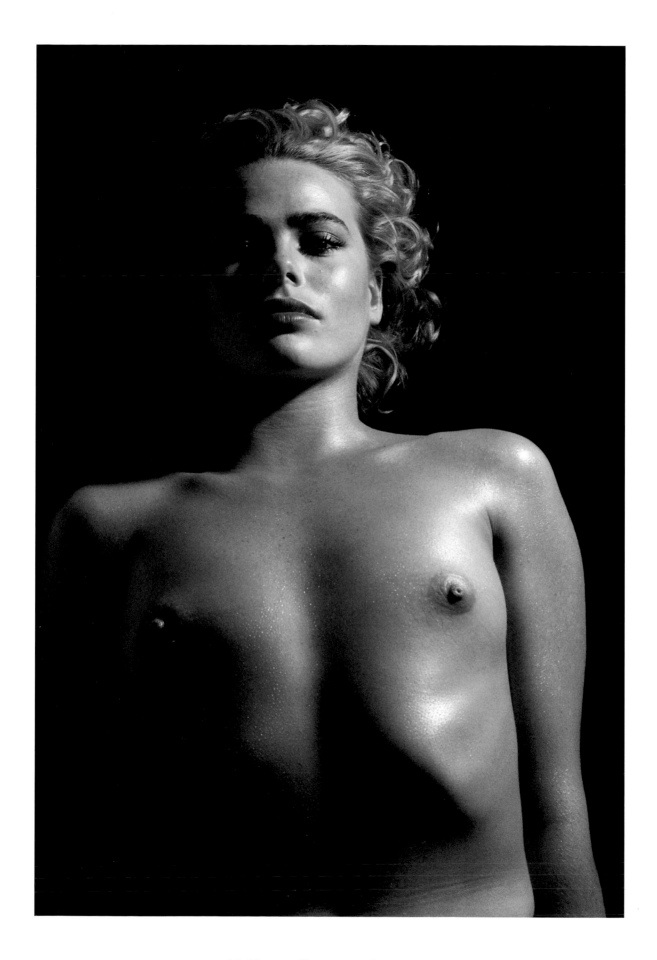

37. Margaux Hemingway, Paris 1975.

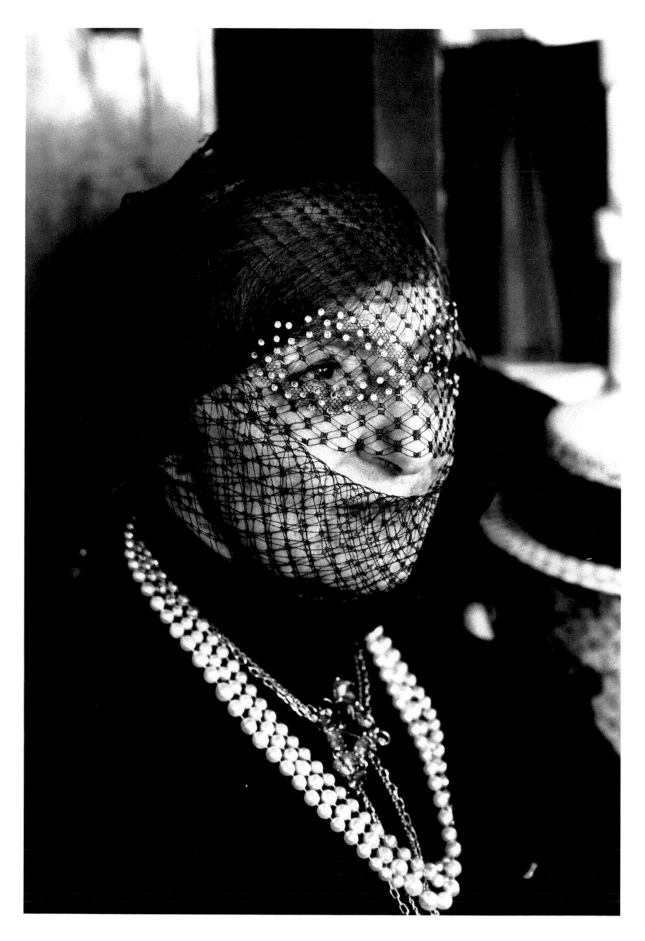

38. Madame Paulette, the most celebrated Parisian hatmaker, 1979.

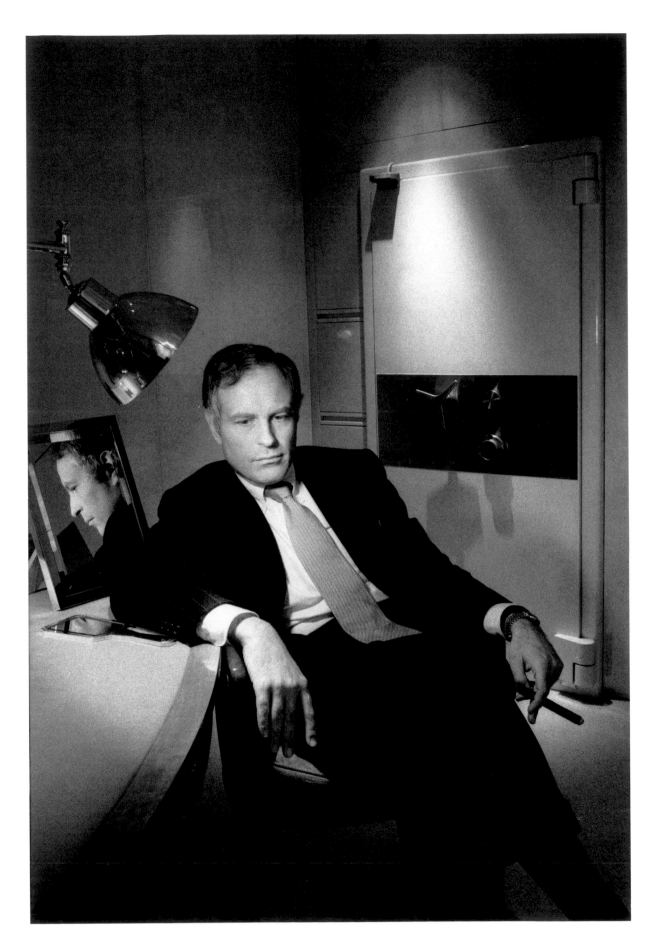

39. The jeweler Gianni Bulgari, Paris 1980.

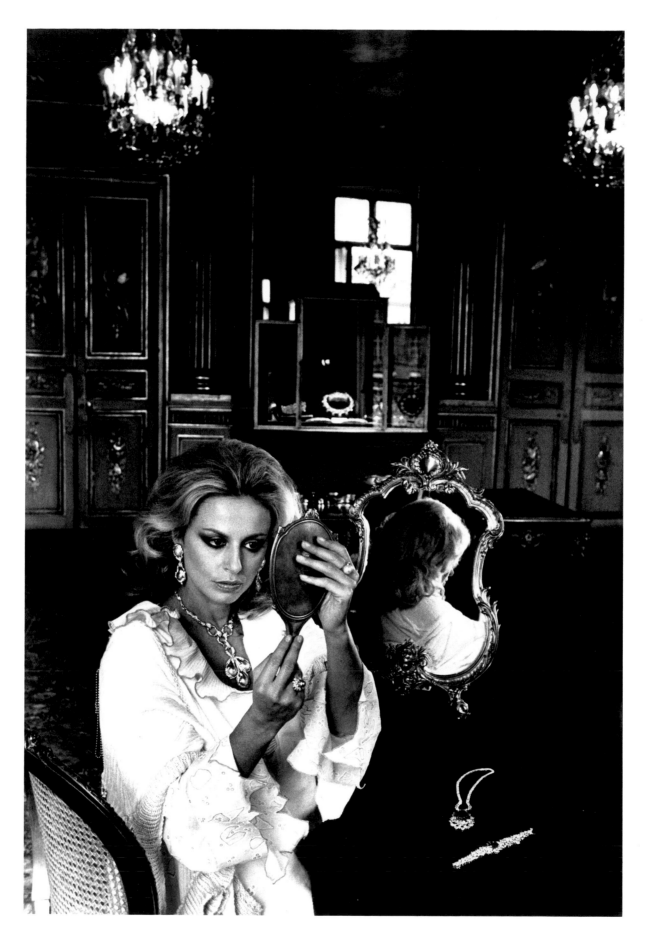

40. Donatella Zegna at a jewelry shop, Paris 1974.

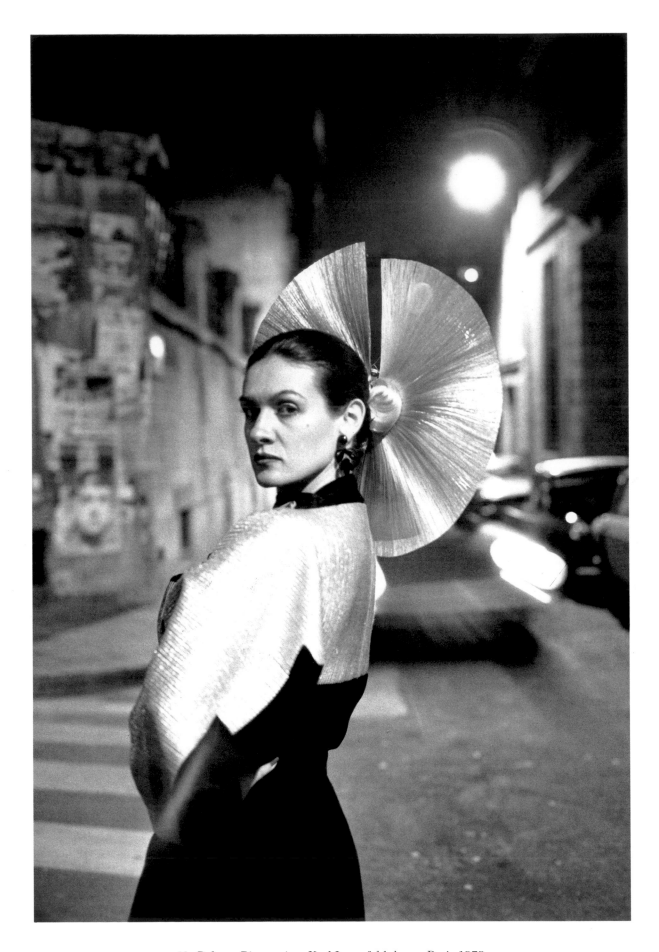

41. Paloma Picasso in a Karl Lagerfeld dress, Paris 1978.

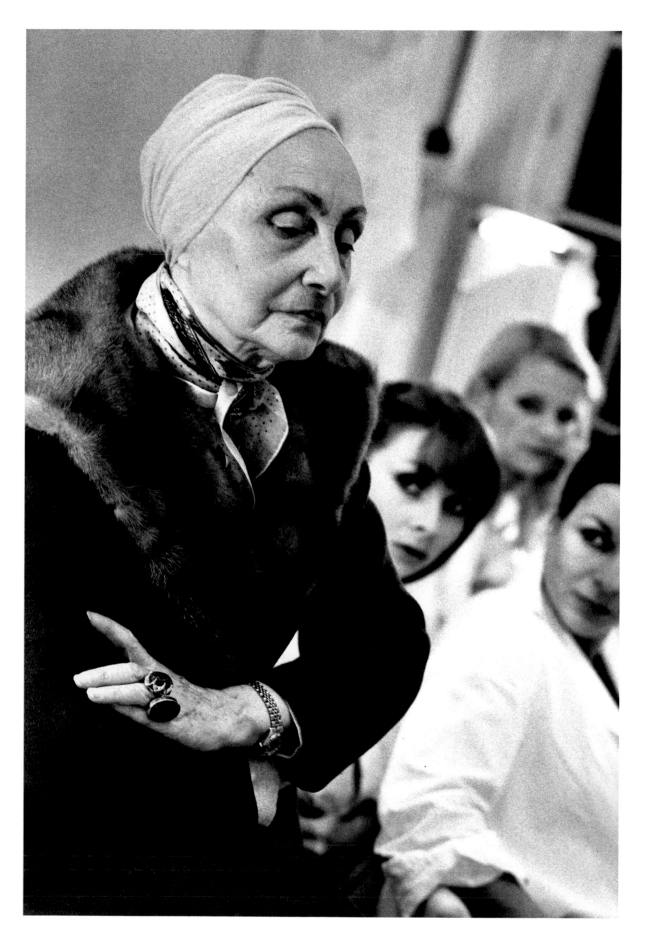

42. Madame Grès, Paris 1978.

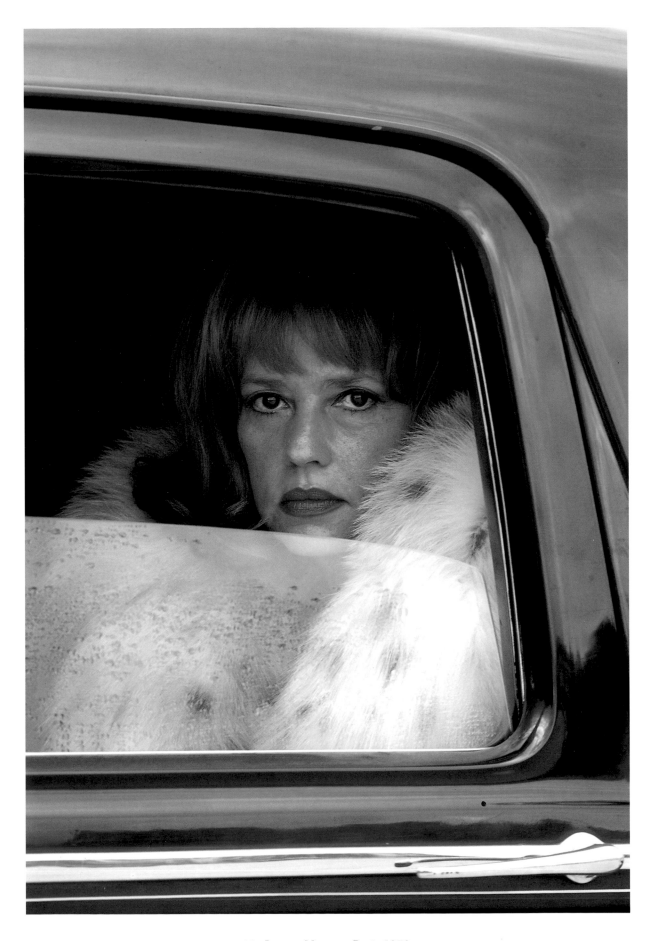

43. Jeanne Moreau, Paris 1970.

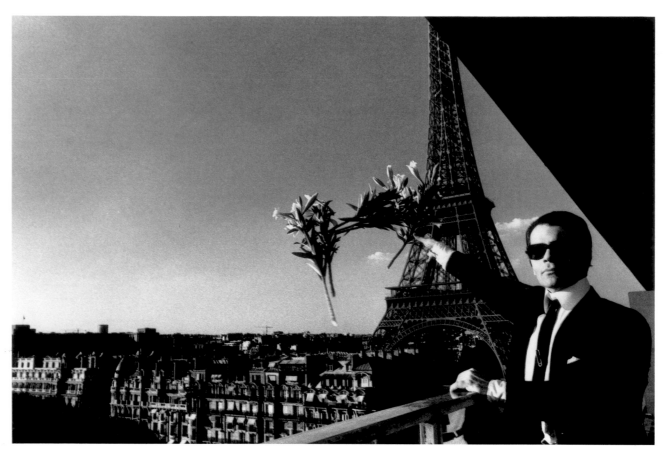

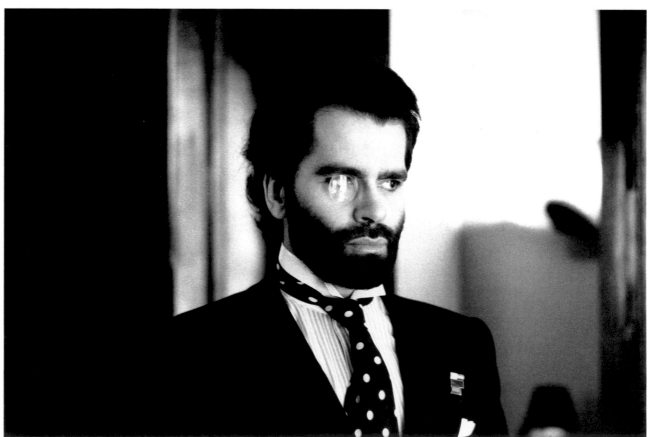

44. Karl Lagerfeld, Paris 1976.
45. Karl Lagerfeld, Paris 1974.

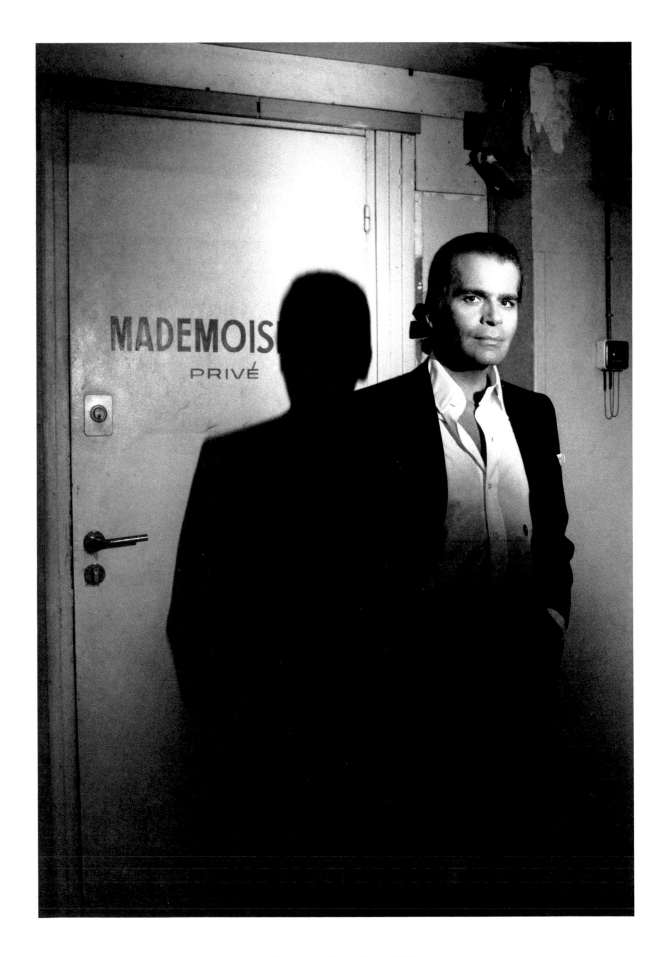

46. Karl Lagerfeld, Paris 1983.

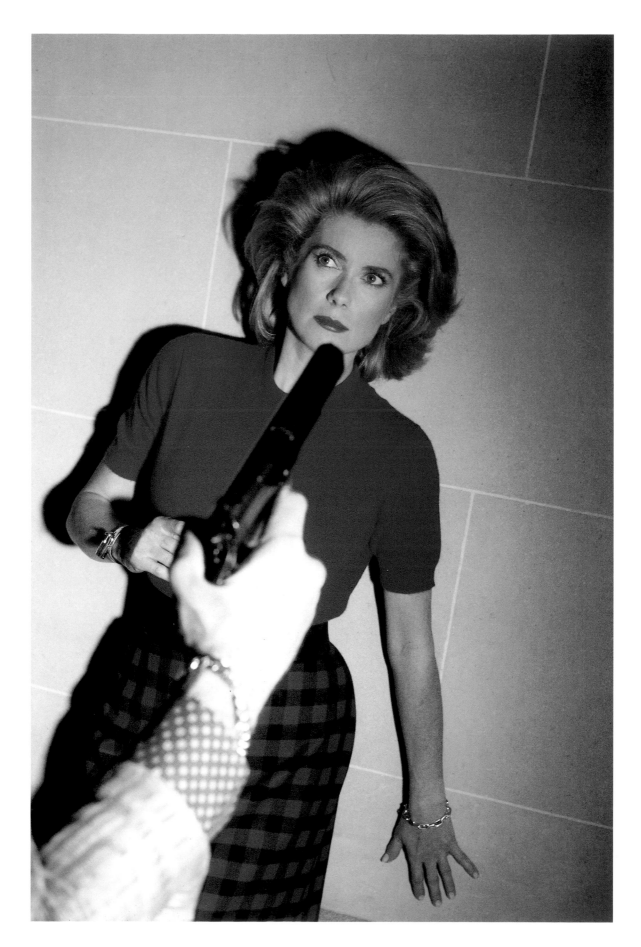

47. Catherine Deneuve for a photo-essay in *Nouvel Observateur*, 1983.

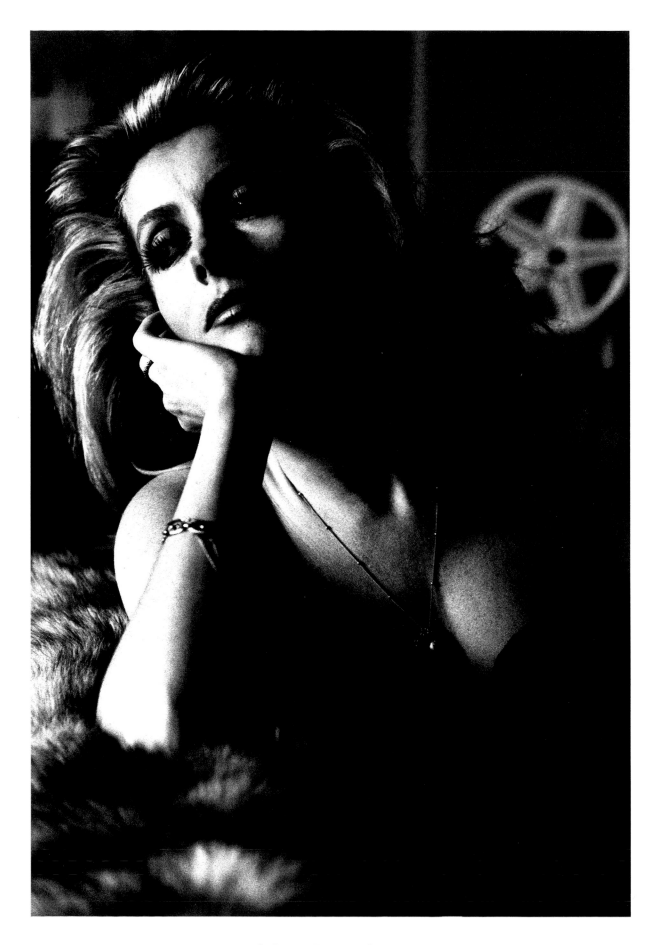

48. Catherine Deneuve, Paris 1976.

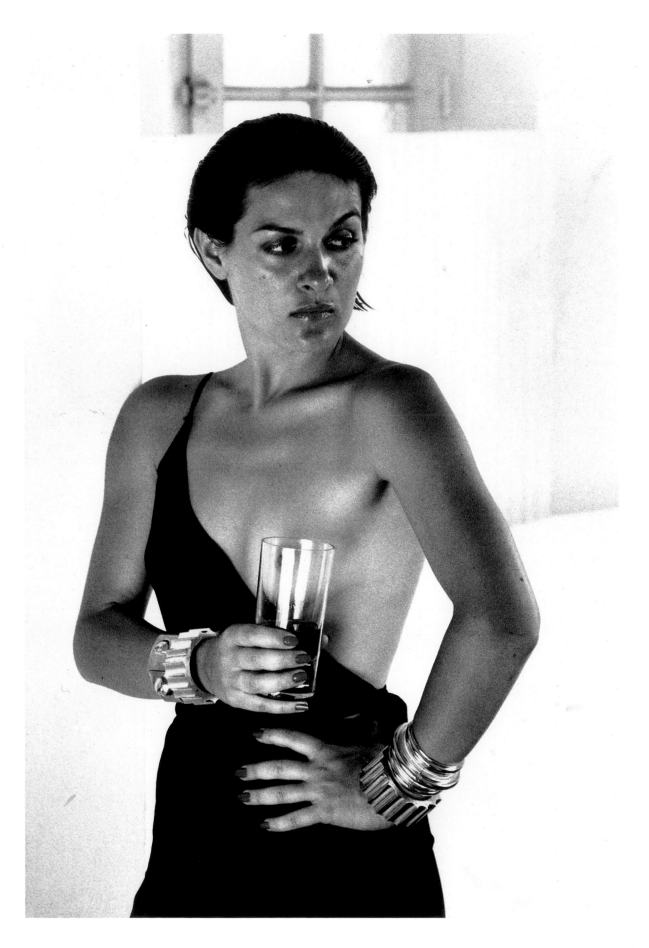

49. Paloma Picasso, Saint Tropez 1973.

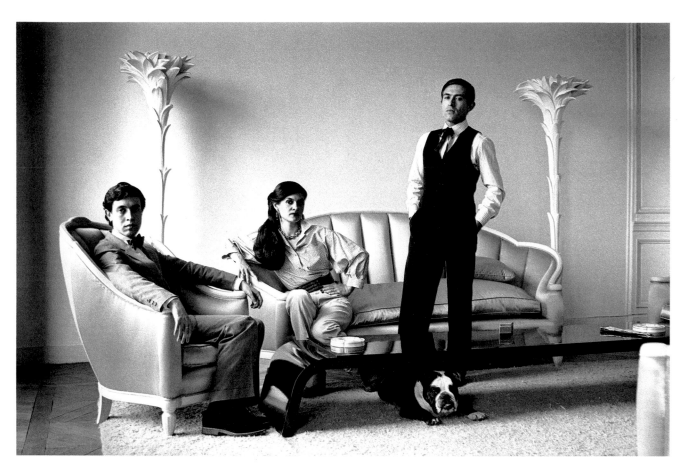

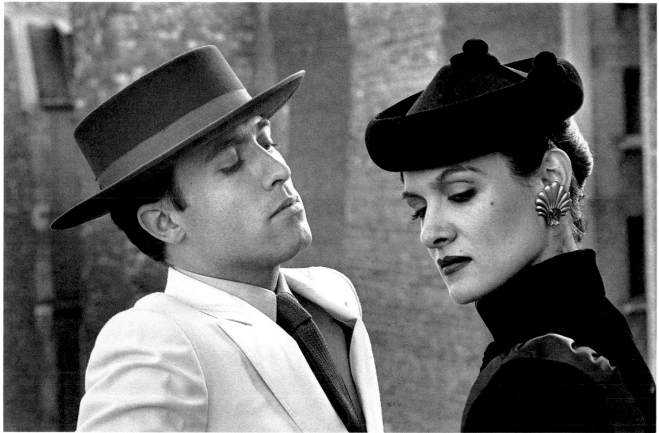

50. Paloma Picasso with Xavier Arroycllon and Rafacl Sánchcz Lópcz, Paris 1978.

51. Paloma Picasso and Rafael Sánchez López, Paris 1978.

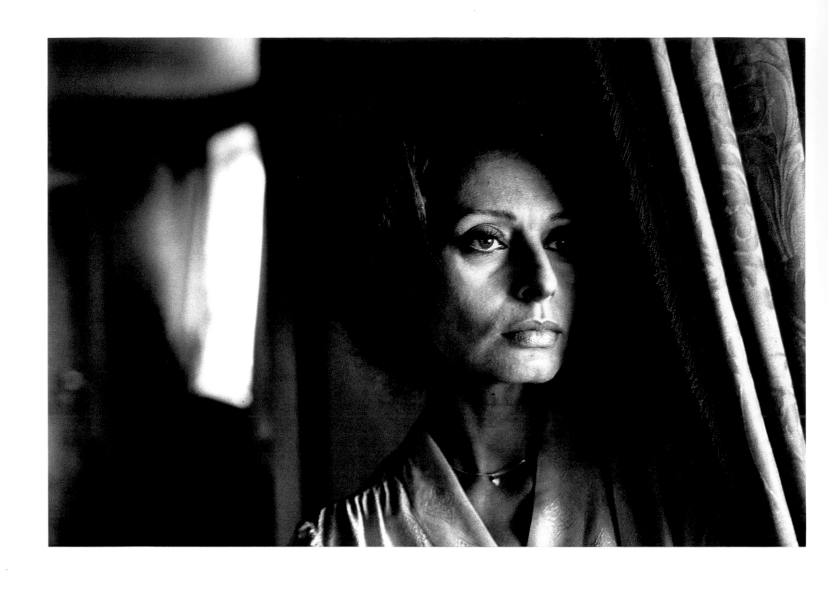

52. Sophia Loren, Paris 1977.

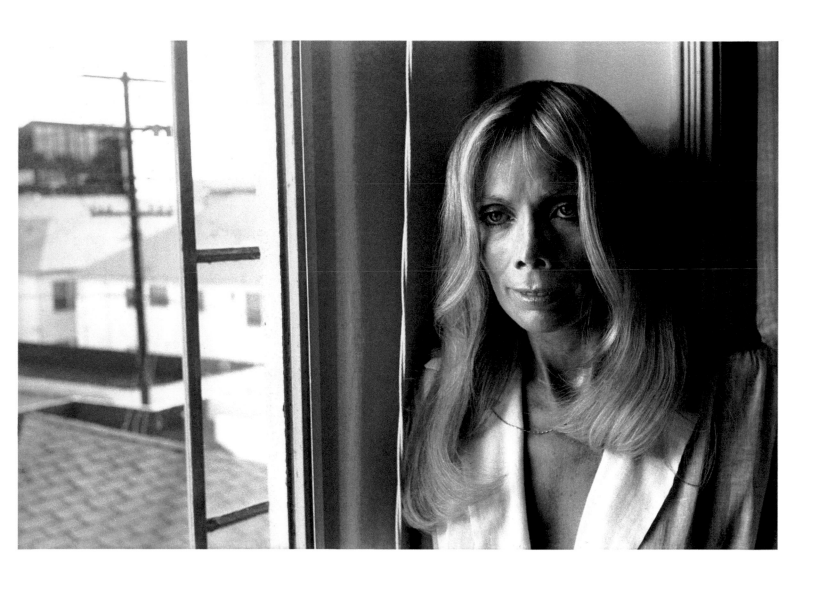

53. Marilyn Grabowski, Los Angeles 1976.

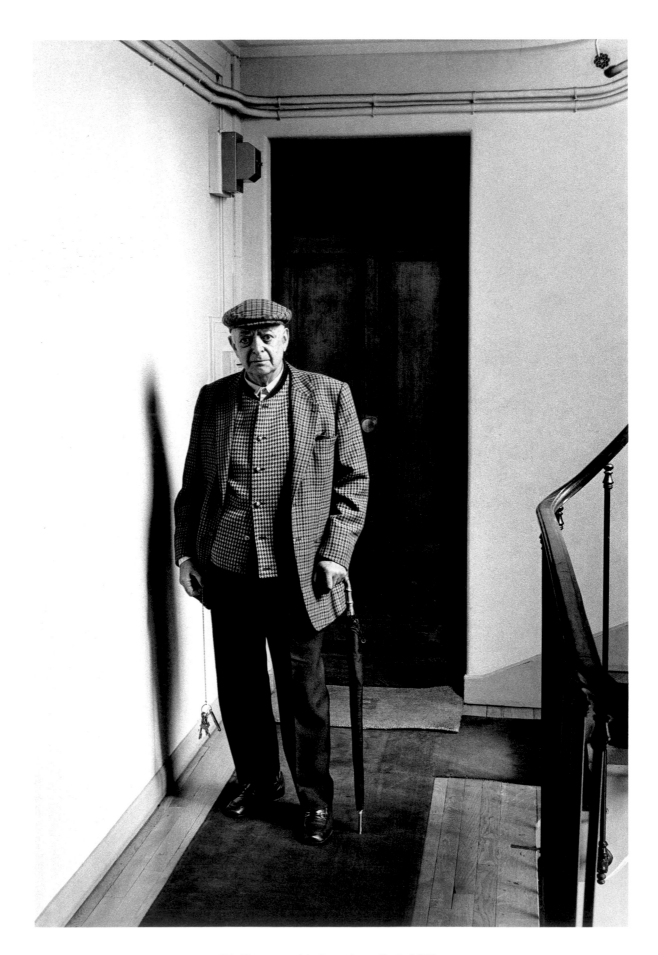

54. Brassaï at his front door, Paris 1975.

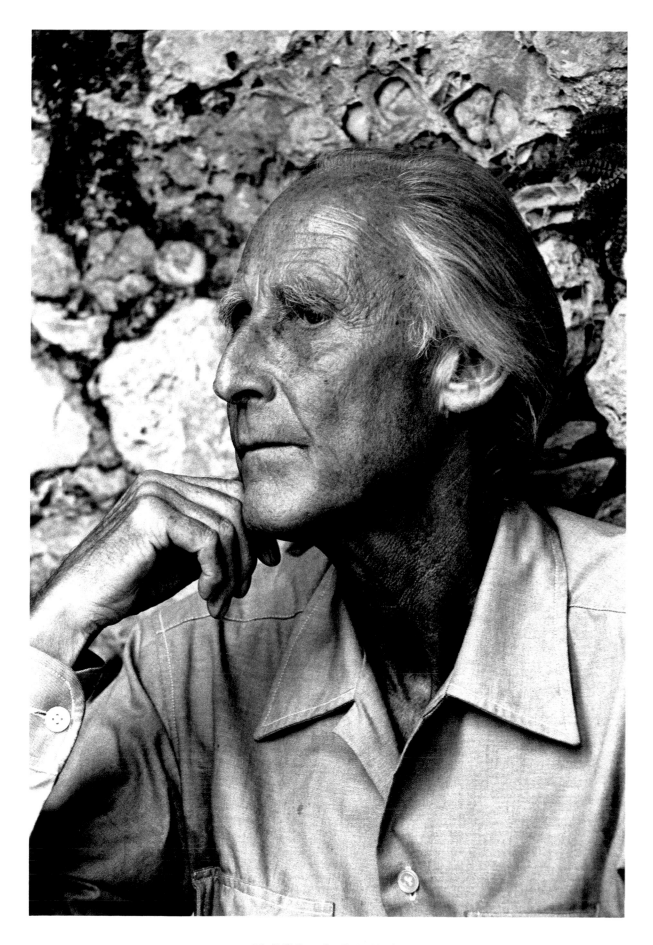

55. Bill Brandt, Opio 1975.

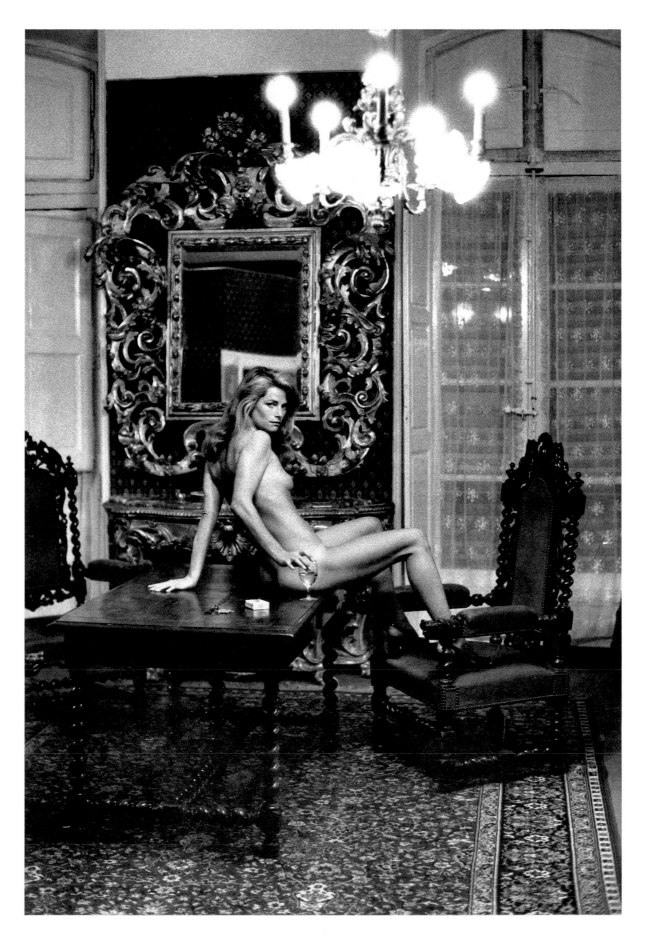

56. Charlotte Rampling at the Hotel Nord-Pinus, Arles 1973.

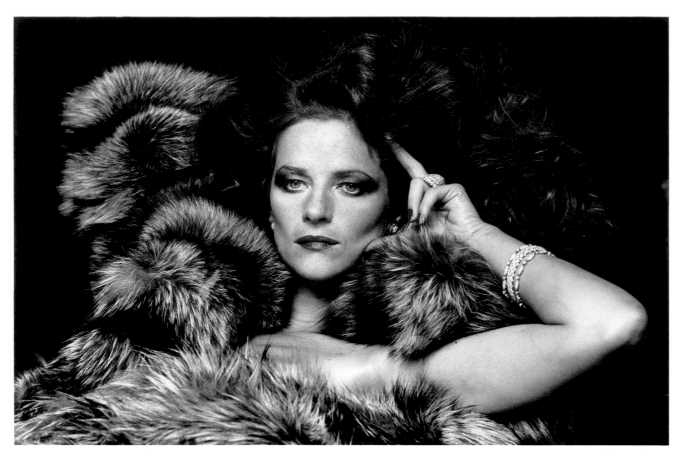

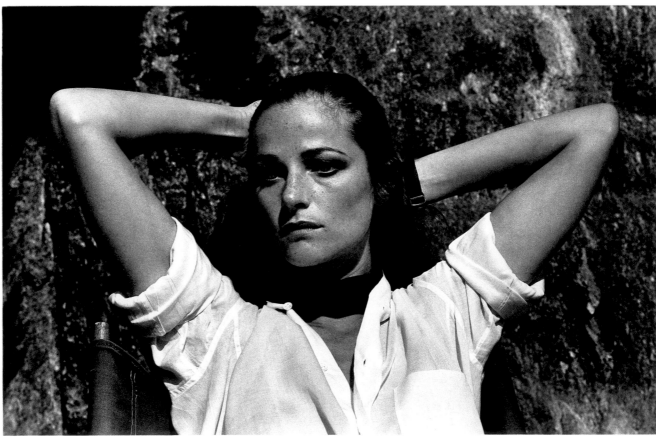

57. Charlotte Rampling, Paris 1977.
58. Charlotte Rampling, Saint Tropez 1976.

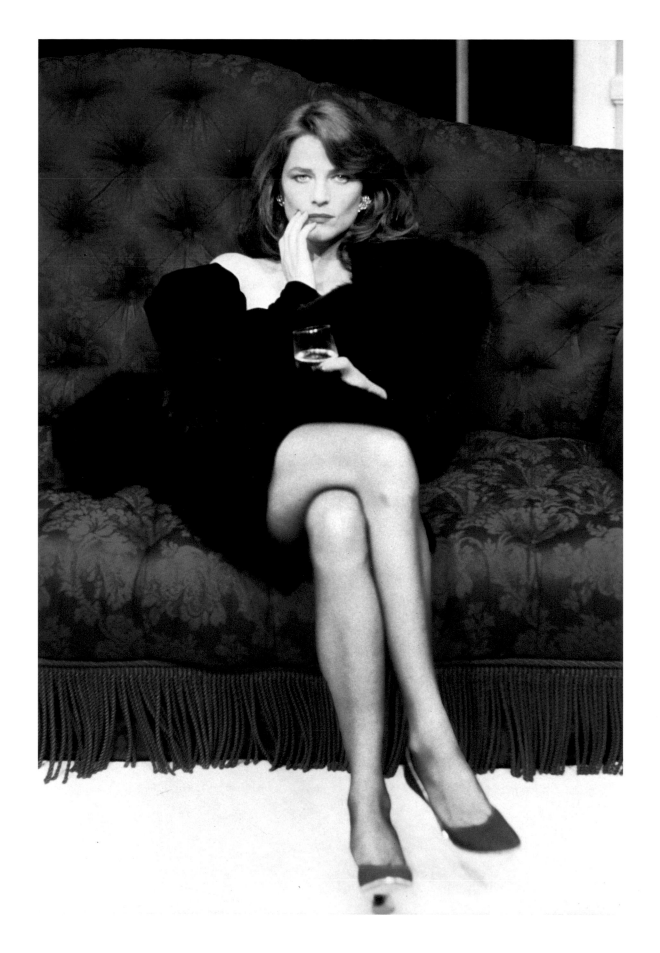

59. Charlotte Rampling at Yves Saint Laurent's, Paris 1984.

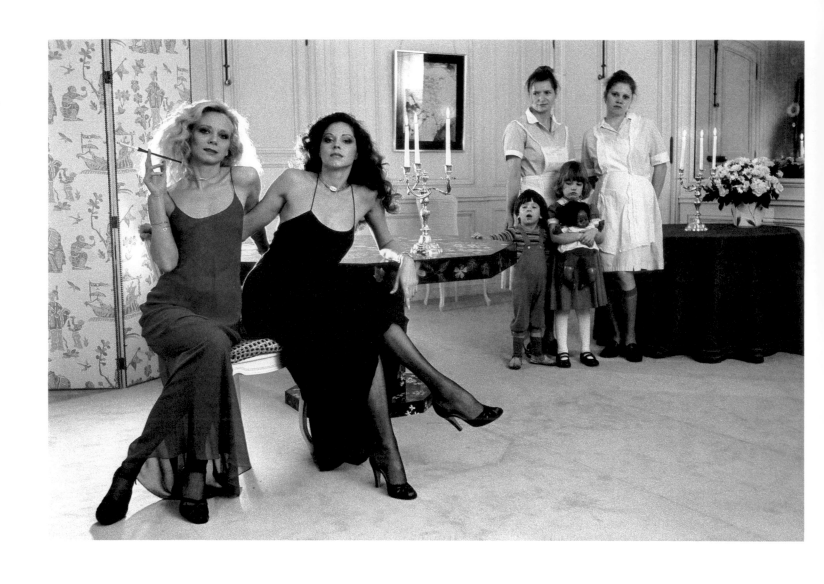

60. The Countess Joy de Rohan-Chabot and Diane Segard, Paris 1978.

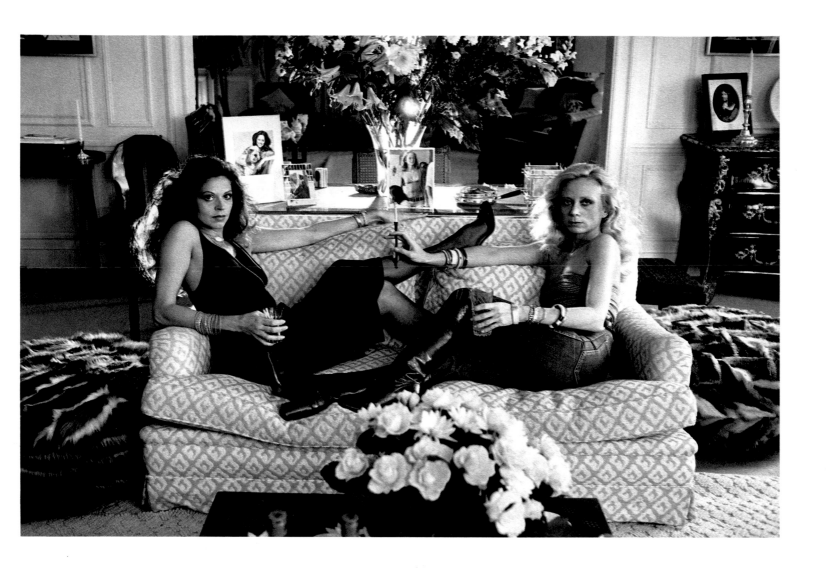

61. Diane Segard and the Countess Joy de Rohan-Chabot, Paris 1978.

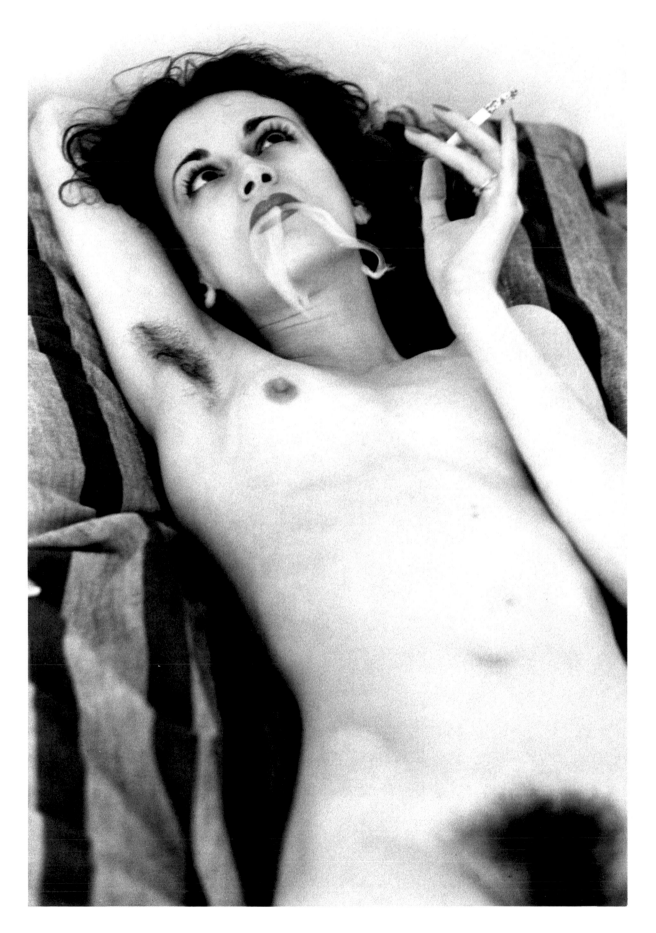

62. Violetta Sánchez, Paris 1979.

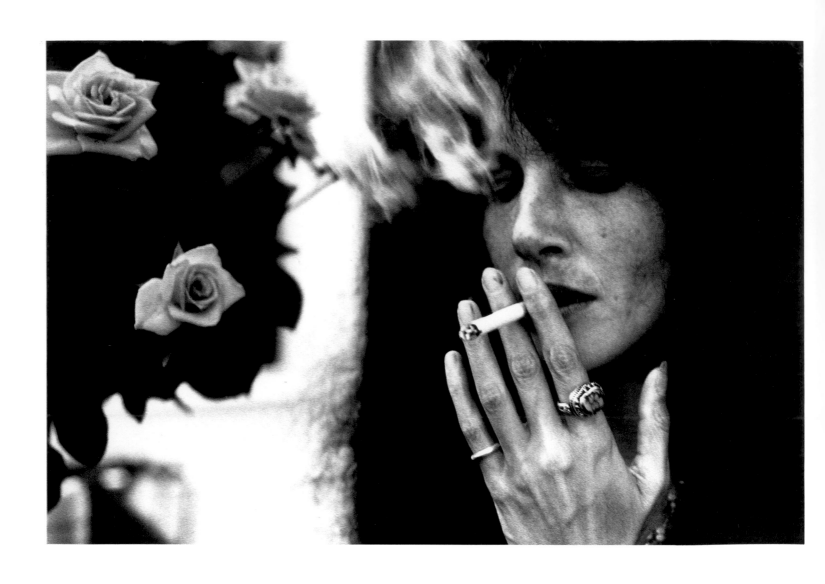

63. Mary Ellen Mark at the Grand Hotel du Cap, Antibes 1977.

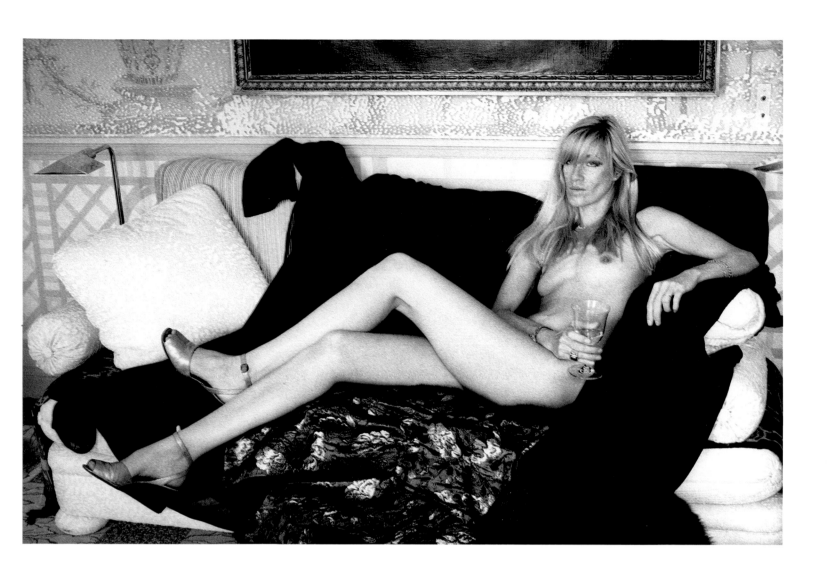

64. Betty Catroux at home, Paris 1980.

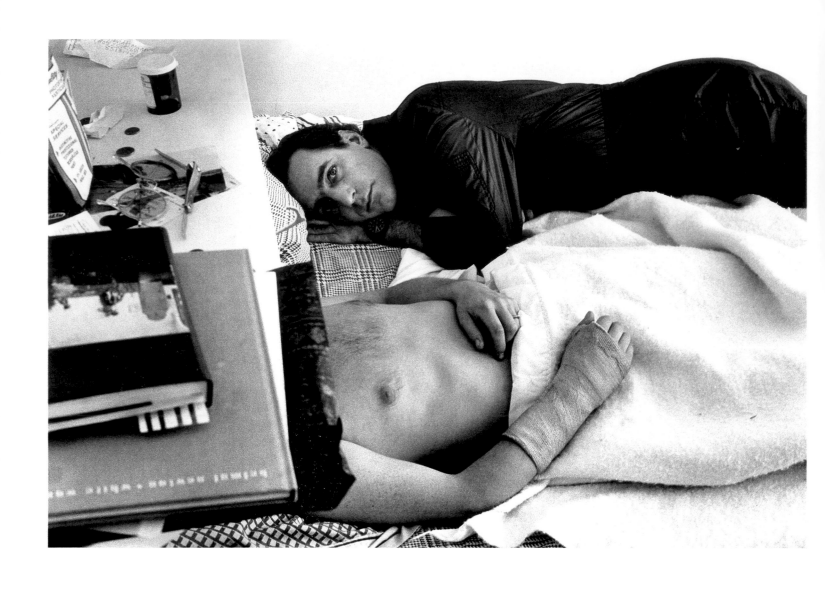

65. Nick Wilder, Los Angeles 1976.

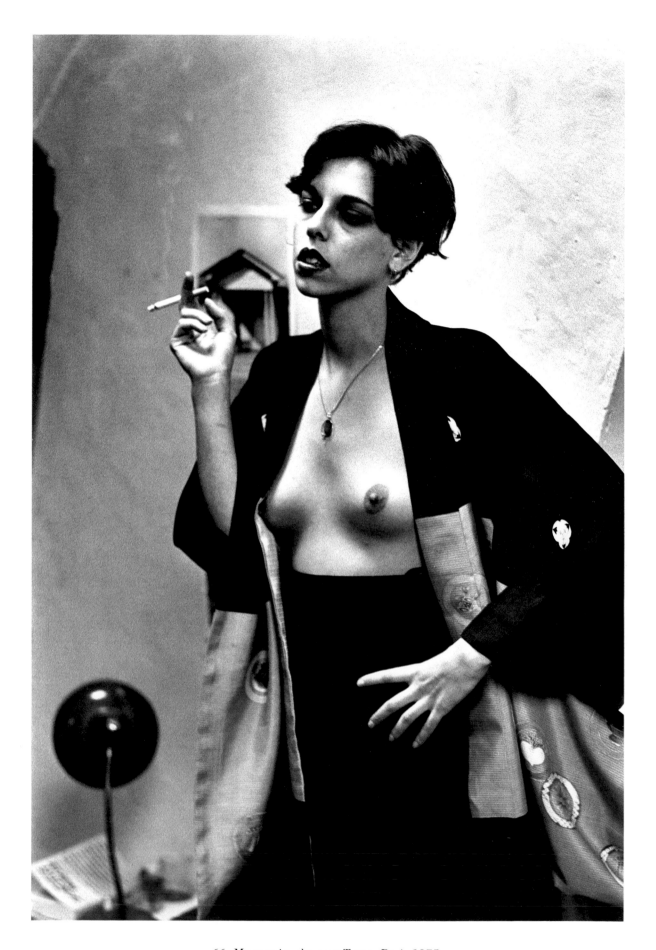

66. My cousin, the poet Tessa, Paris 1975.

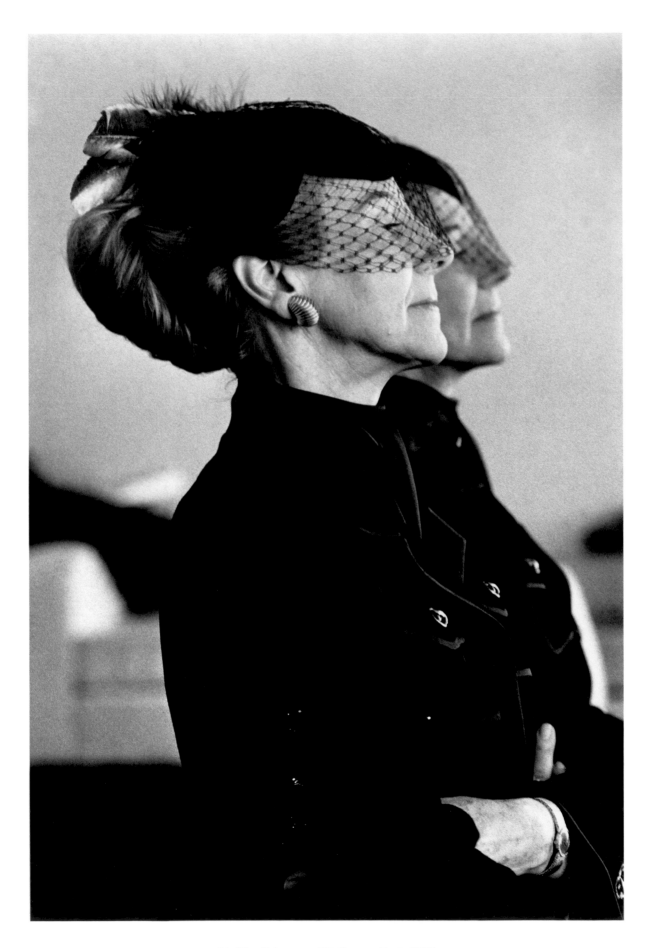

67. The Princess of Polignac, Paris 1979.

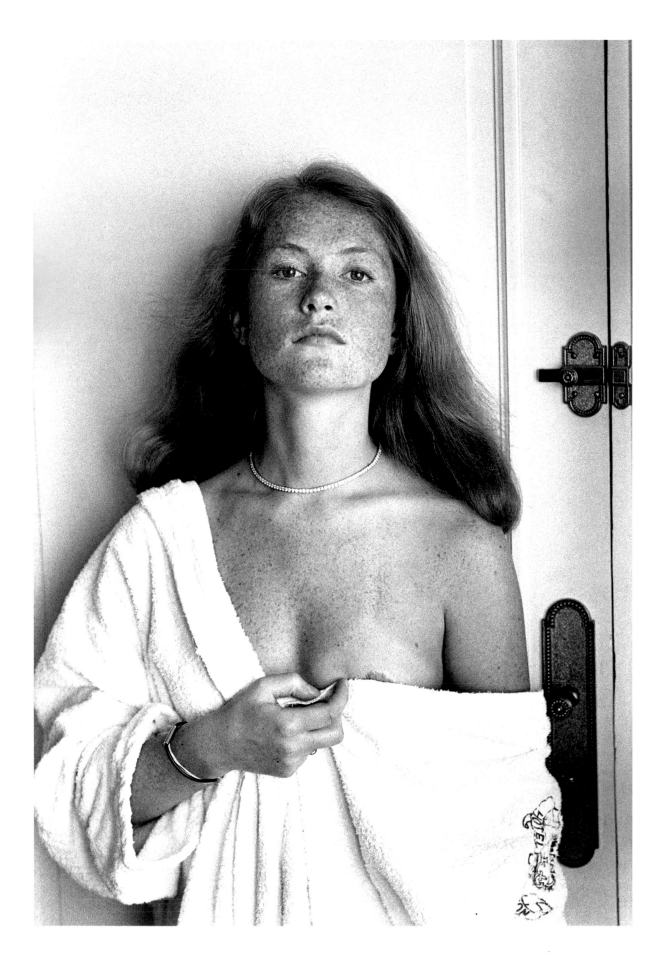

68. Isabelle Huppert, Hotel Carlton, Cannes 1976.

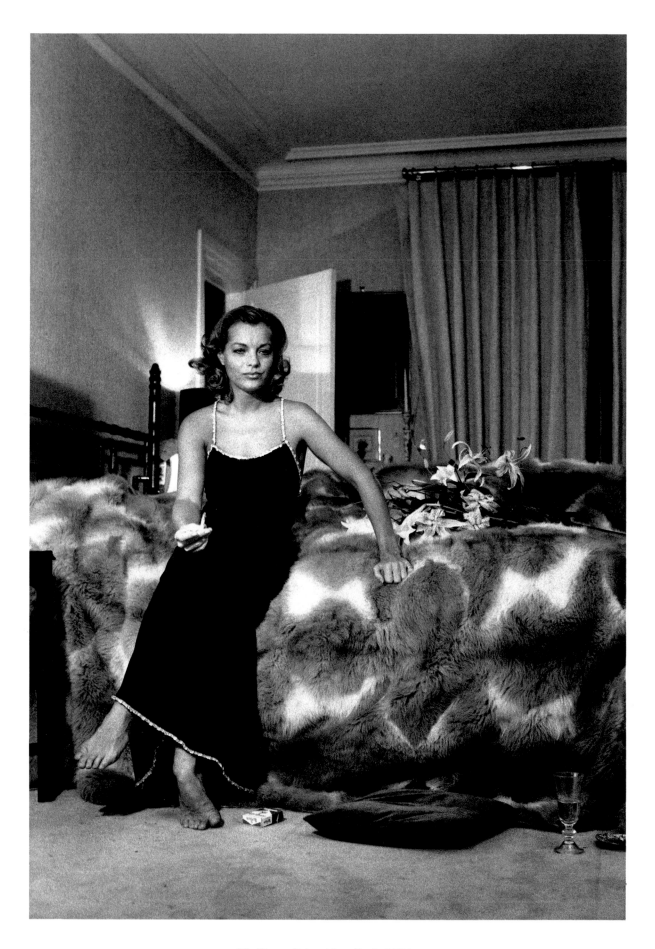

69. Romy Schneider, Paris 1974.

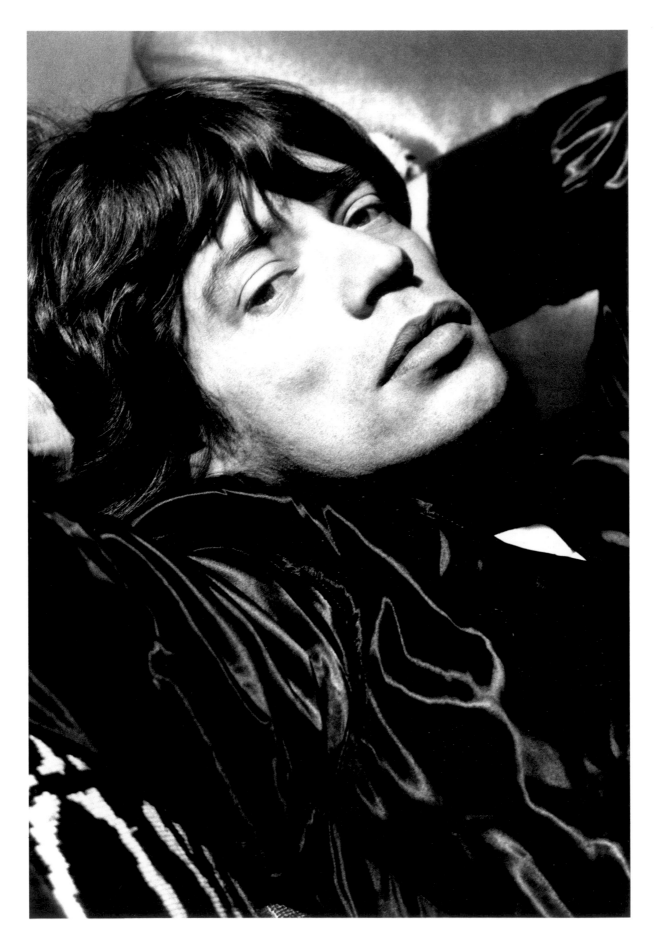

70. Mick Jagger, Paris 1977.

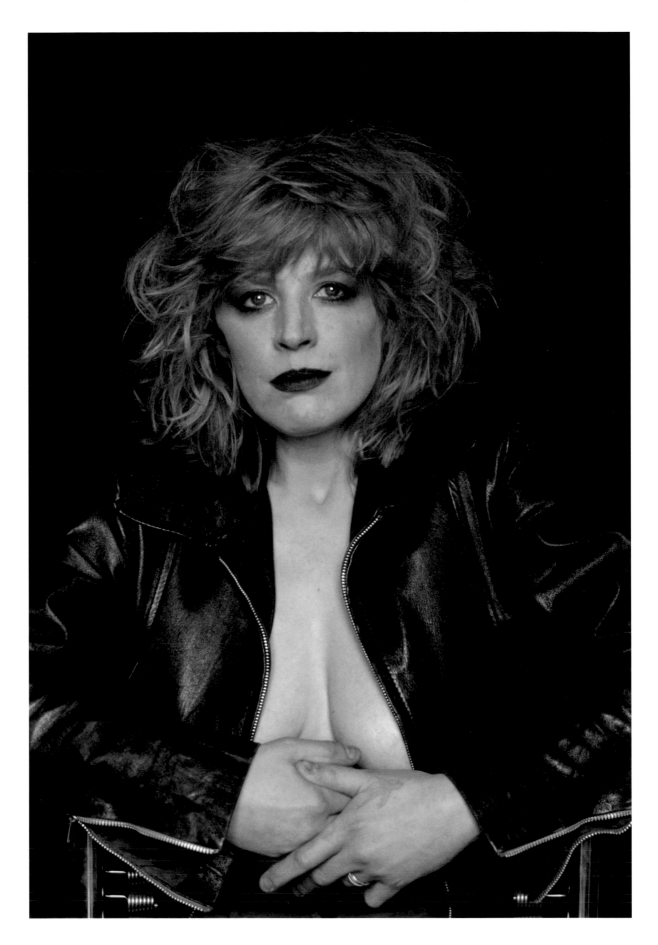

71. Marianne Faithfull, Paris 1979.

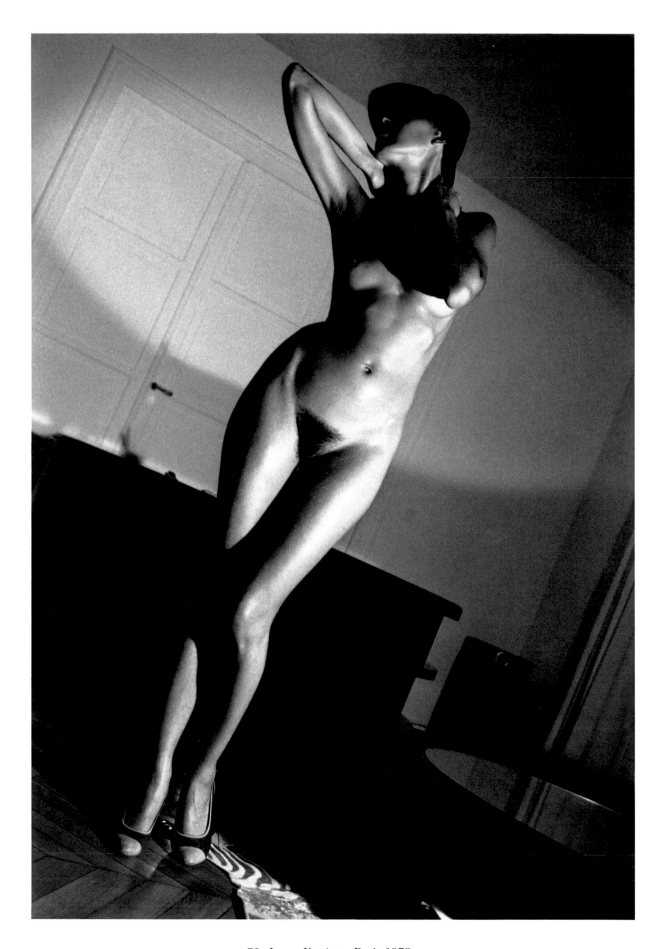

72. Jenny Kapitän, Paris 1978.

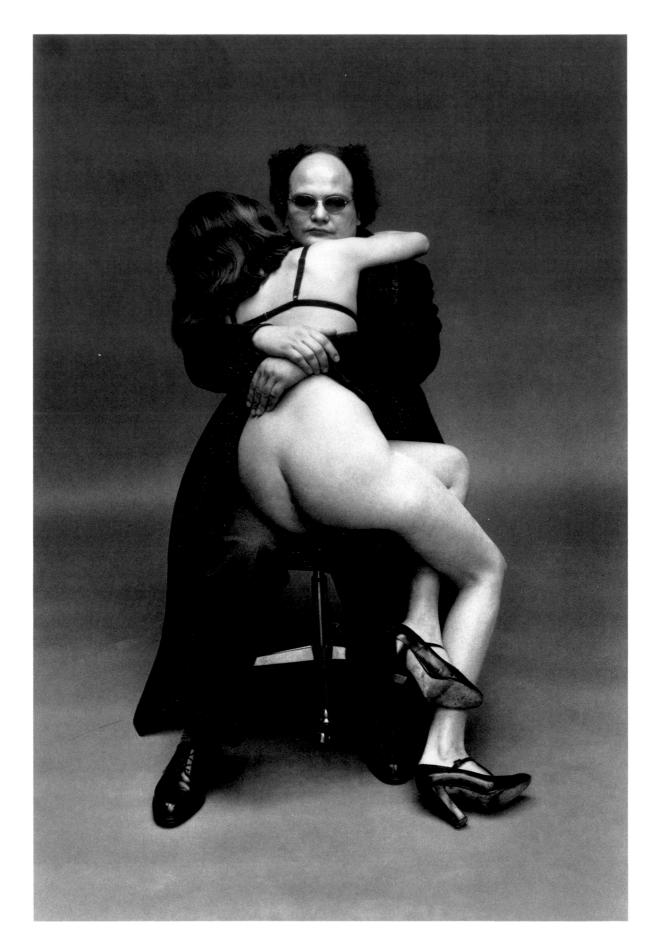

73. Xavier Moreau with girl friend, Paris 1974.

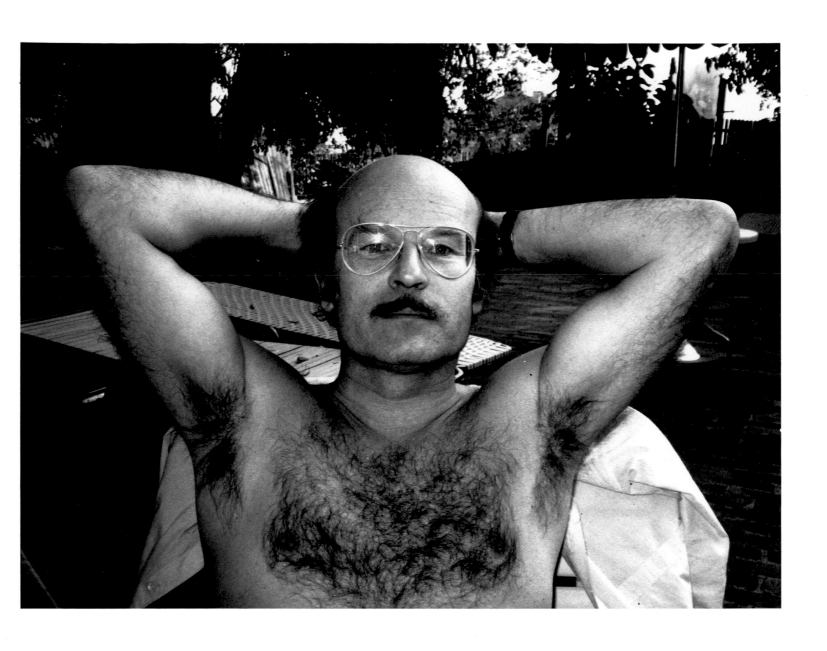

74. Volker Schlöndorff, Hollywood 1986.

75. Laurie Livingston, Beverly Hills 1981.

76. An unknown beauty, Monte Carlo 1979.

77. Raquel Welch, Los Angeles 1980.

78. Raquel Welch, Los Angeles 1980.

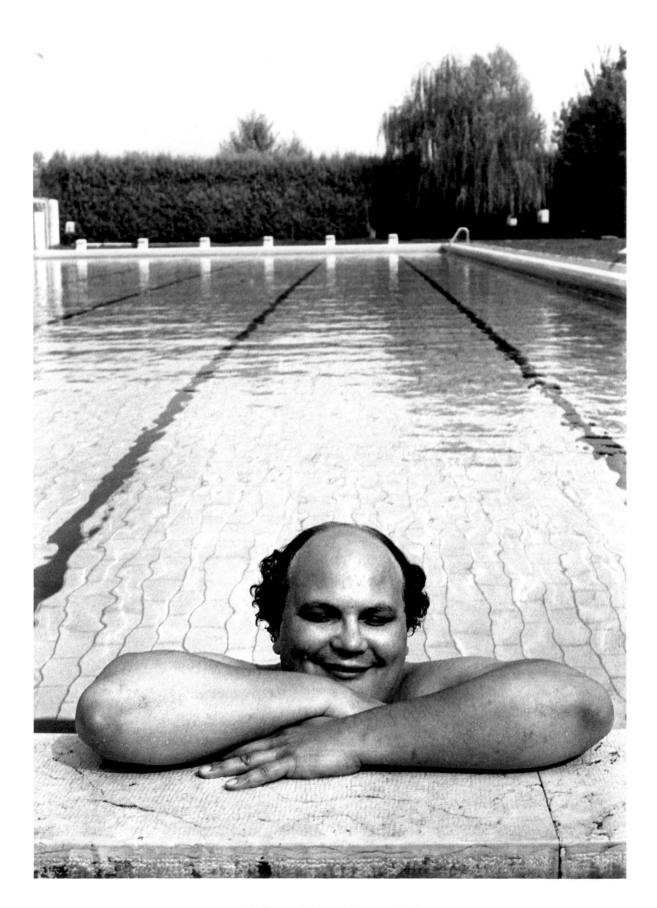

79. Xavier Moreau, Verona 1979.

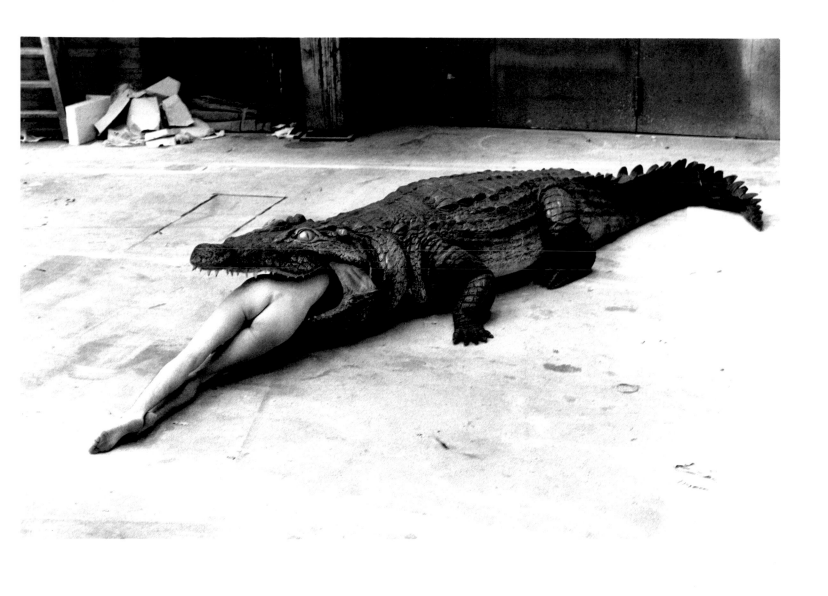

"*... Naturally I insisted that the crocodile be photographed; I had to persuade Pina Bausch that the crocodile was simply another member of her troupe and so should have its portrait taken too.*"

80. A scene from Pina Bausch's ballet *Die Keuschheitslegende* (The Legend of Virginity), Wuppertal 1983.

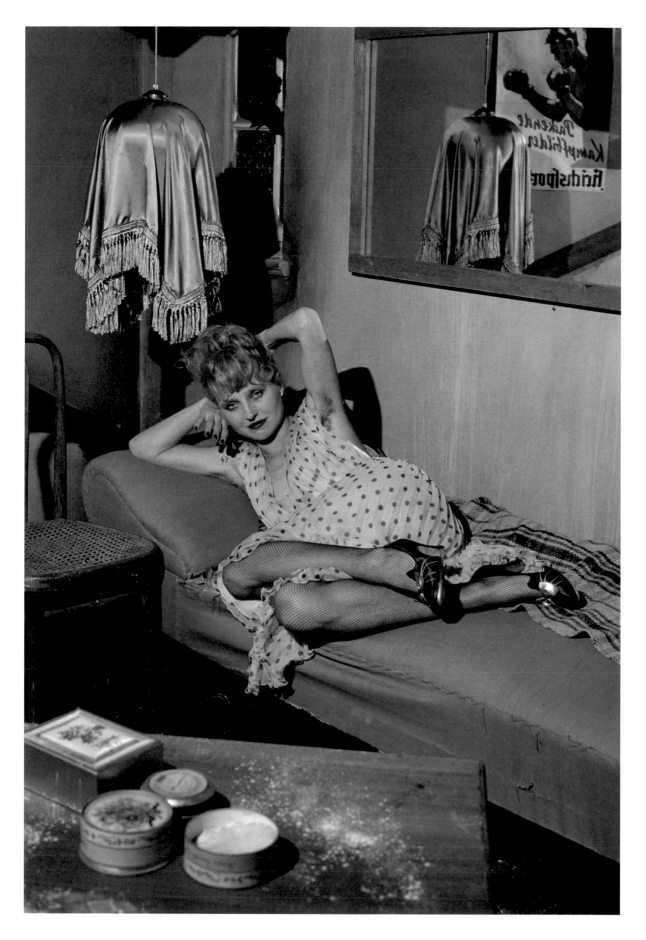

81. Hanna Schygulla, Munich 1980.

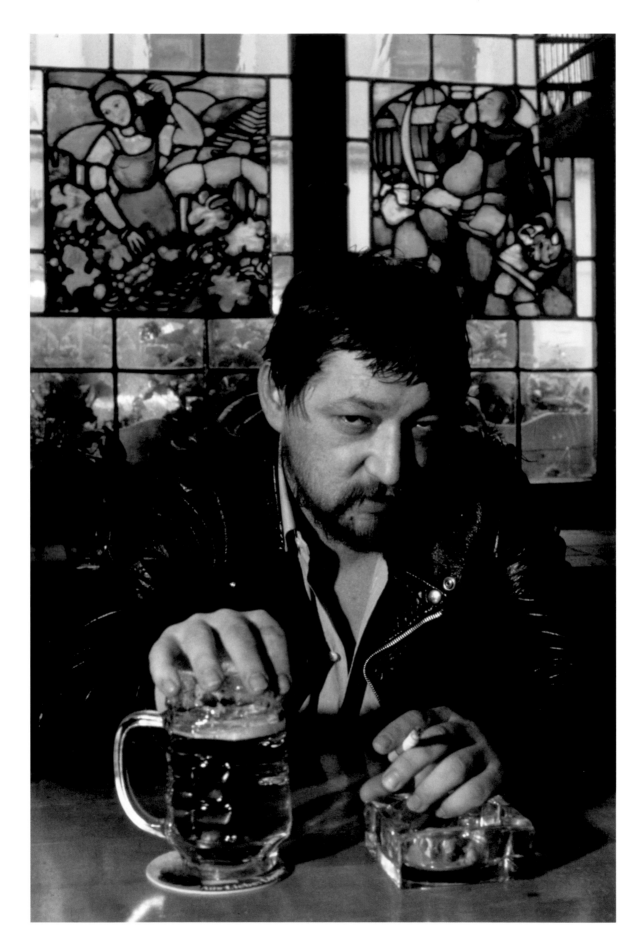

82. Rainer Werner Fassbinder, Munich 1980.

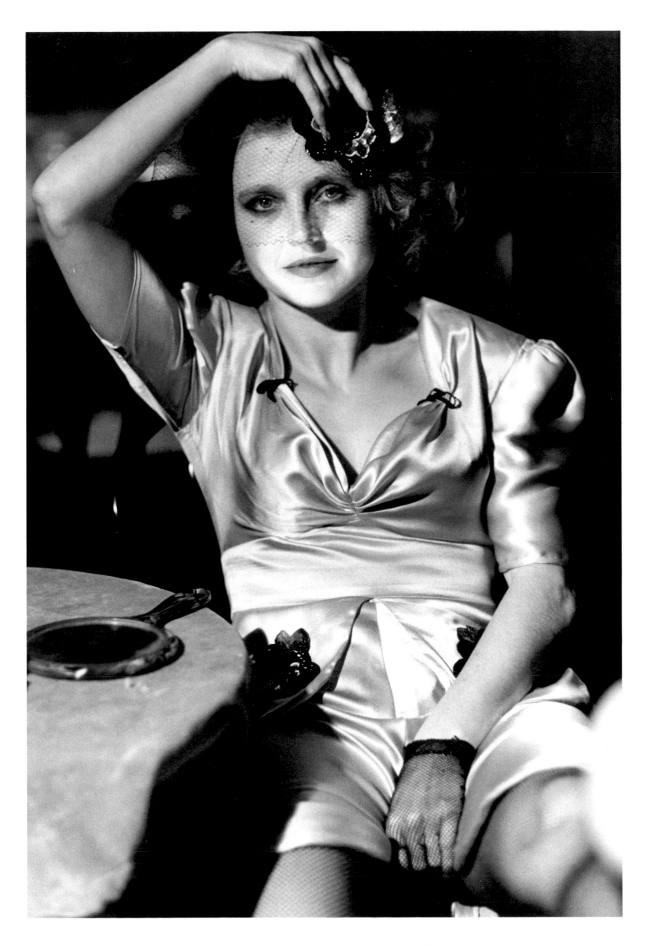

83. Hanna Schygulla as Lili Marlene, Munich 1980.

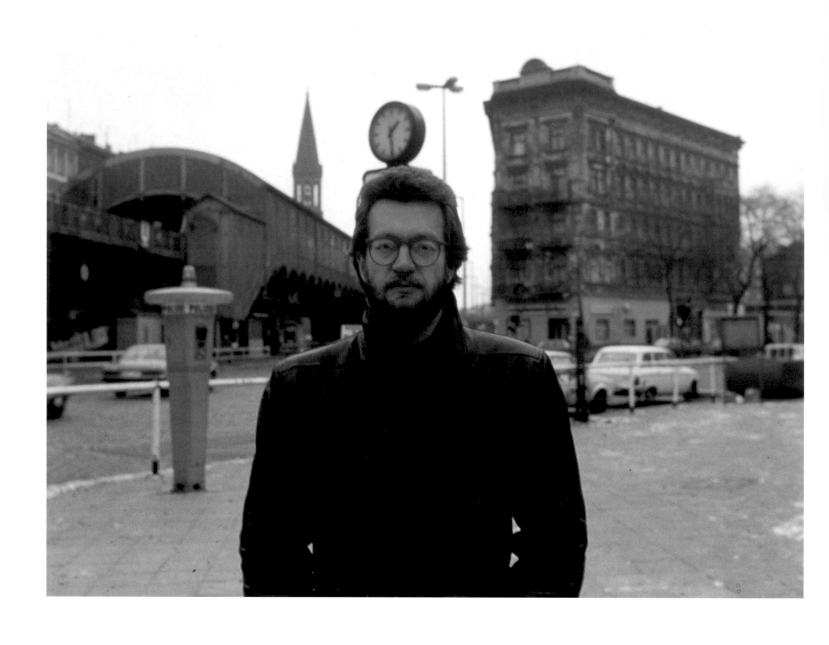

84. Wim Wenders, Berlin 1980.

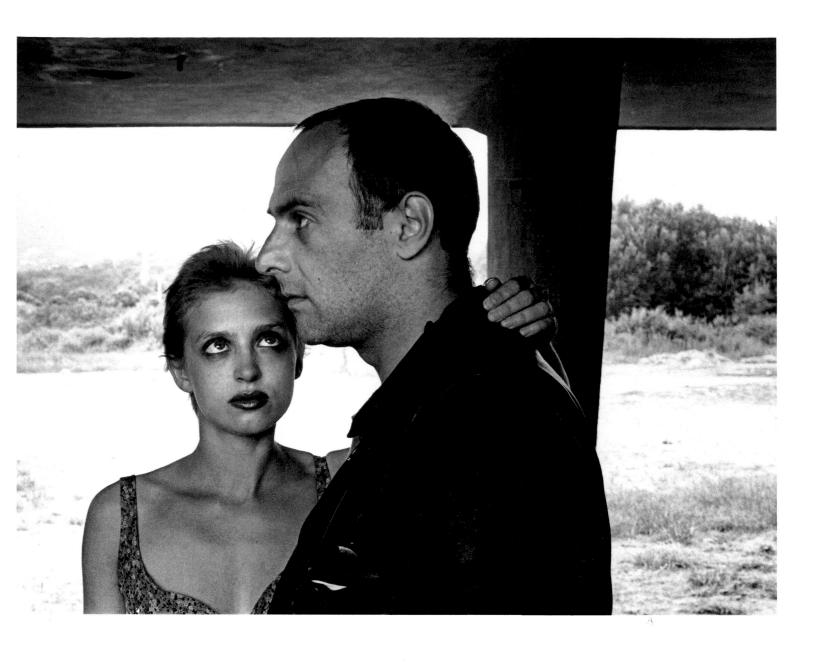

85. Thomas Brasch and Katharina Thalbach, Croix Valmer 1980.

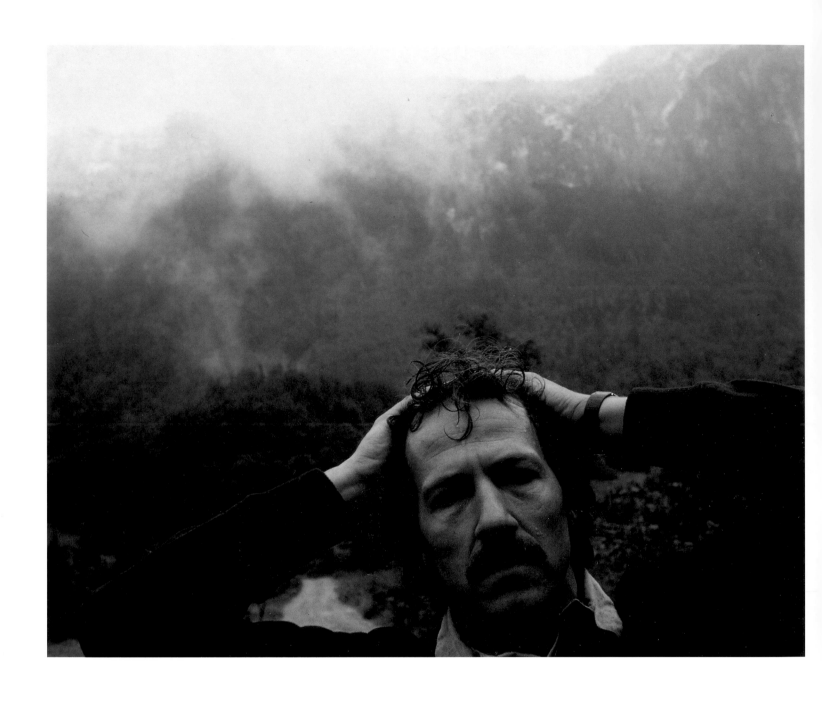

86. Werner Herzog, Bavaria 1980.

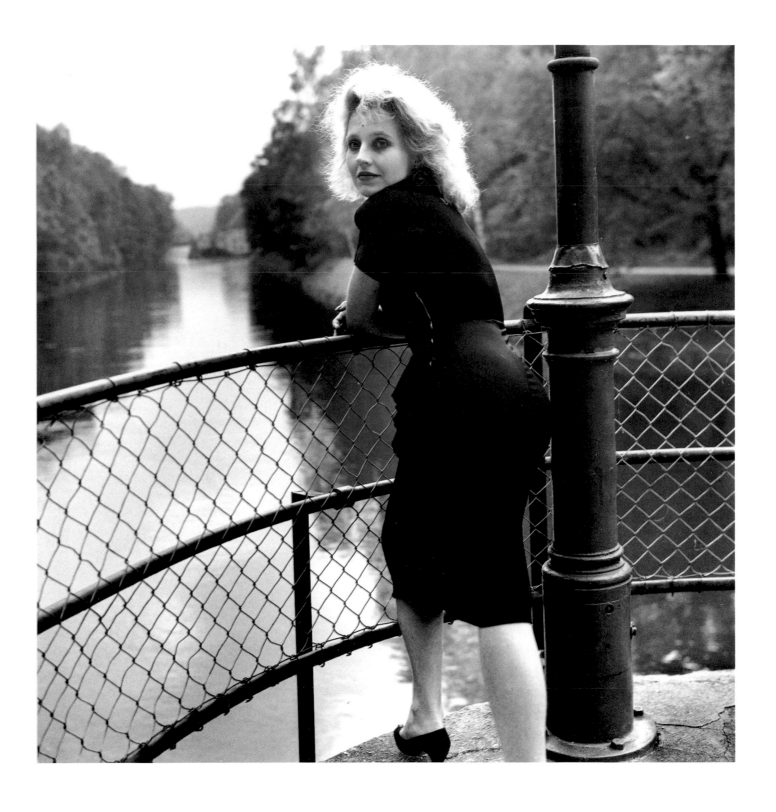

87. Hanna Schygulla, Munich 1980.

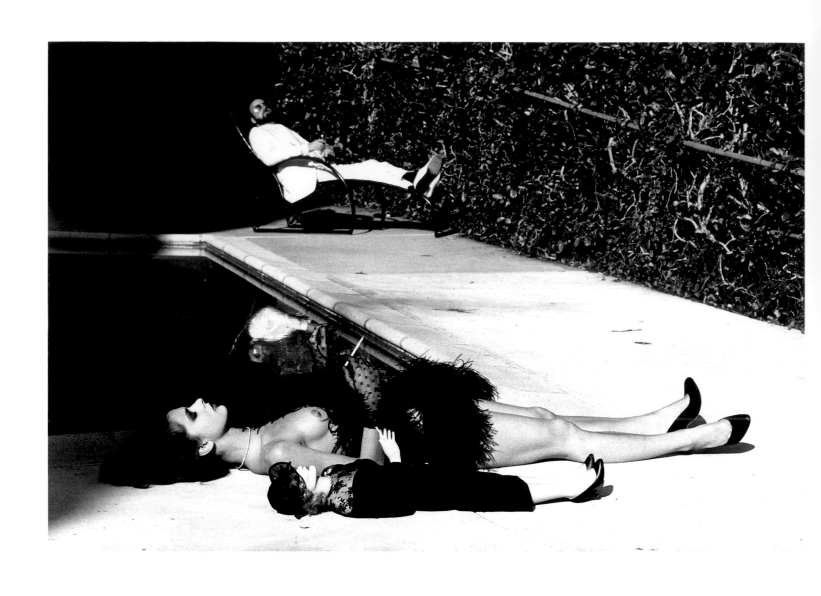

88. Nastassia Kinski with Marlene Dietrich doll and movie director James Toback, Hollywood 1983.

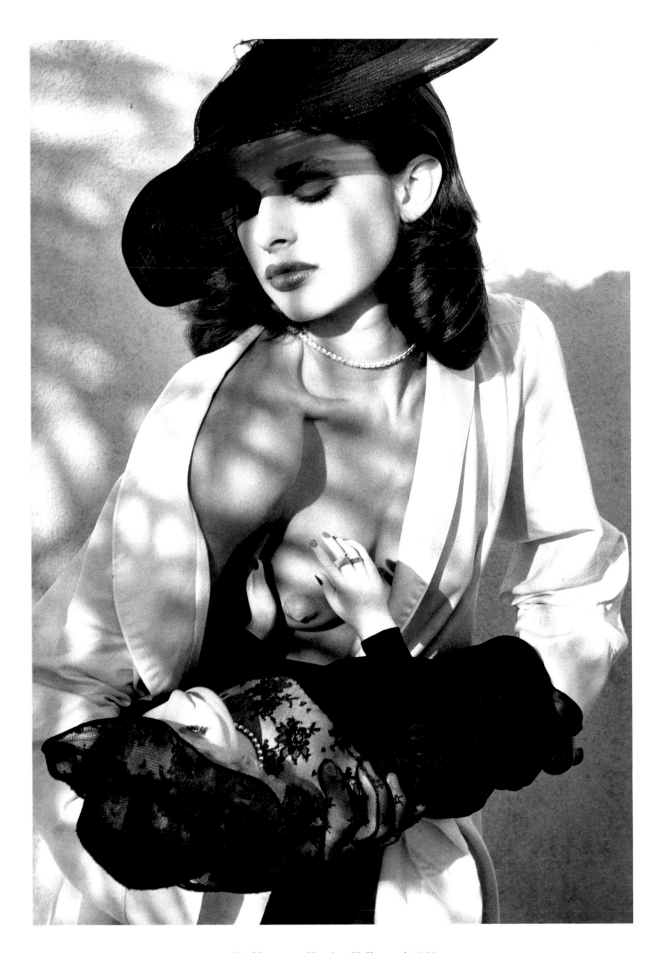

89. Nastassia Kinski, Hollywood 1983.

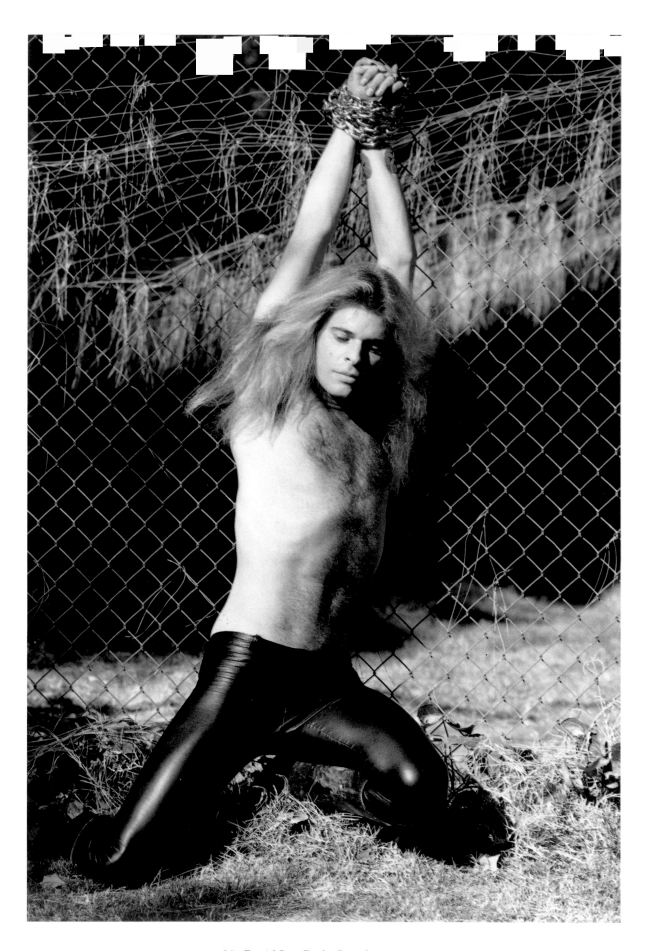

90. David Lee Roth, Pasadena 1979.

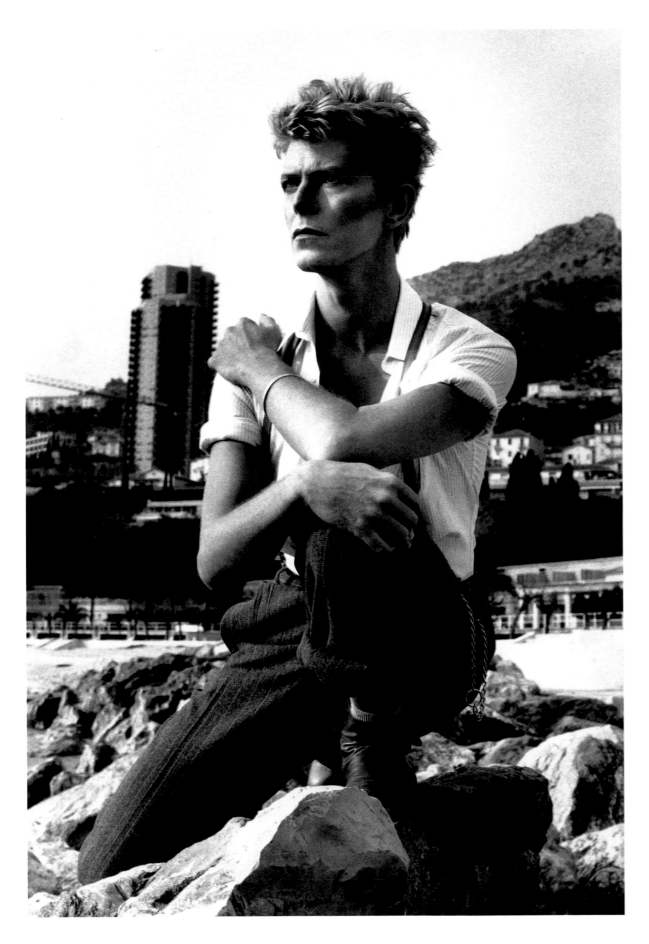

91. David Bowie, Monte Carlo 1983.

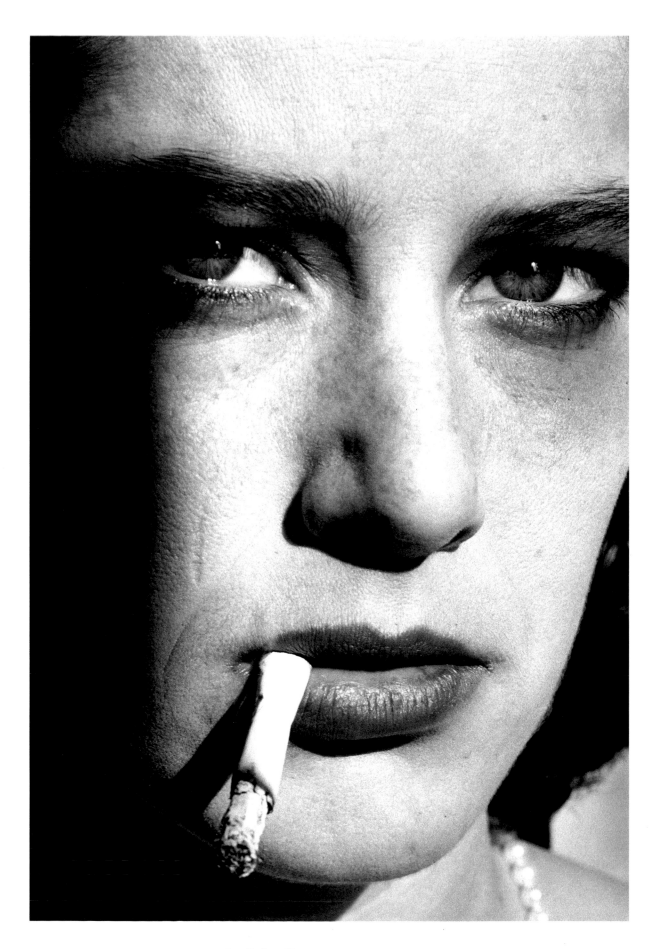

92. Debra Winger, Los Angeles 1983.

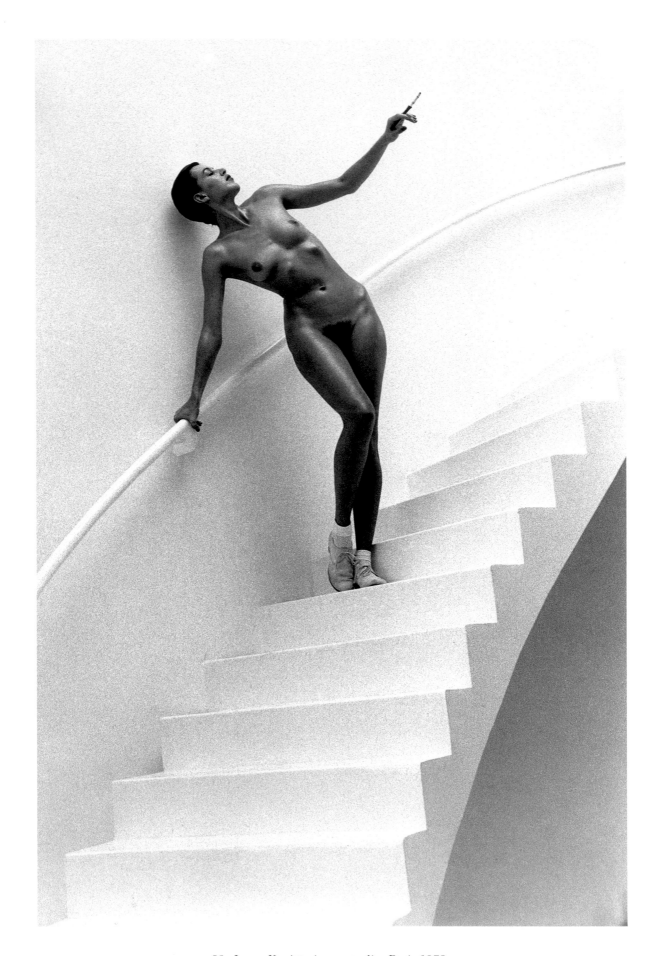

93. Jenny Kapitän in my studio, Paris 1978.

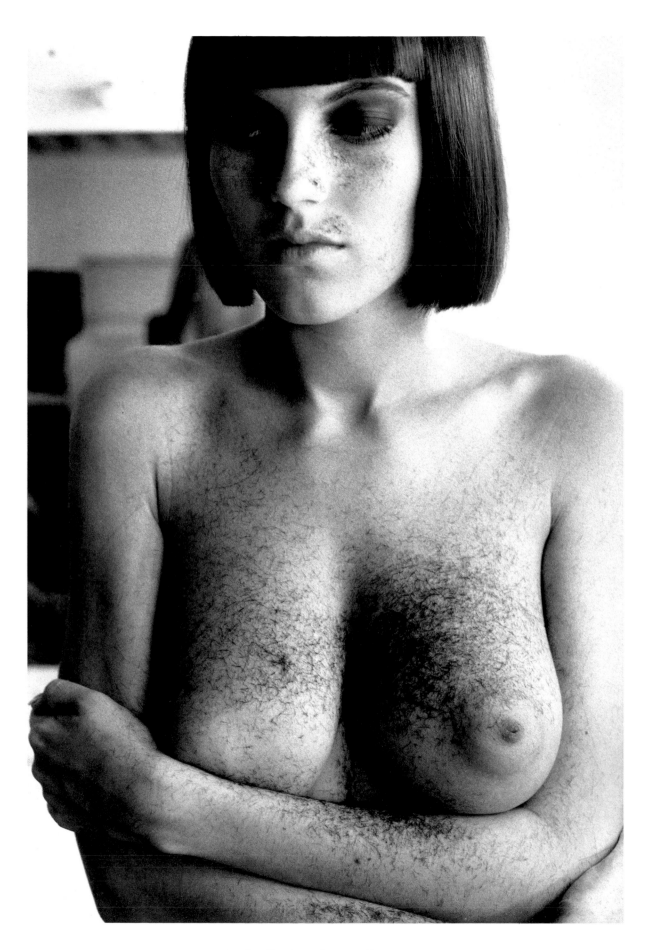

94. Arielle after a haircut, Paris 1982.

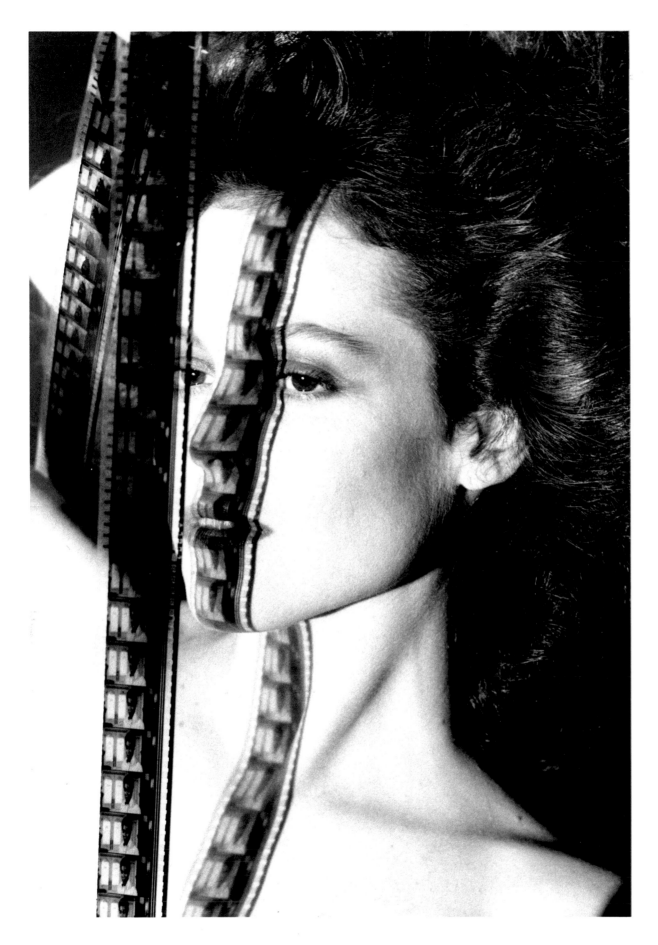

95. Sigourney Weaver, Los Angeles 1983.

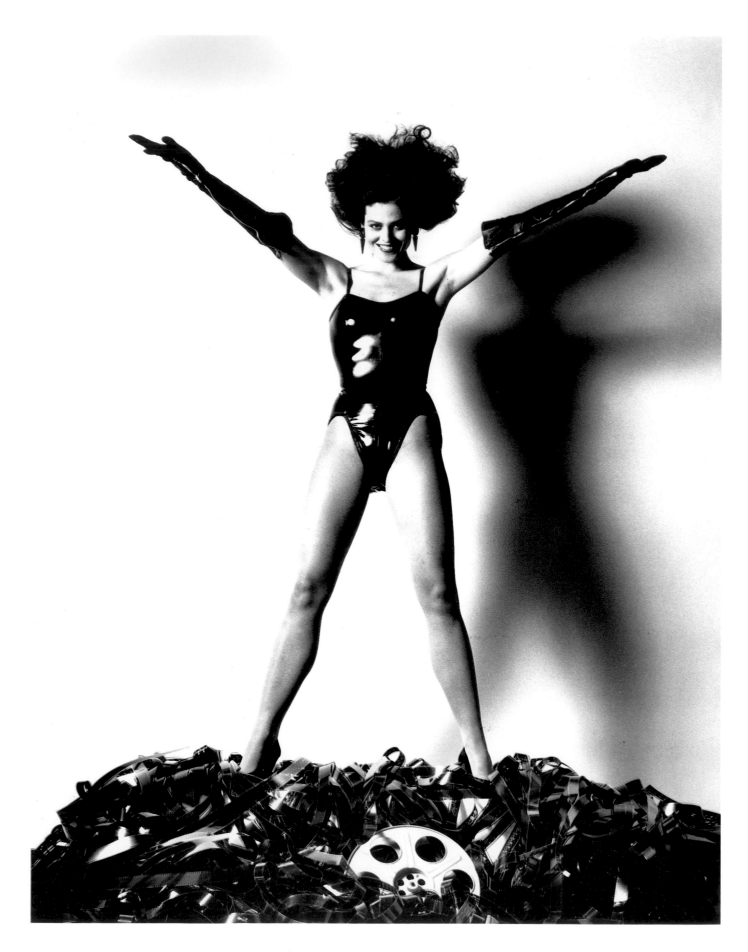

96. Sigourney Weaver, Los Angeles 1983.

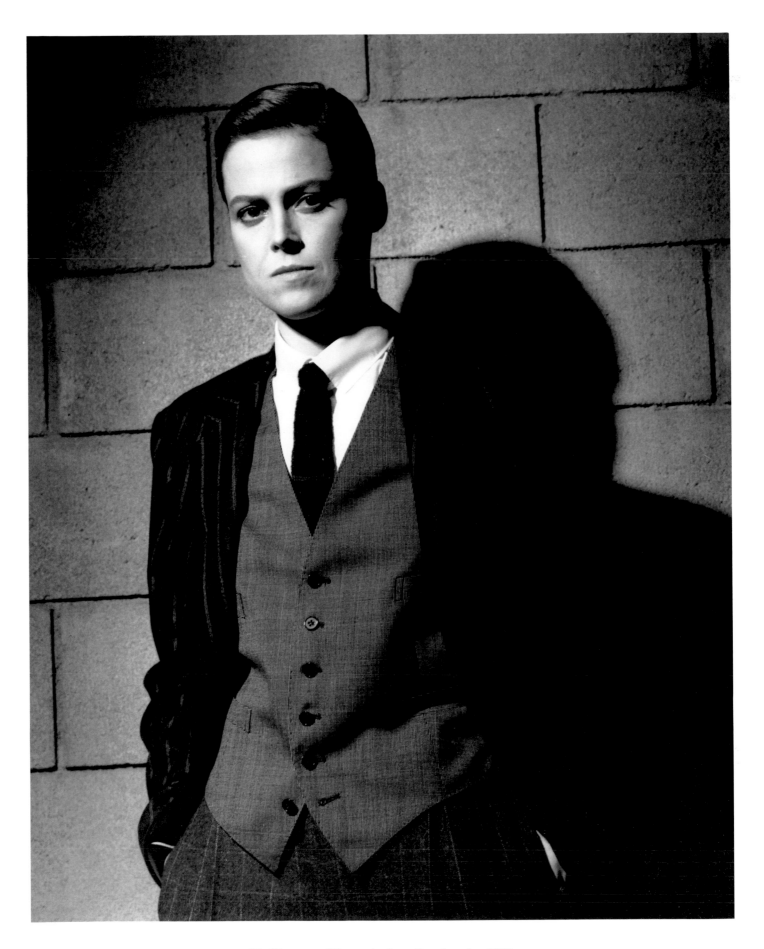

97. Sigourney Weaver in drag, Los Angeles 1983.

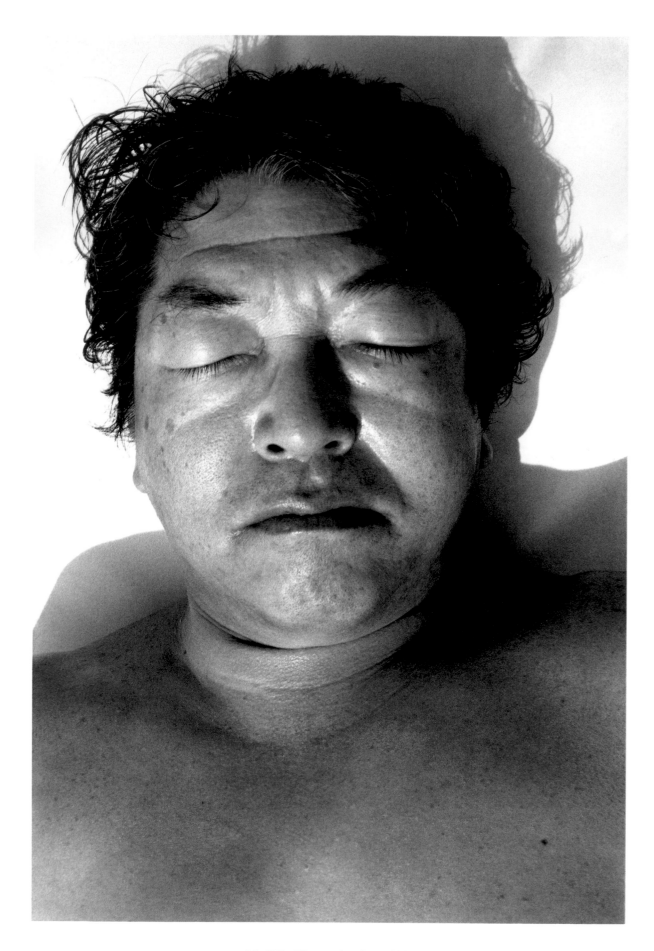

98. Eiko Hosoe, Antibes 1983.

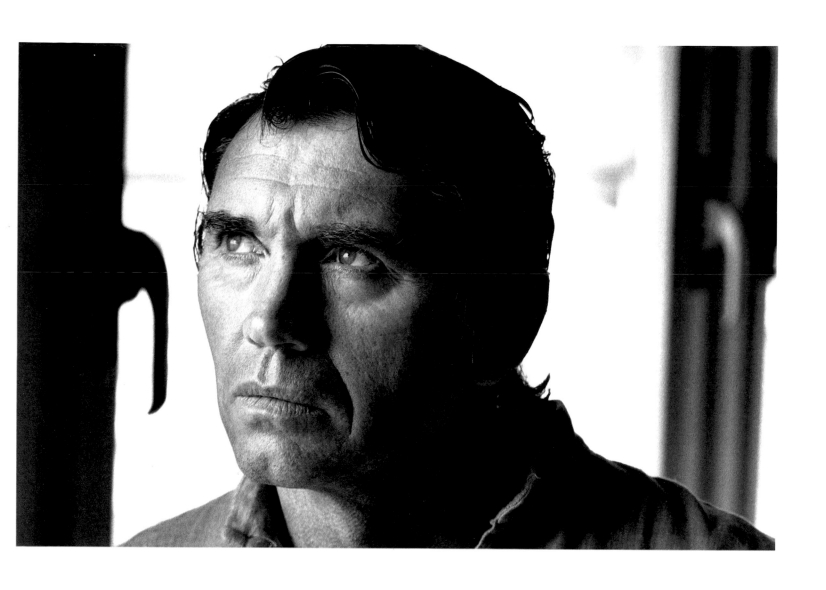

99. Don McCullin, Antibes 1983.

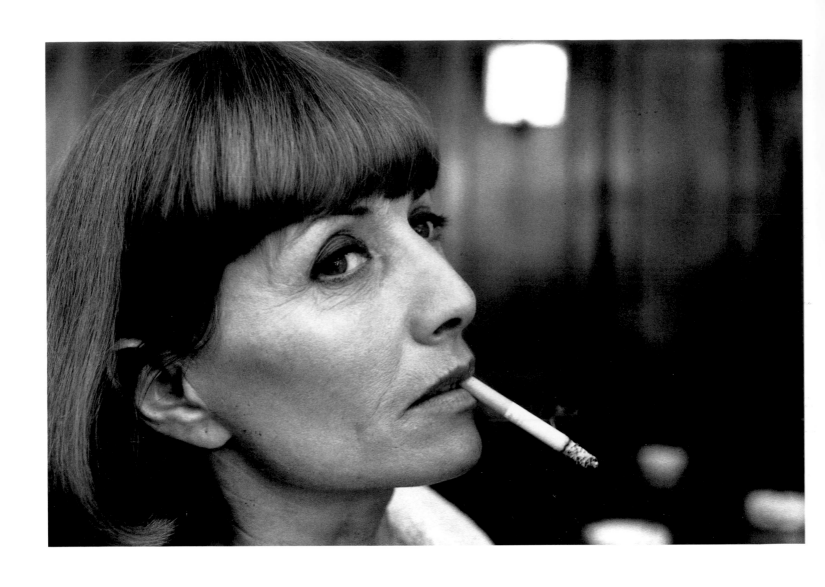

100. Stéphane Audran, Paris 1984.

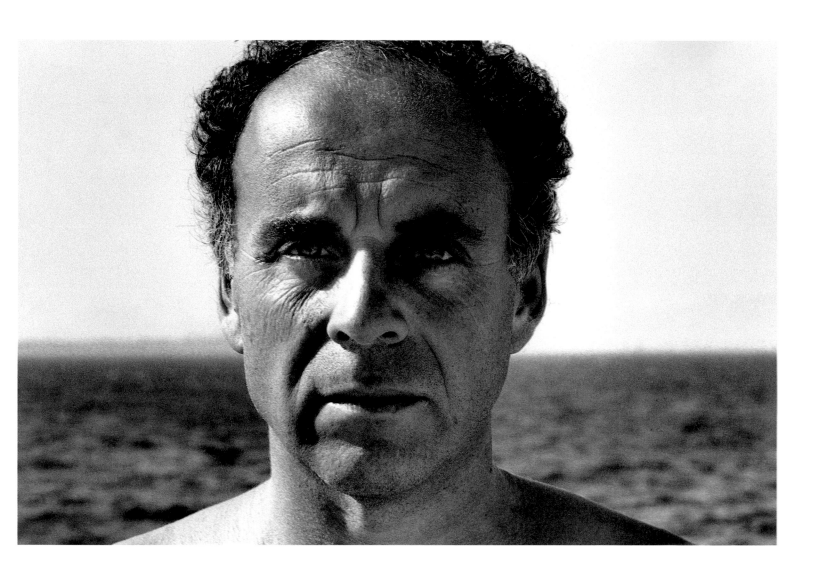

101. Ralph Gibson, Antibes 1983.

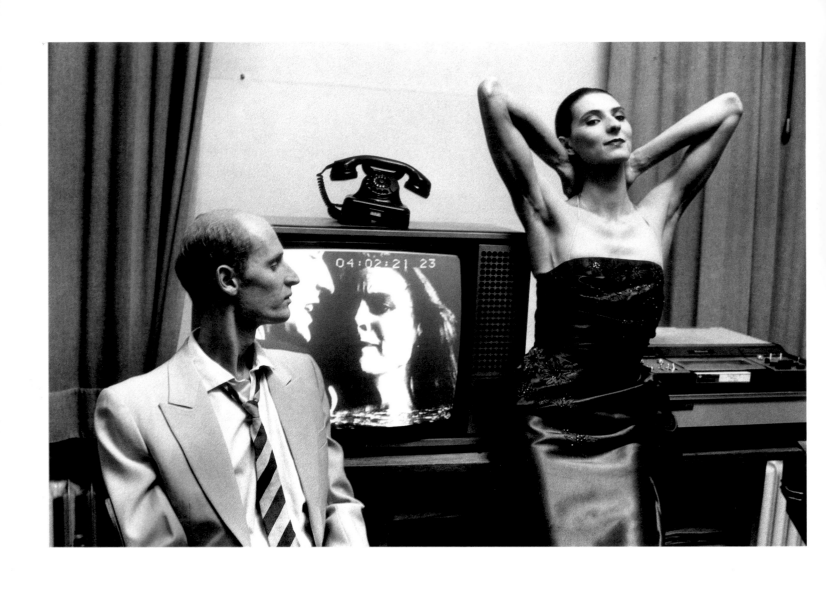

102. Jakob Andersen and Helene Pikon, members of Pina Bausch's ballet company
(on TV: Jakob Andersen and Josephine Ann Endicott), Wuppertal 1983.

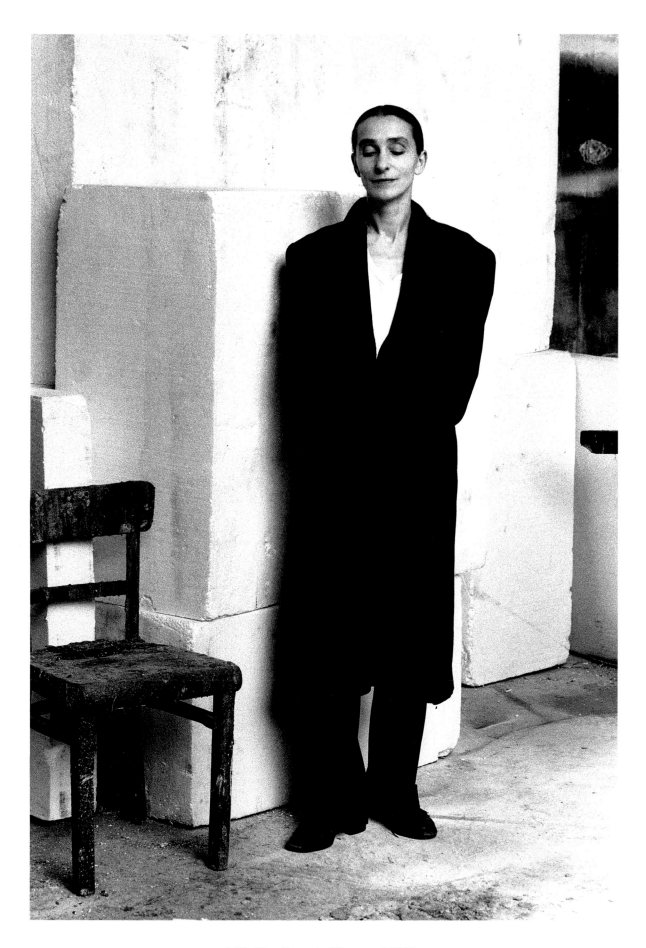

103. Pina Bausch, Wuppertal 1983.

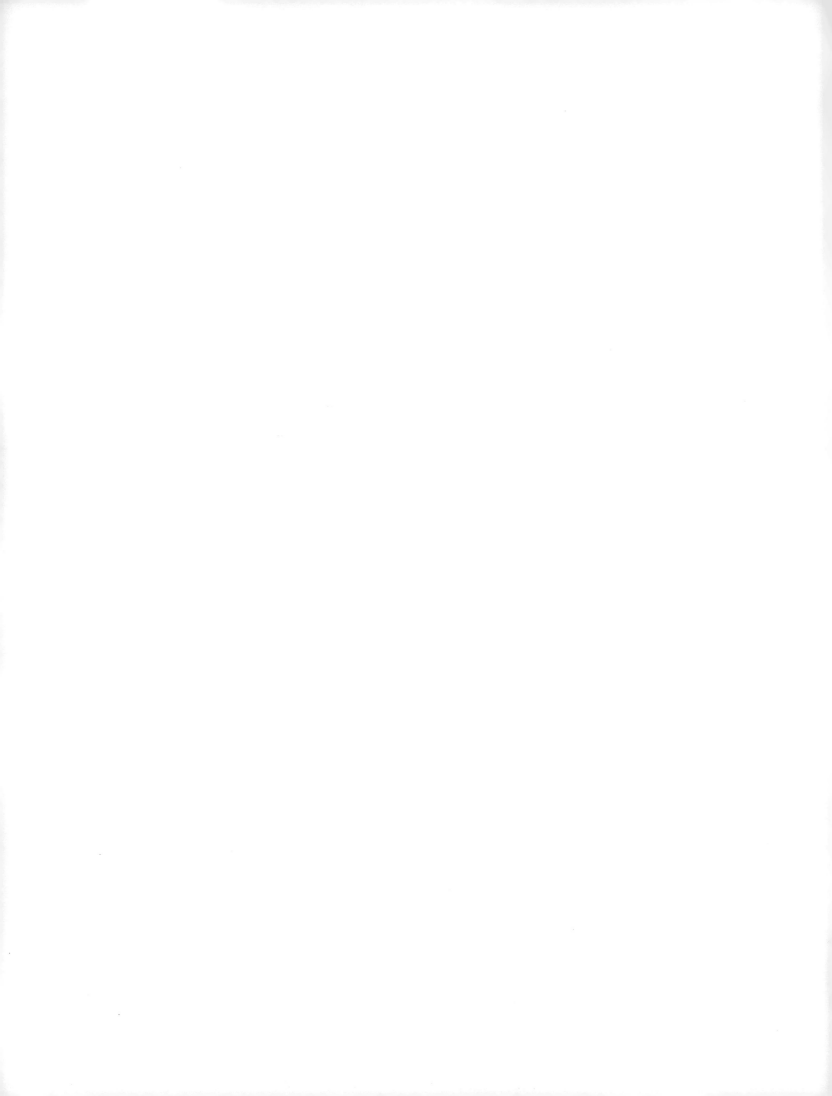

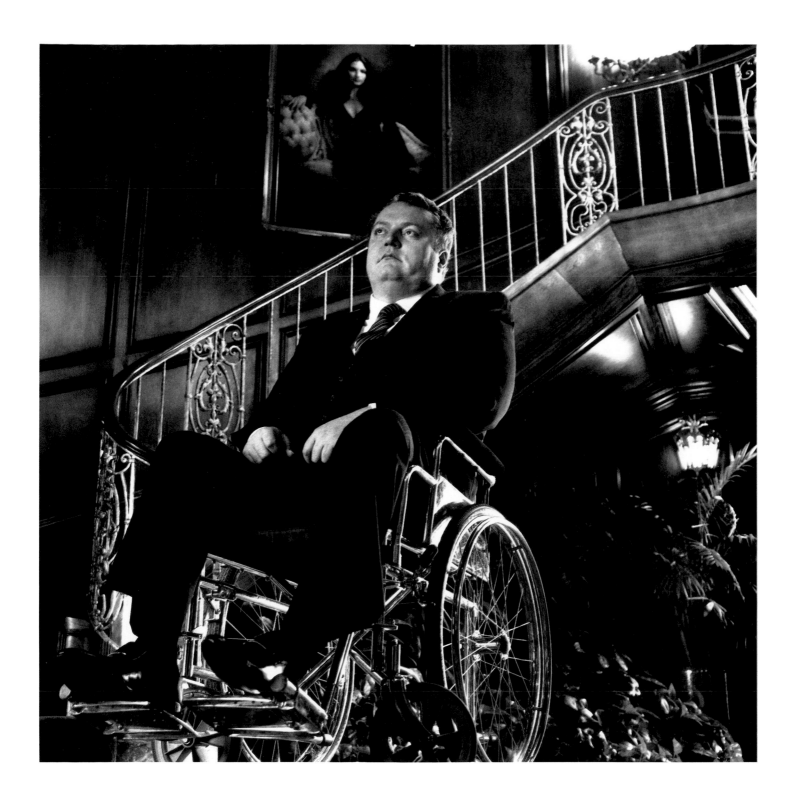

104. Larry Flynt, Beverly Hills 1986.

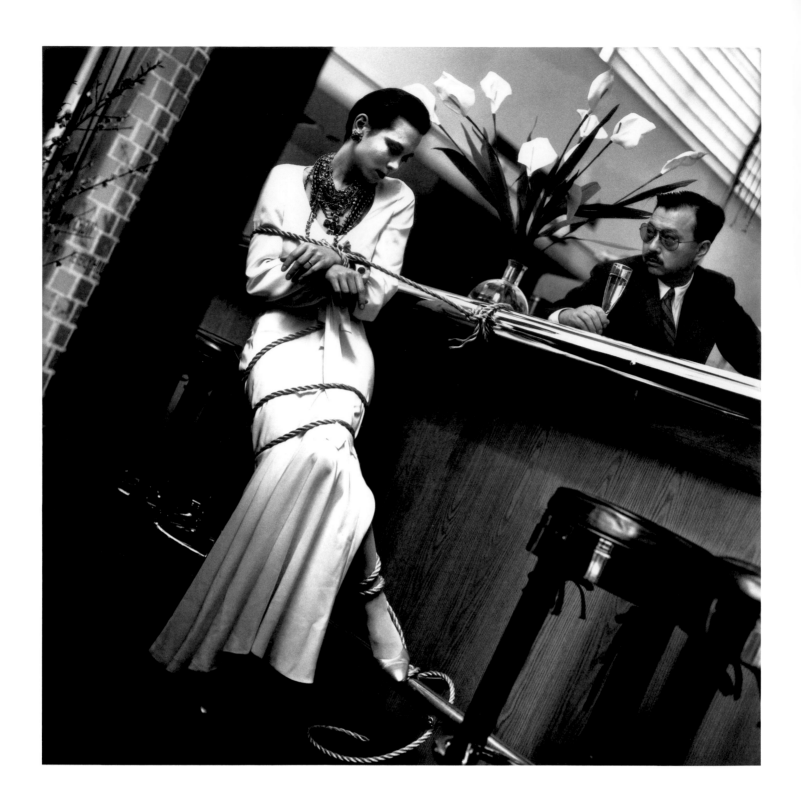

105. Tina and Michael Chow, Beverly Hills 1984.

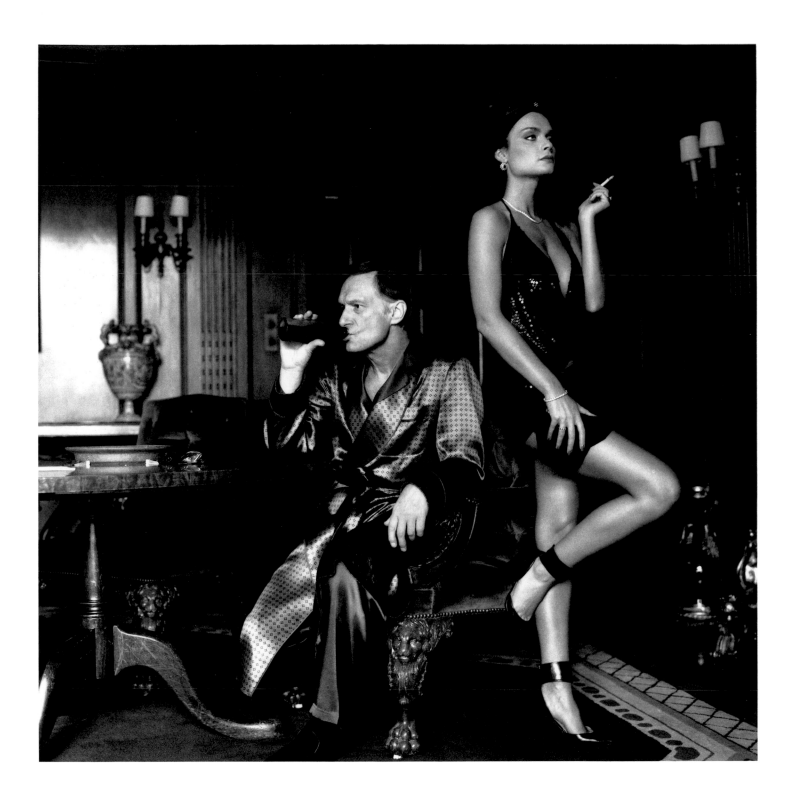

106. Hugh Hefner and Carrie Leigh, Beverly Hills 1984.

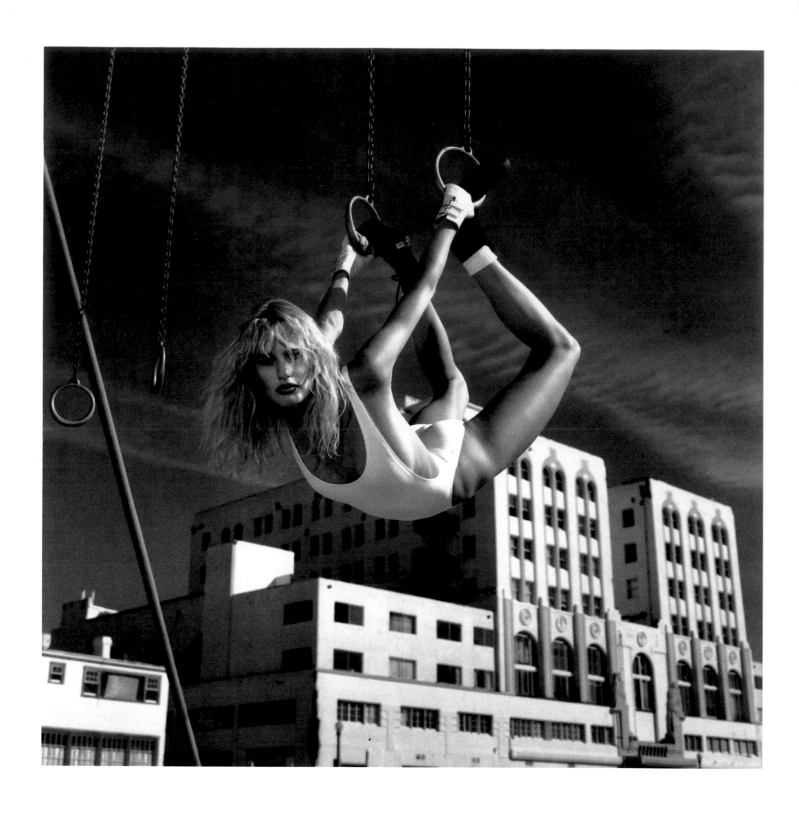

107. Daryl Hannah, Los Angeles 1984.

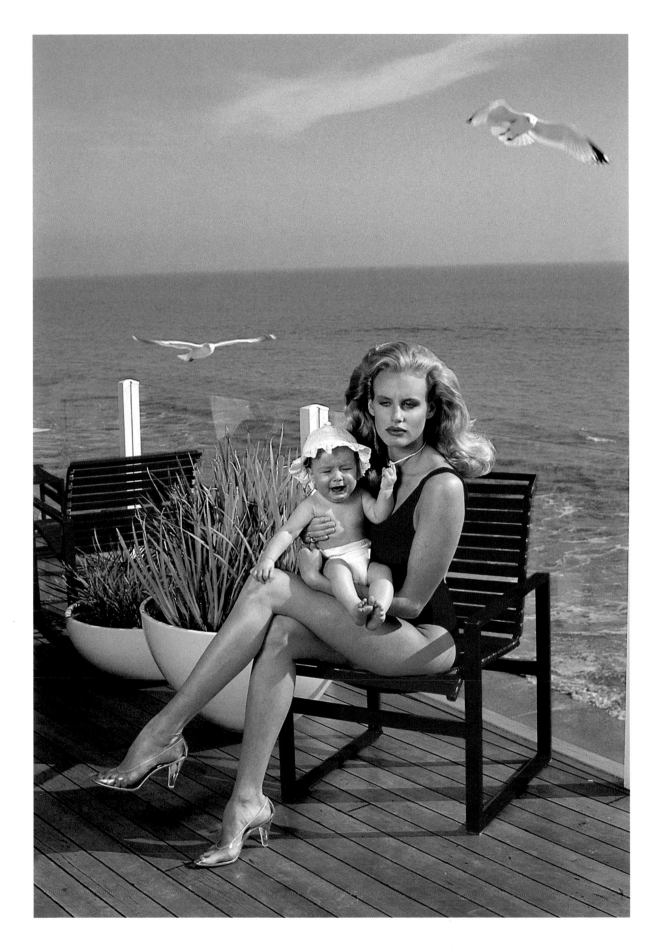

108. Daryl Hannah with unidentified baby, Los Angeles 1984.

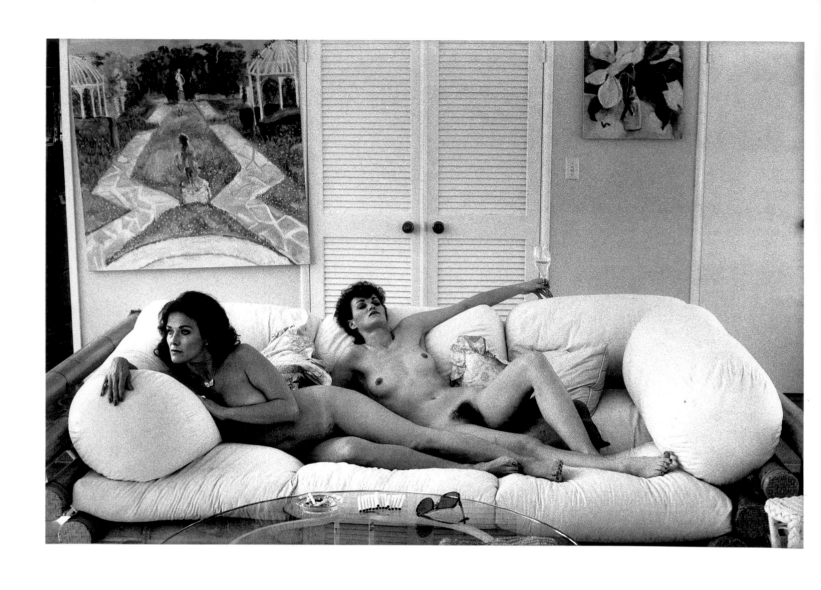

109. Teri Rojas and her sister Cheri Hamilton, Santa Barbara 1984.

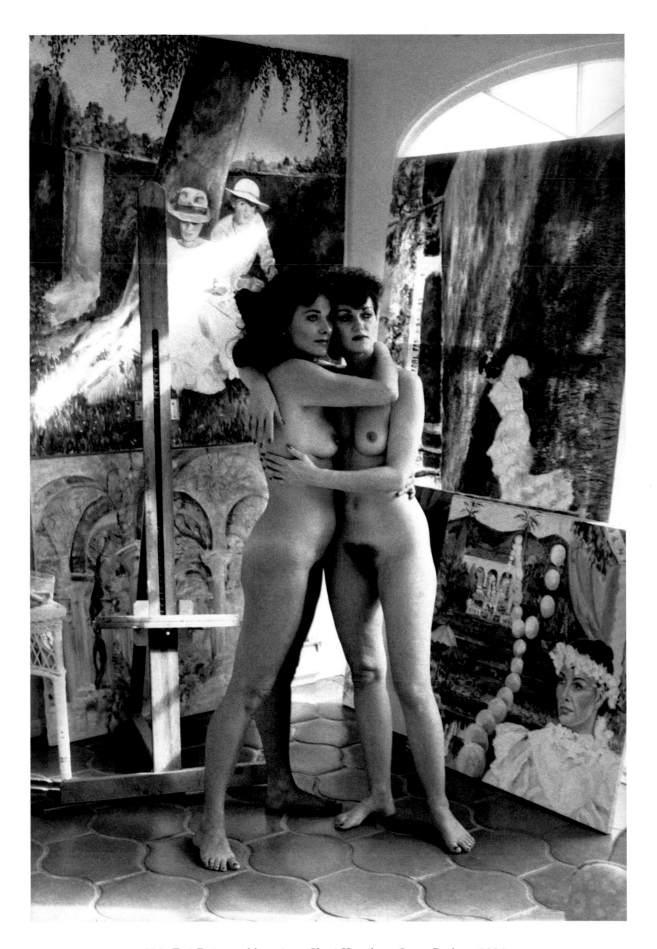

110. Teri Rojas and her sister Cheri Hamilton, Santa Barbara 1984.

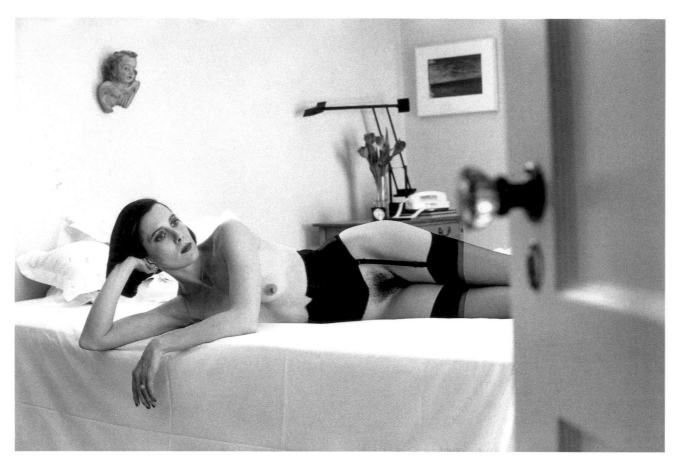

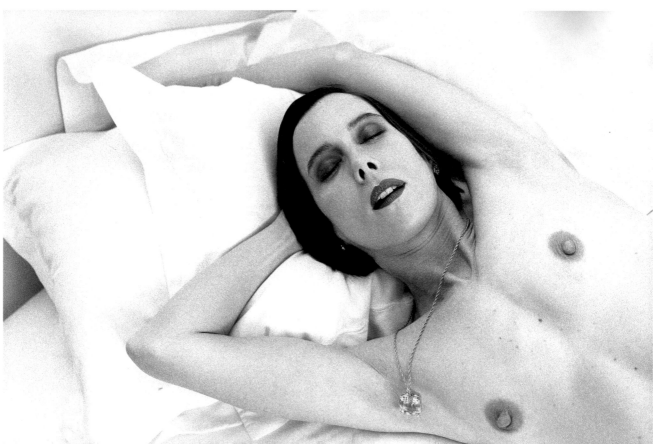

111.–112. Lisa Kitchen, Santa Monica 1984.

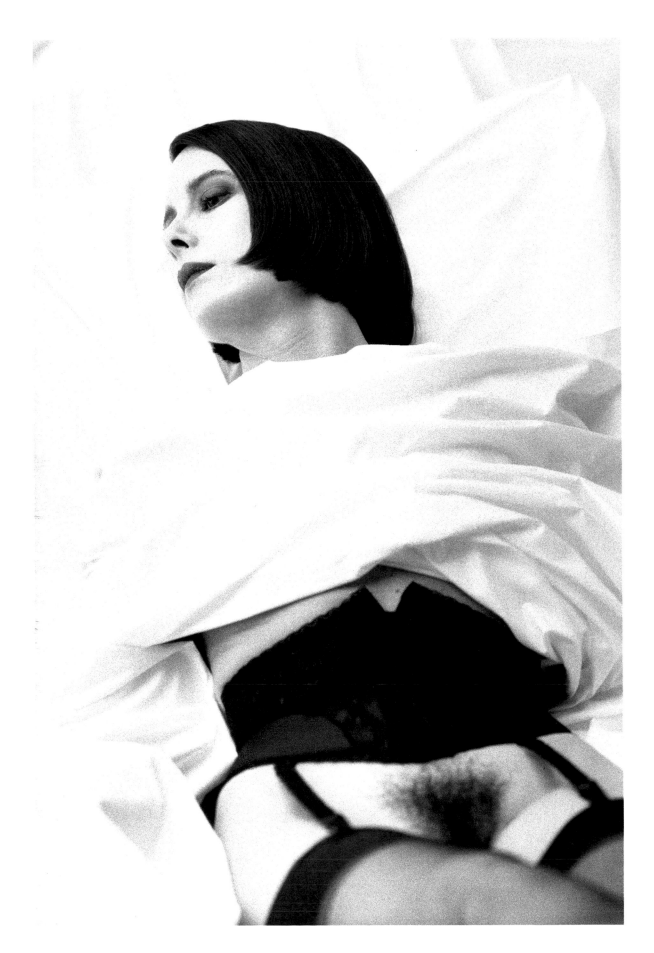

113. Lisa Kitchen, Santa Monica 1984.

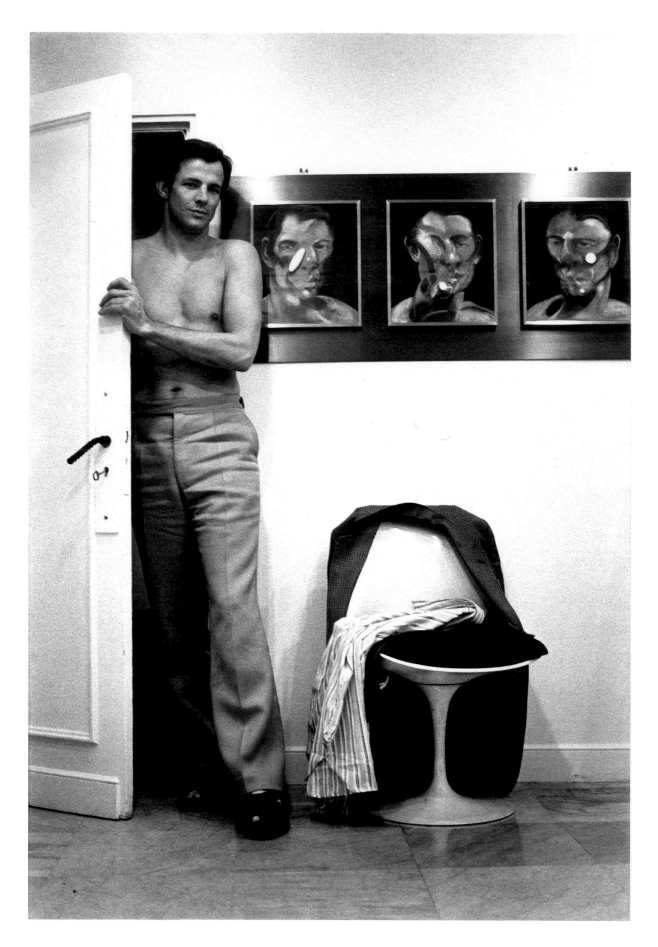

114. Peter Beard with his portrait by Francis Bacon, Paris 1976.

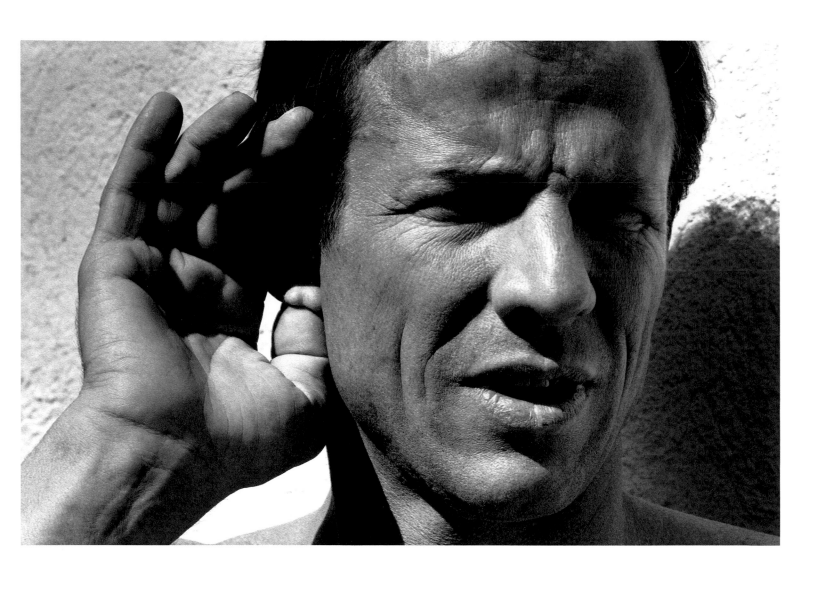

115. Peter Beard, Hollywood 1984.

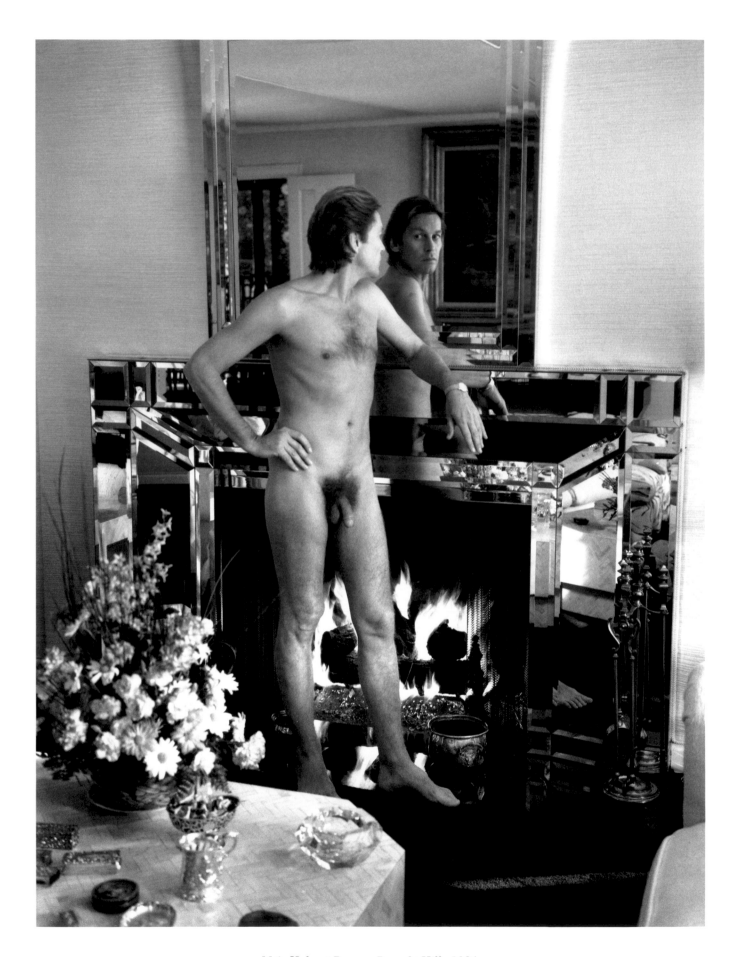

116. Helmut Berger, Beverly Hills 1984.

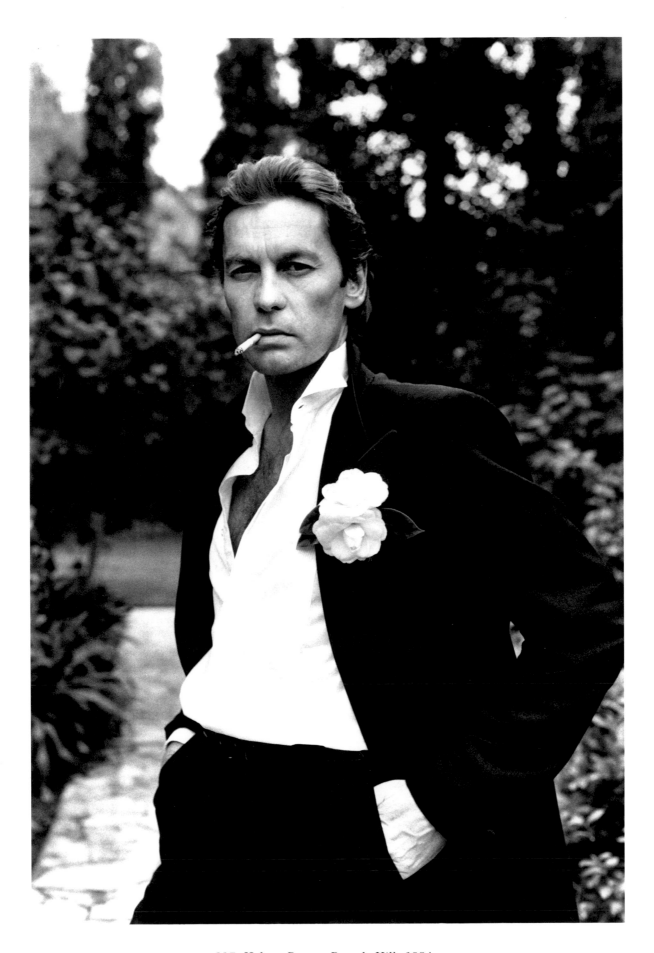

117. Helmut Berger, Beverly Hills 1984.

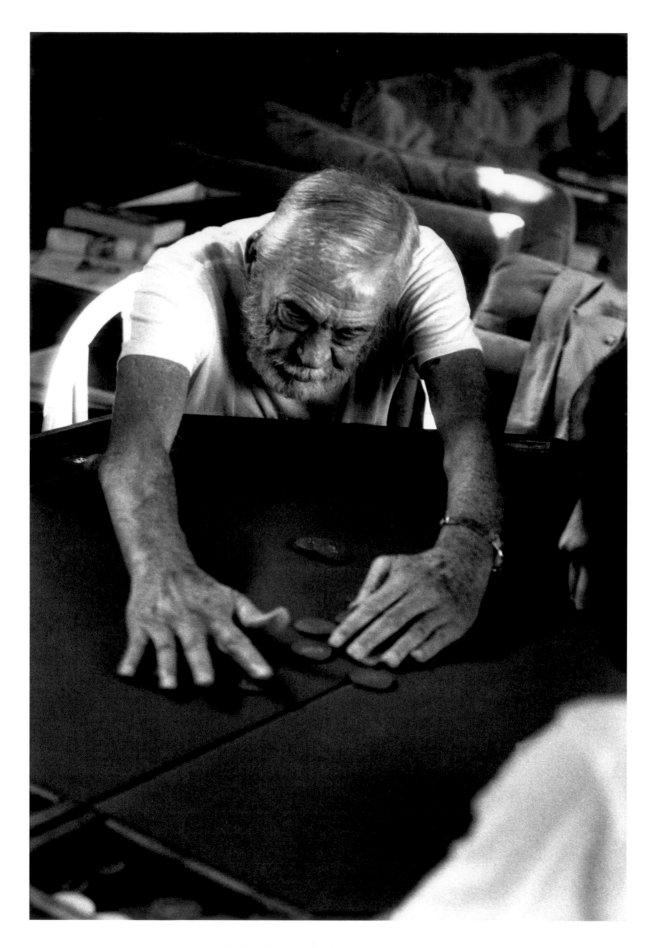

118. John Huston, Los Angeles 1984.

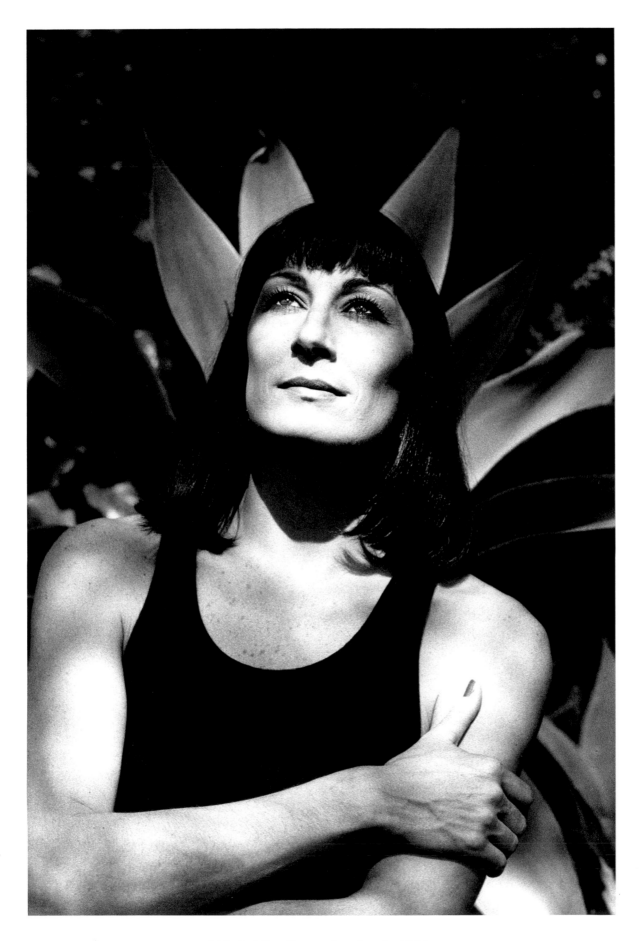

119. Anjelica Huston, Los Angeles 1986.

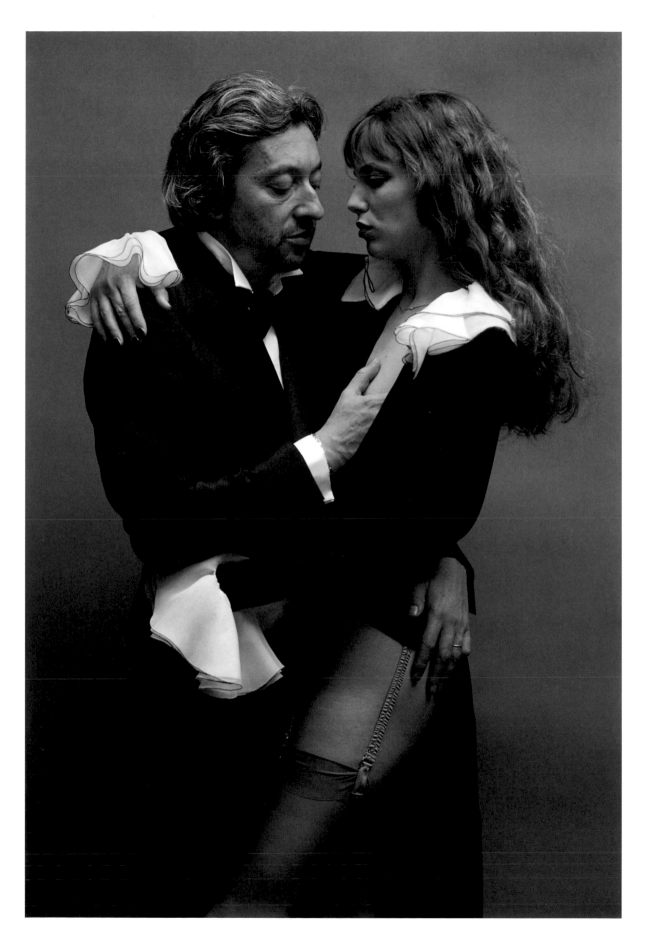

120. Serge Gainsbourg and Jane Birkin, Paris 1978.

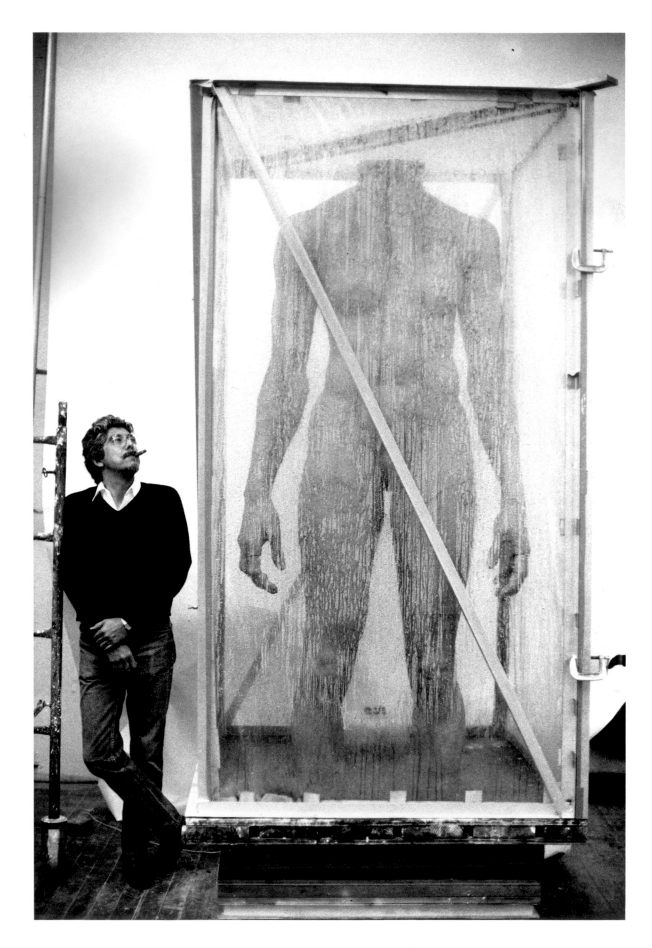

121. The sculptor Robert Graham, Venice, California 1984.

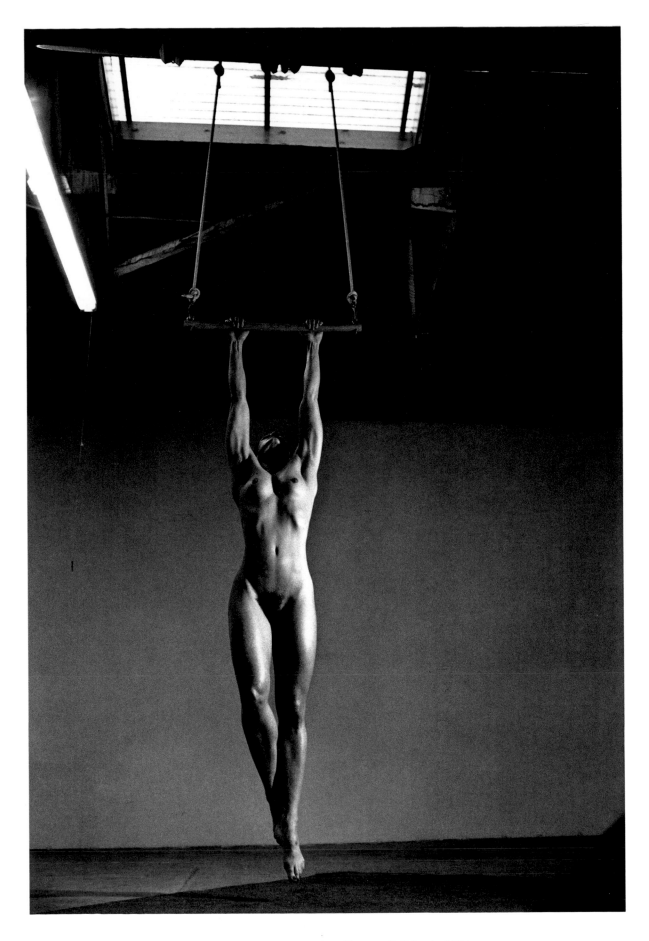

122. Lisa Lyon in her studio, Venice, California 1981.

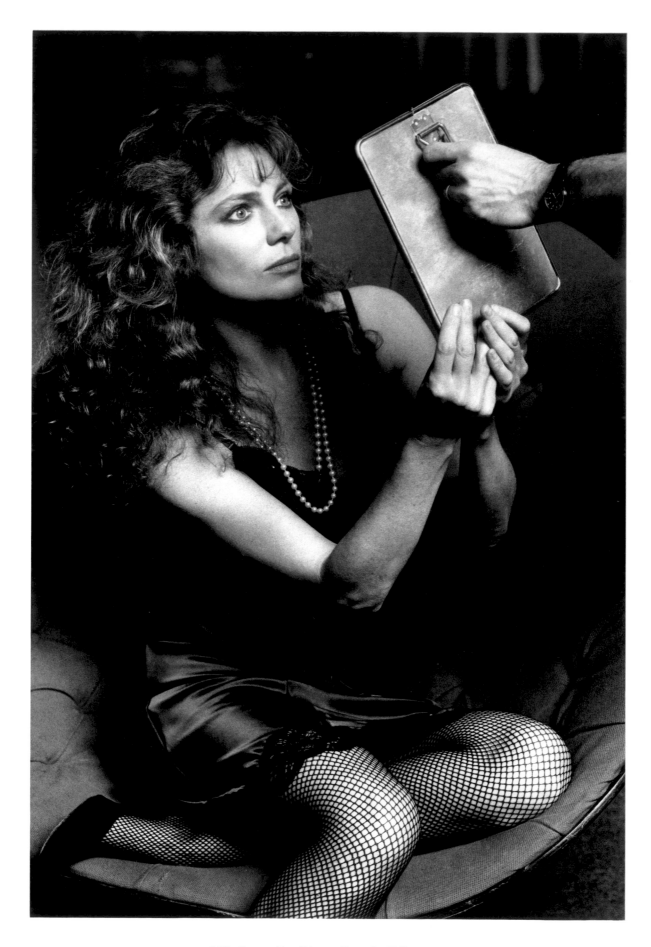

123. Jacqueline Bisset, Beverly Hills 1984.

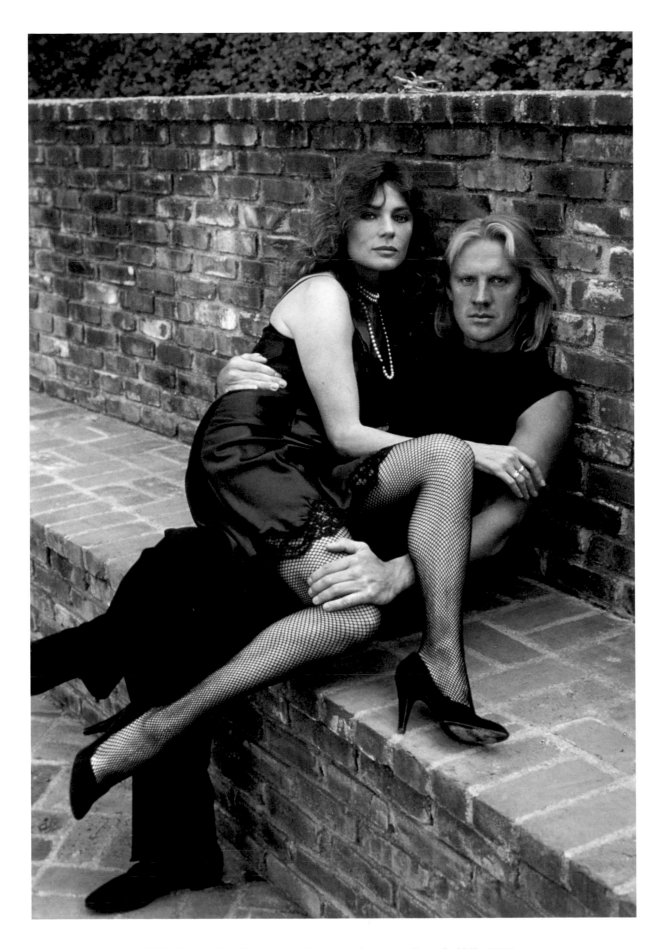

124. Jacqueline Bisset and Alexander Godunov, Beverly Hills 1985.

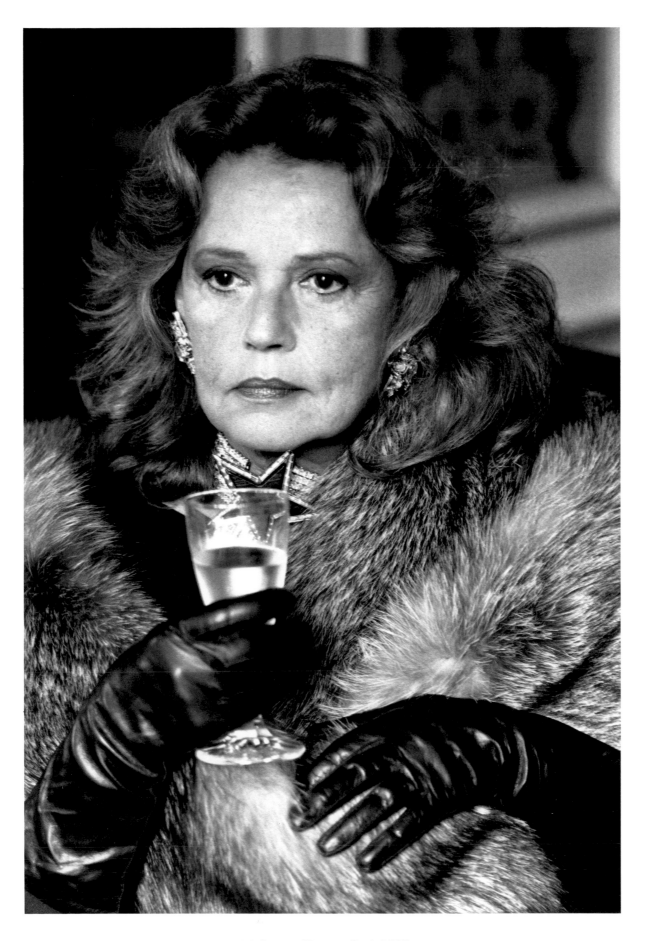

125. Jeanne Moreau, Paris 1985.

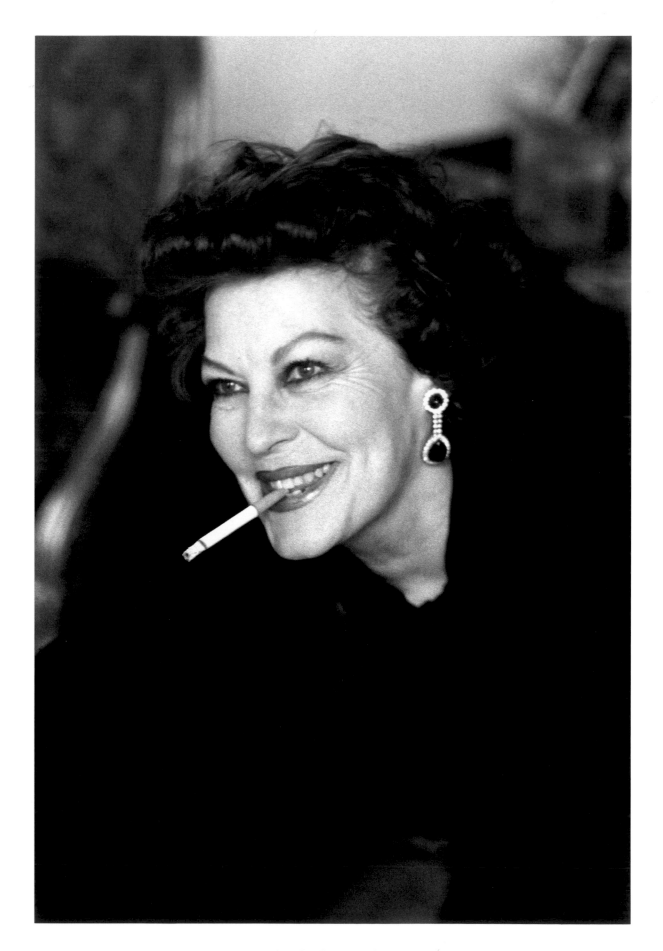

126. Ava Gardner, London 1984.

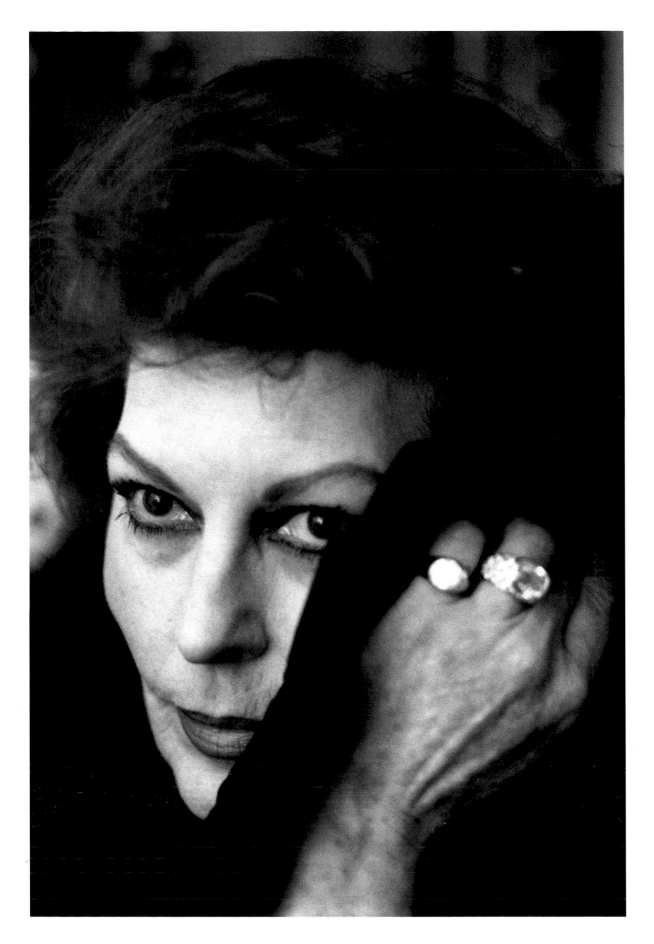

127. Ava Gardner, London 1984.

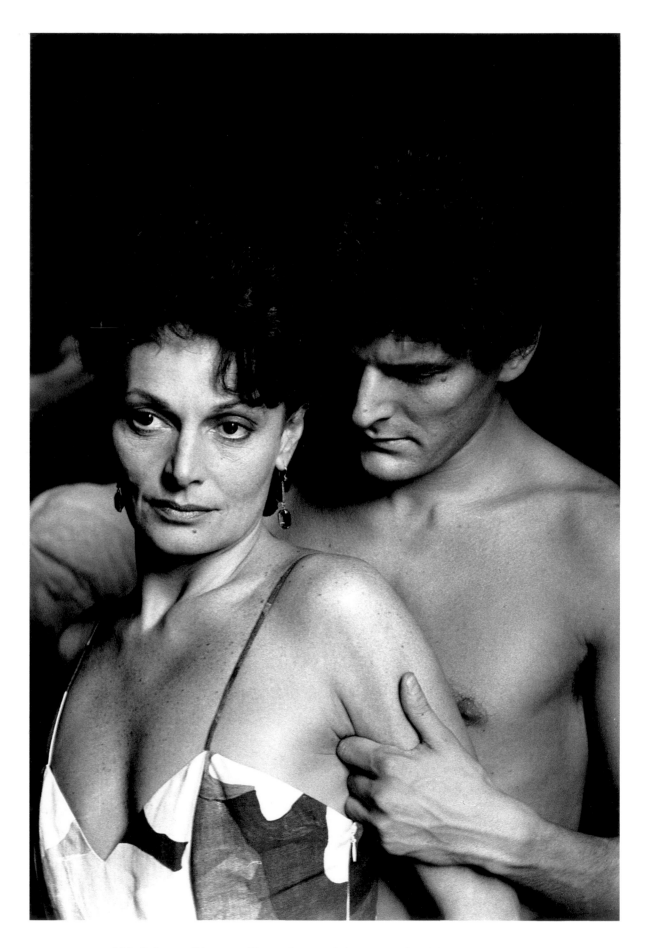

128. Princess Diane von Fürstenberg and the writer Alain Elkann, Nice 1984.

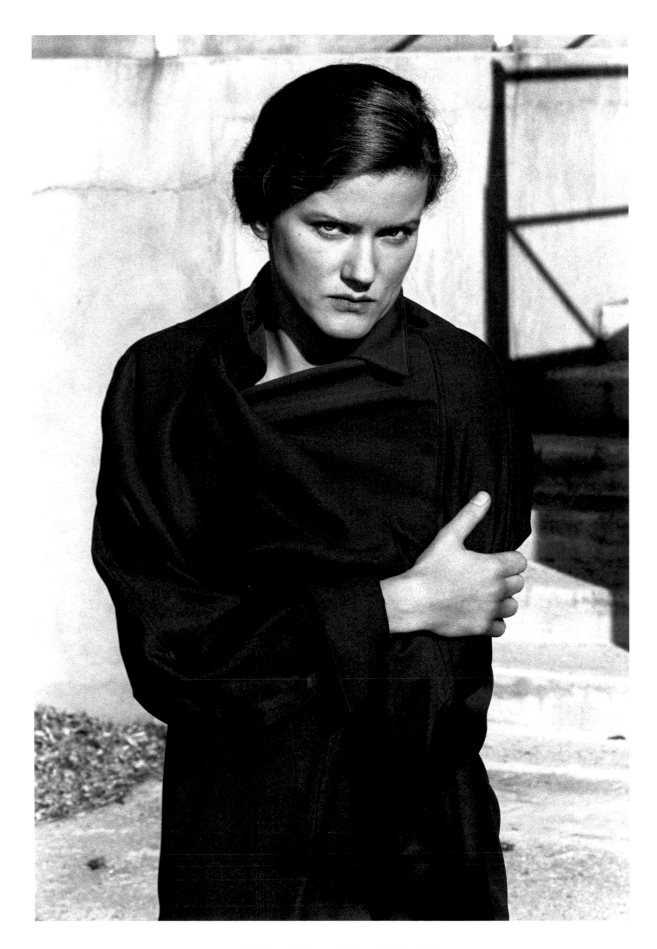

129. Barbara Sukowa, Monte Carlo 1985.

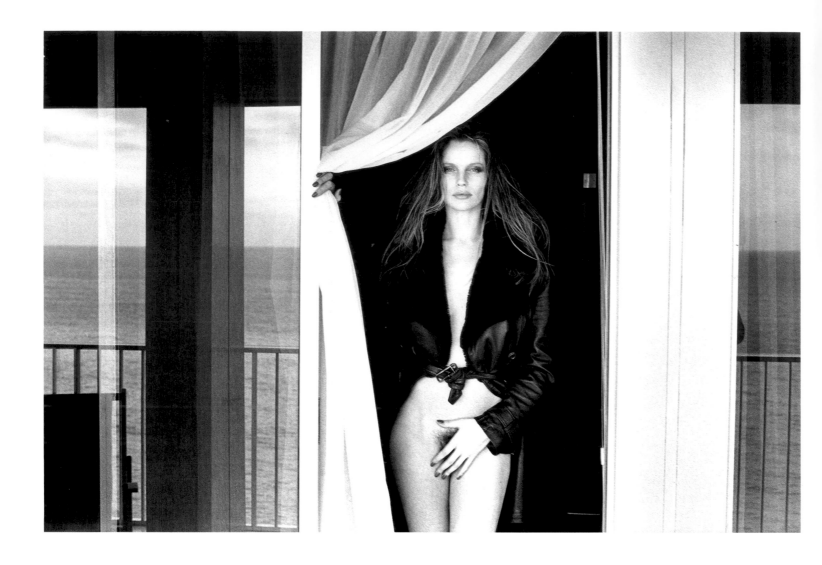

130. Veroushka, Nice 1975.

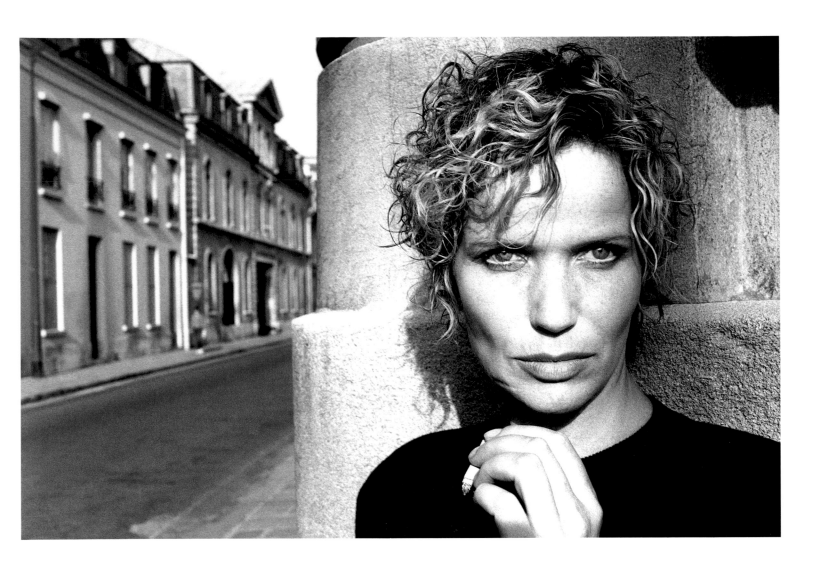

131. Veroushka, Paris 1984.

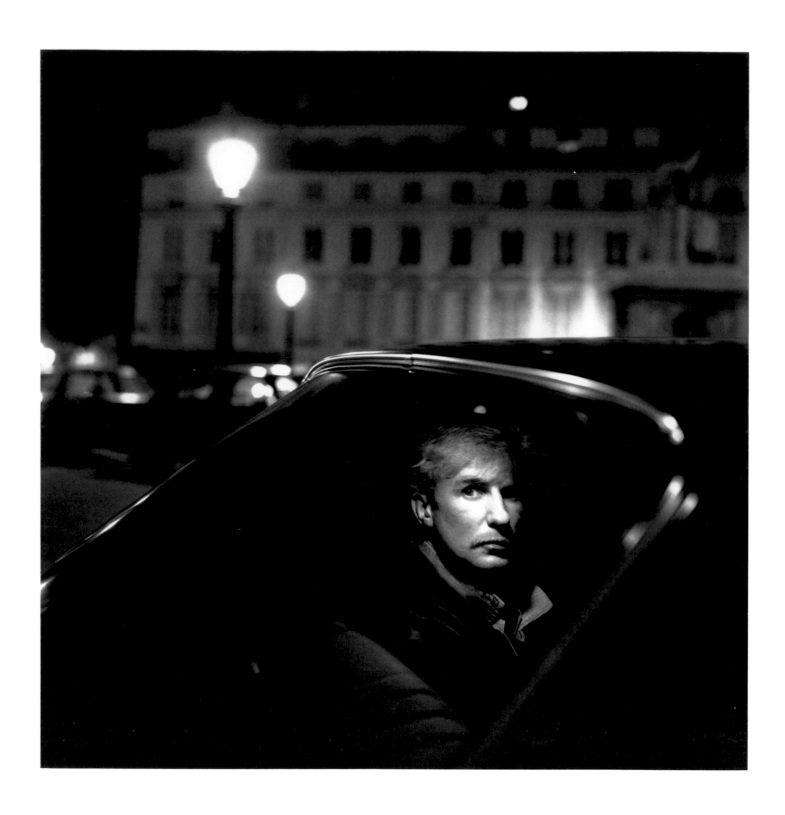

132. Claude Montana, Paris 1982.

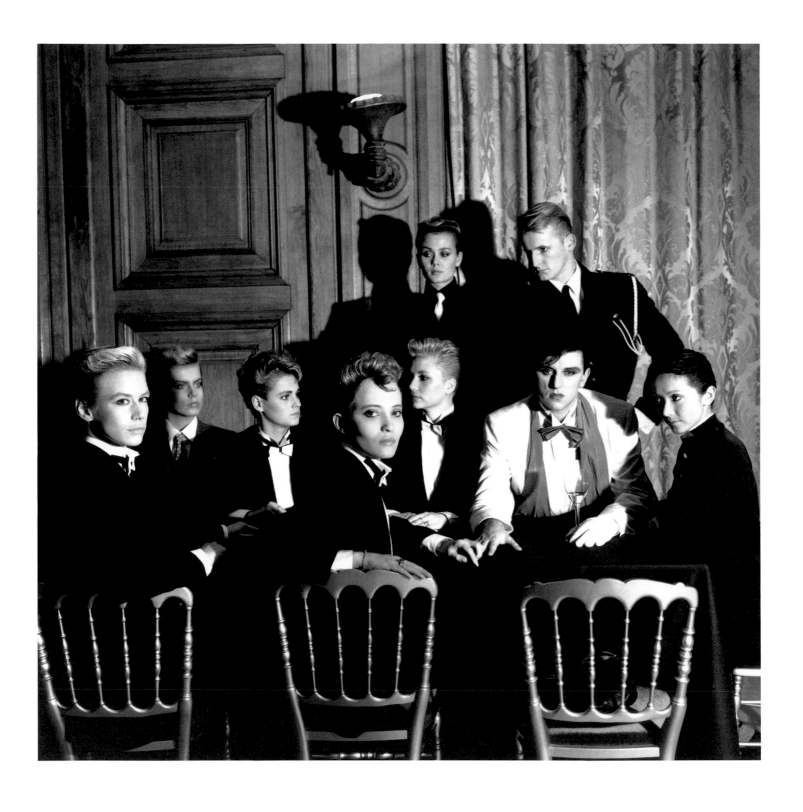

133. Steve Strange, friends, and bodyguard, Paris 1982.

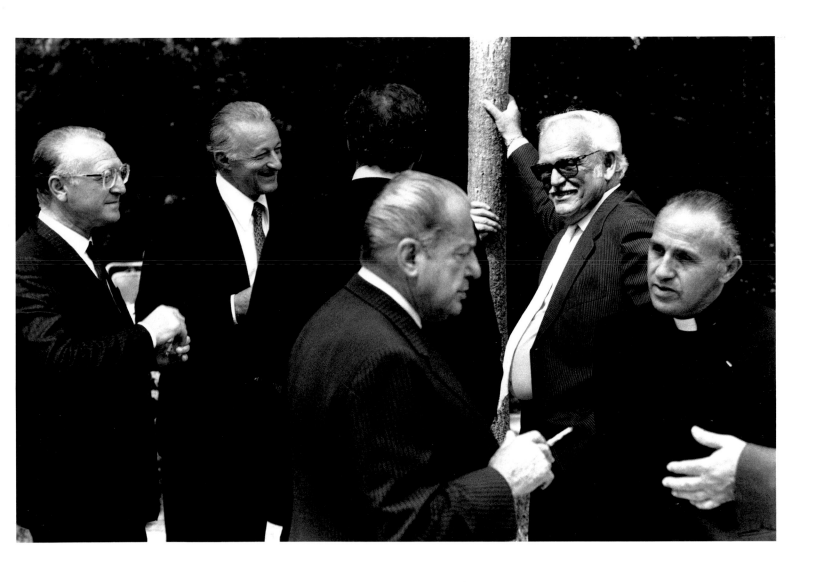

134. Prince Rainier of Monaco with close friends, Monte Carlo 1984.

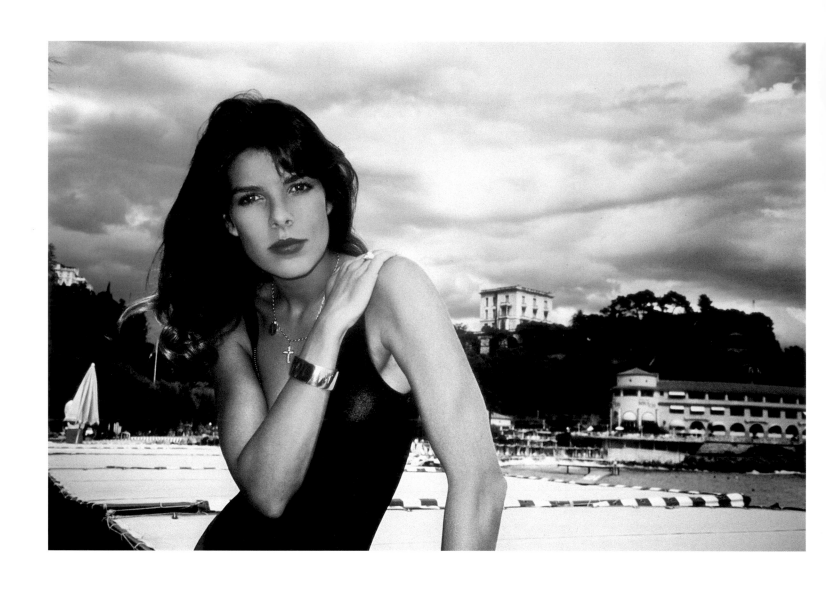

135. Princess Caroline of Monaco, Monte Carlo 1983.

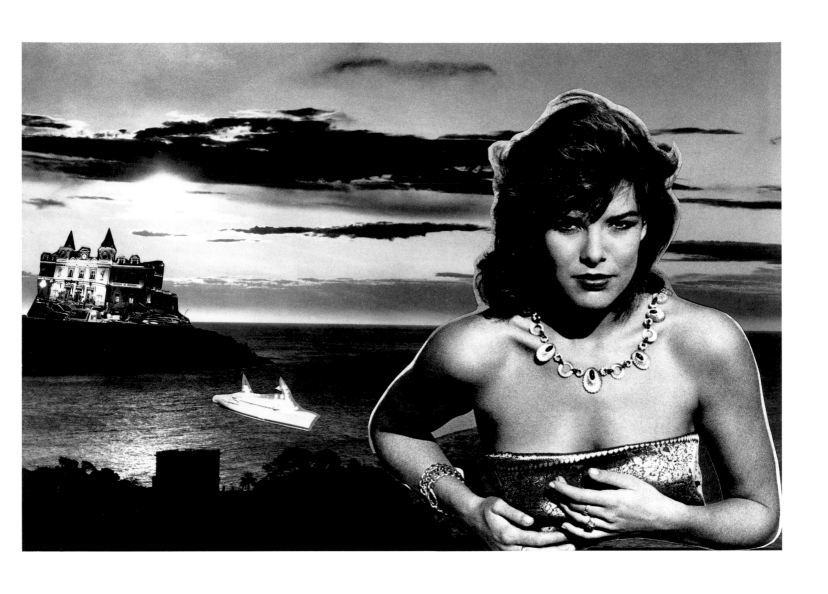

136. Princess Caroline of Monaco, Monte Carlo 1983. Collage.

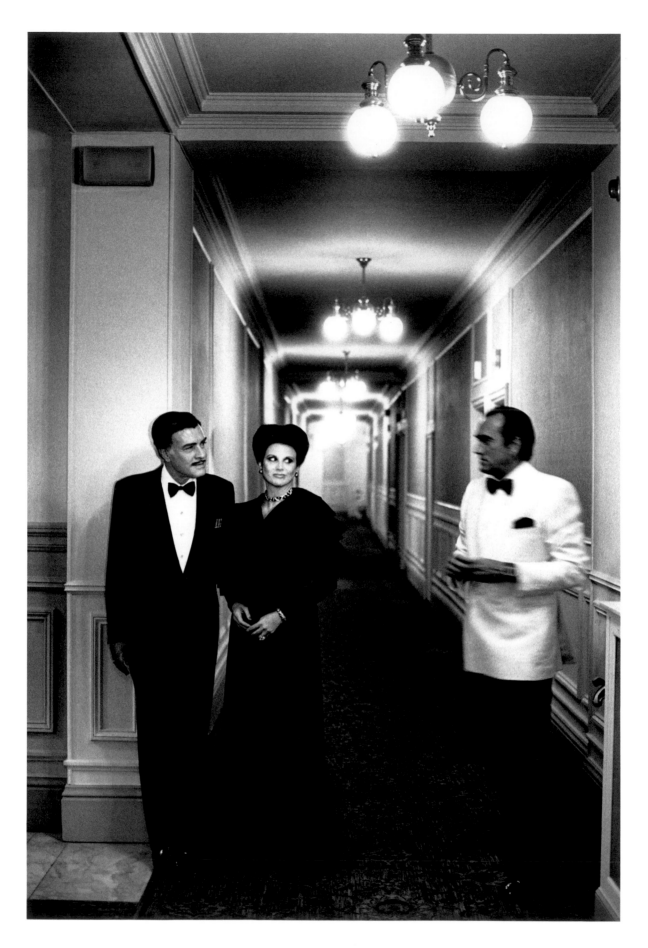

137. Baron and Baroness di Portanova with an unknown guest at the Hotel de Paris, Monte Carlo 1984.

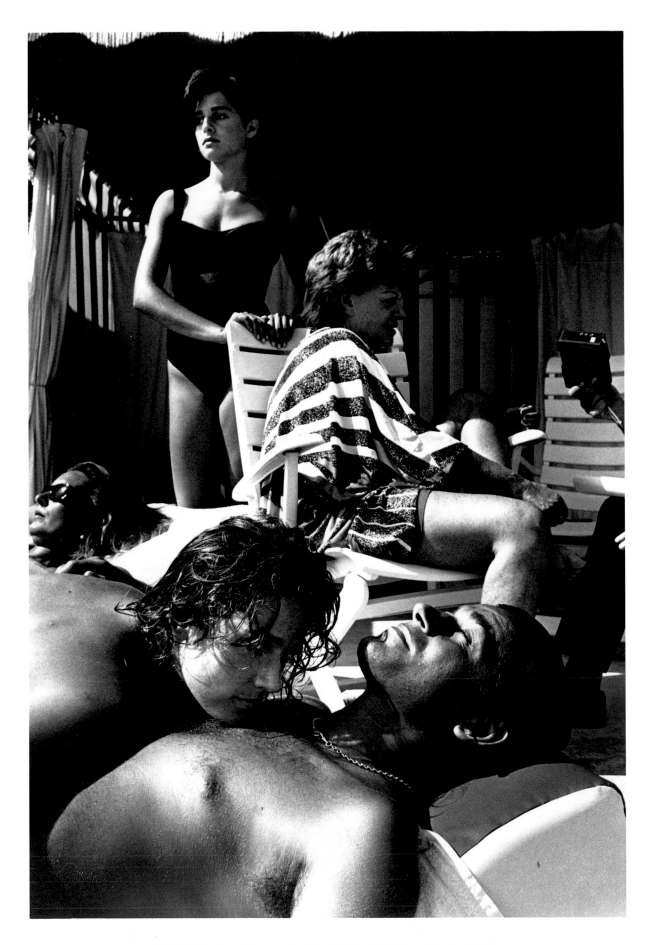

138. Régine's cabana at the Beach Hotel in Monte Carlo, 1984.

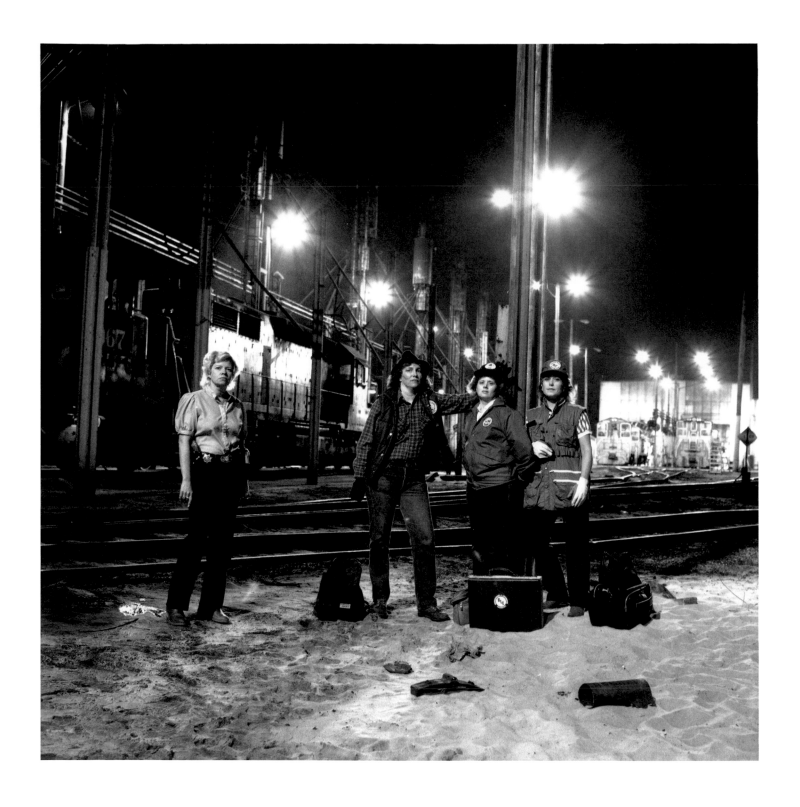

139. Female train engineers and a policewoman (left), Houston, Texas 1985.

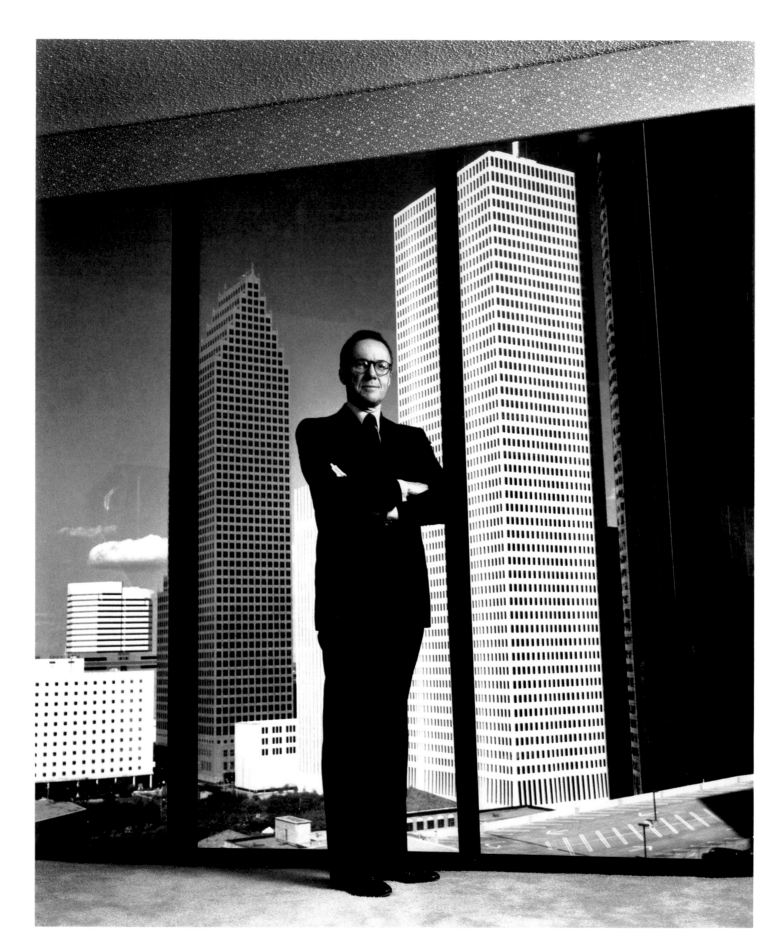

140. Gerald D. Hines, Houston 1985.

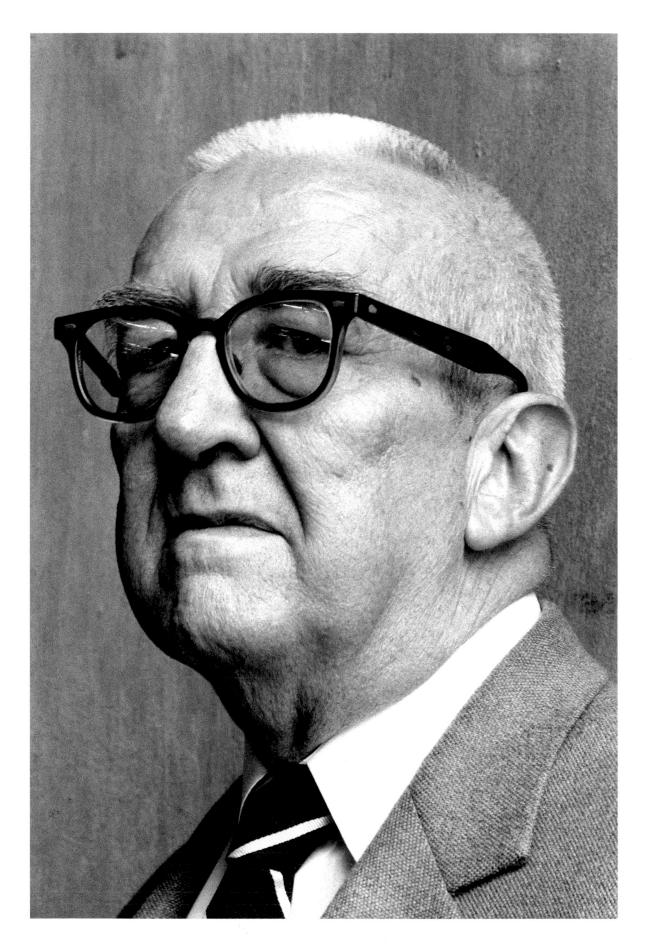

141. H. R. "Bum" Bright, Dallas 1985.

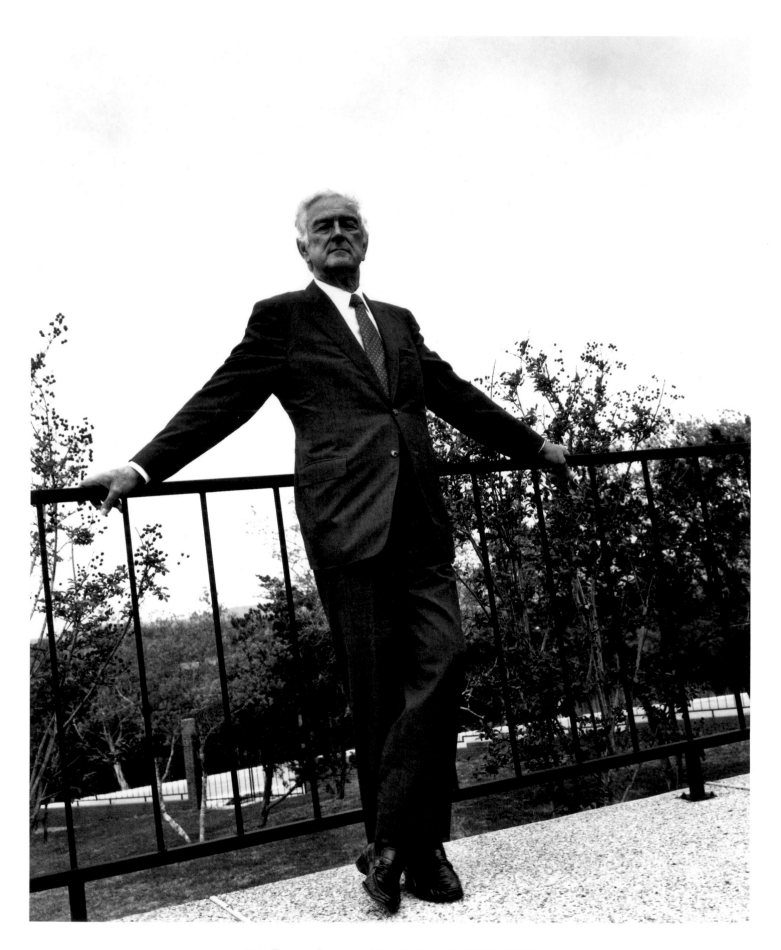

142. Former Governor John B. Connally, Dallas 1985.

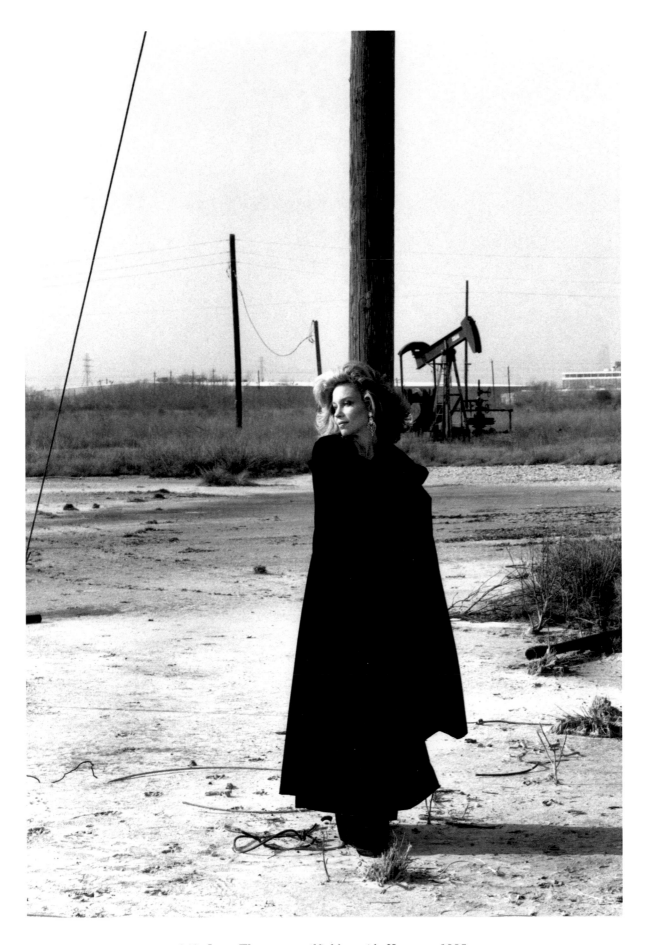

143. Lynn Wyatt at an oilfield outside Houston, 1985.

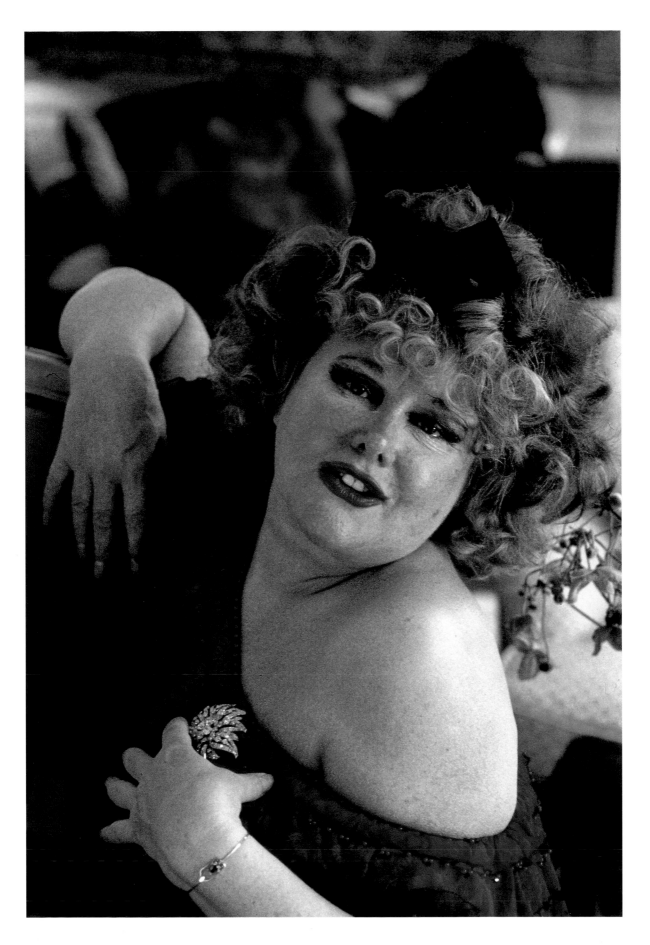

144. Viscountess Patricia Rothermere at her home in London, 1985.

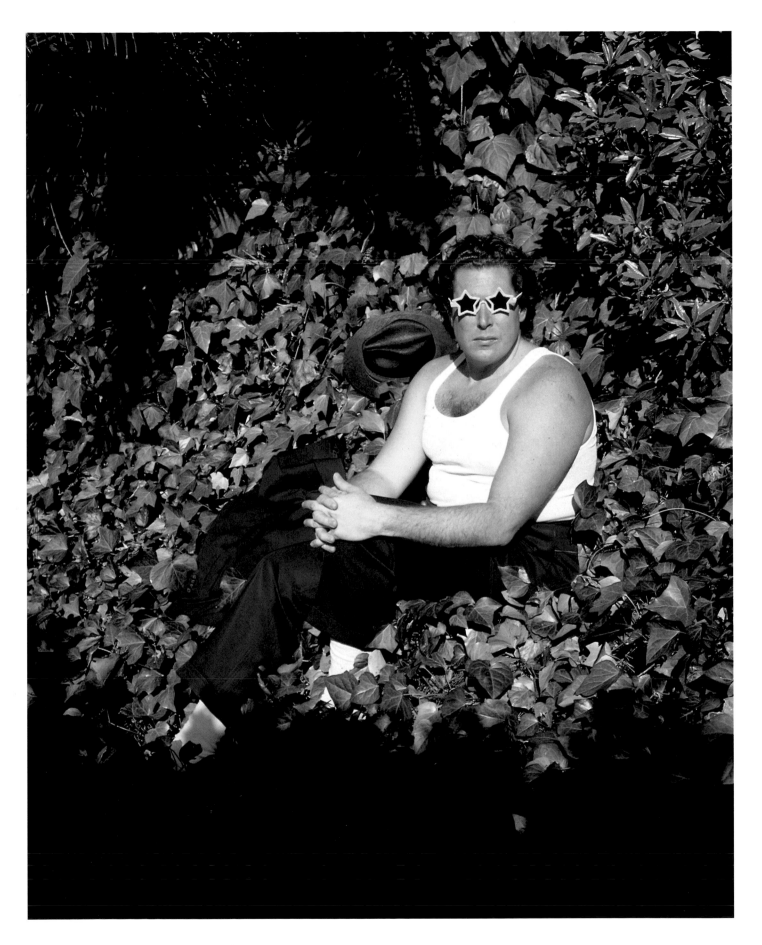

145. Julian Schnabel, Beverly Hills 1985.

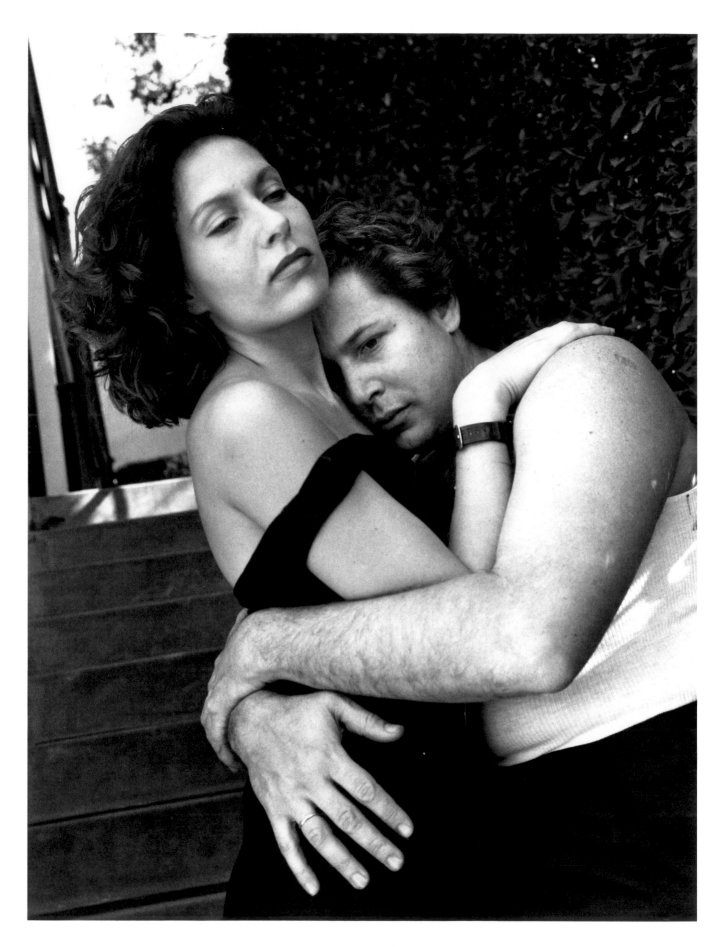

146. The artist Julian Schnabel and his wife Jacqueline, Beverly Hills 1985.

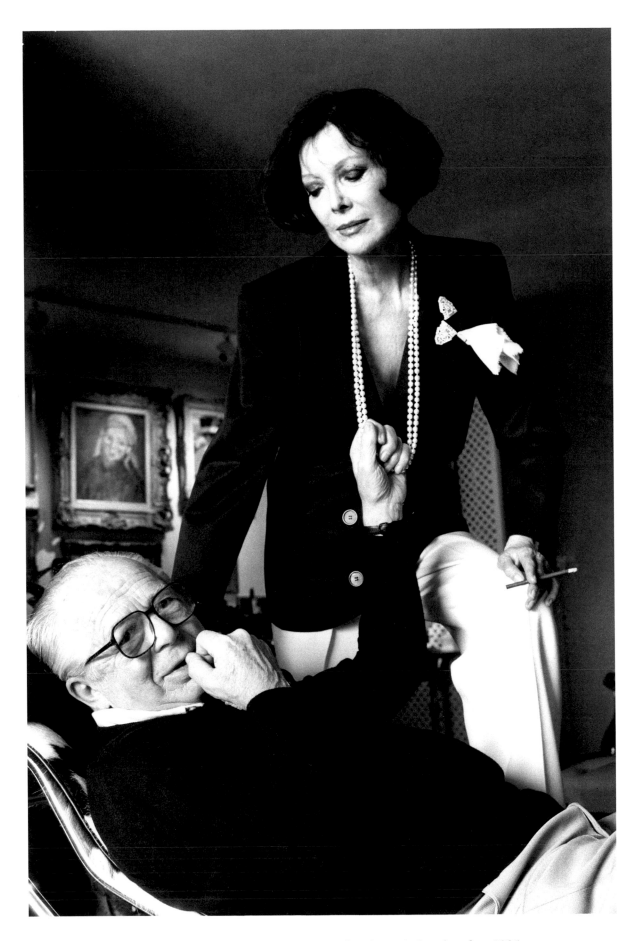

147. Billy Wilder and his wife Audrey at their home in Los Angeles, 1985.

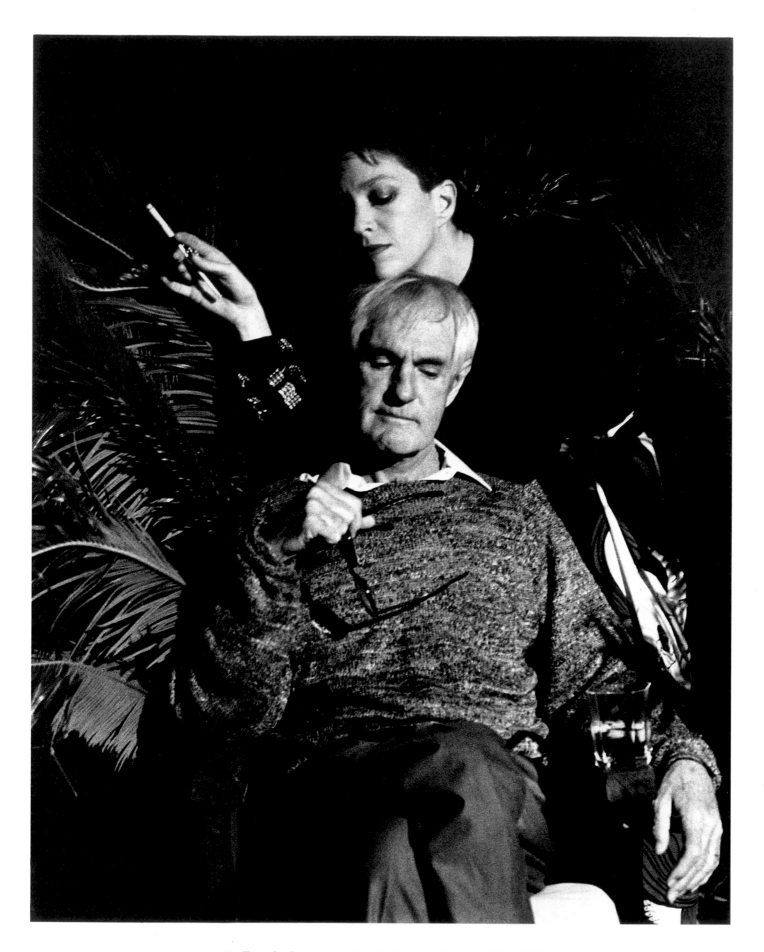

148. Timothy Leary and his wife Barbara, Beverly Hills 1986.

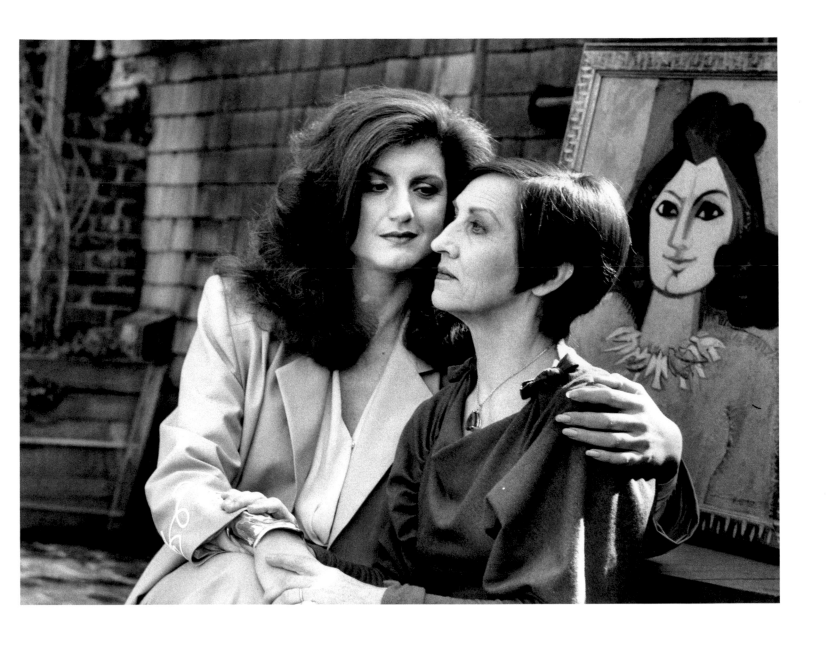

149. The writer Anna Stassinopoulos (left) and Françoise Gilot-Salk, Paloma Picasso's mother, Los Angeles 1985.

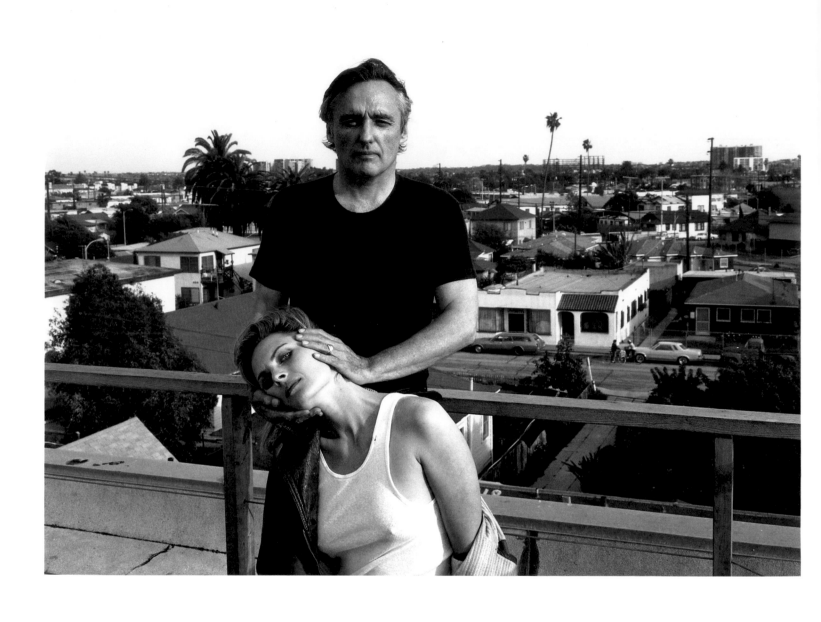

150. Dennis Hopper and Denise Crosby, granddaughter of Bing Crosby, at Hopper's studio in Venice, California 1985.

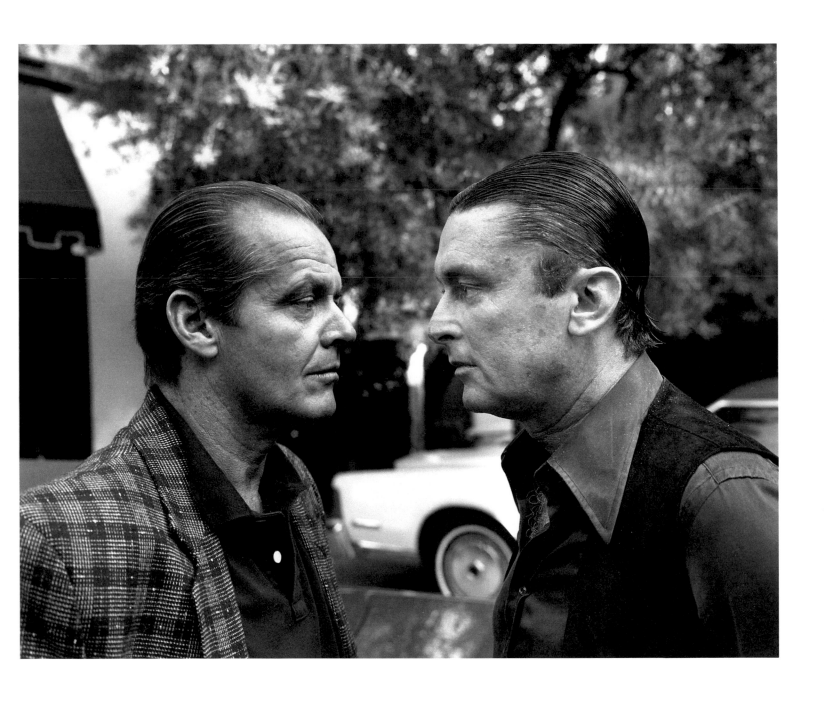

151. Jack Nicholson and Robert Evans, Los Angeles 1985.

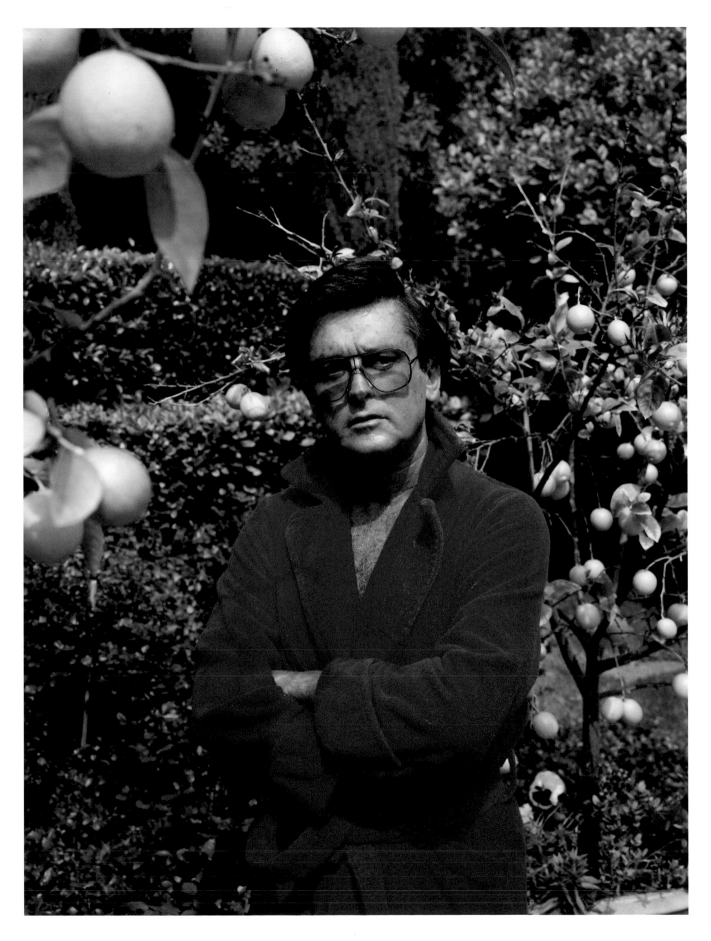

152. Robert Evans in his garden in Beverly Hills, 1985.

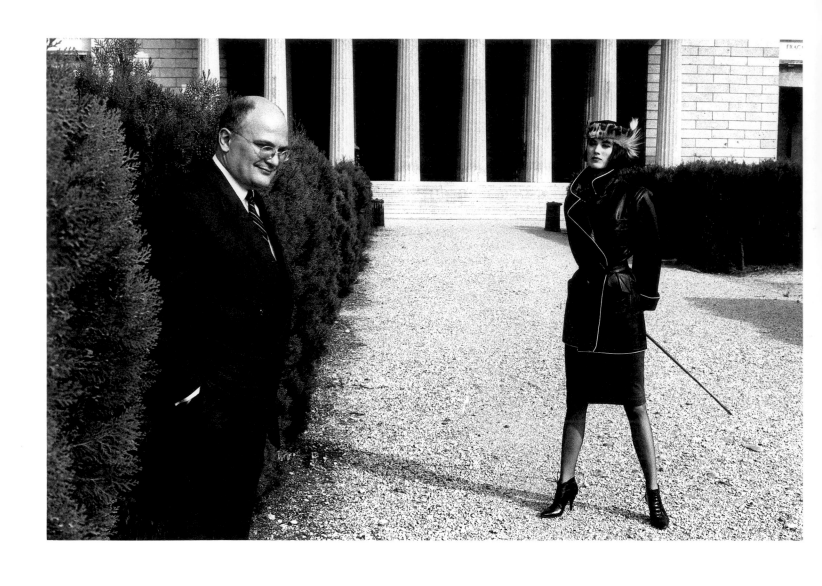

153. Xavier Moreau and his wife, Verona 1984.

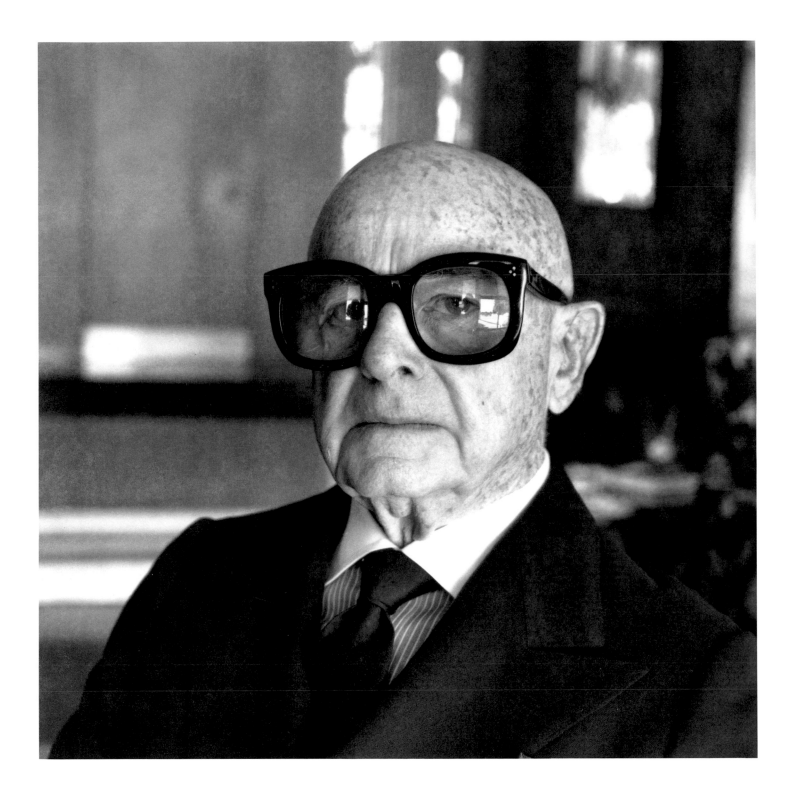

154. Irving "Swifty" Lazar, Beverly Hills 1986.

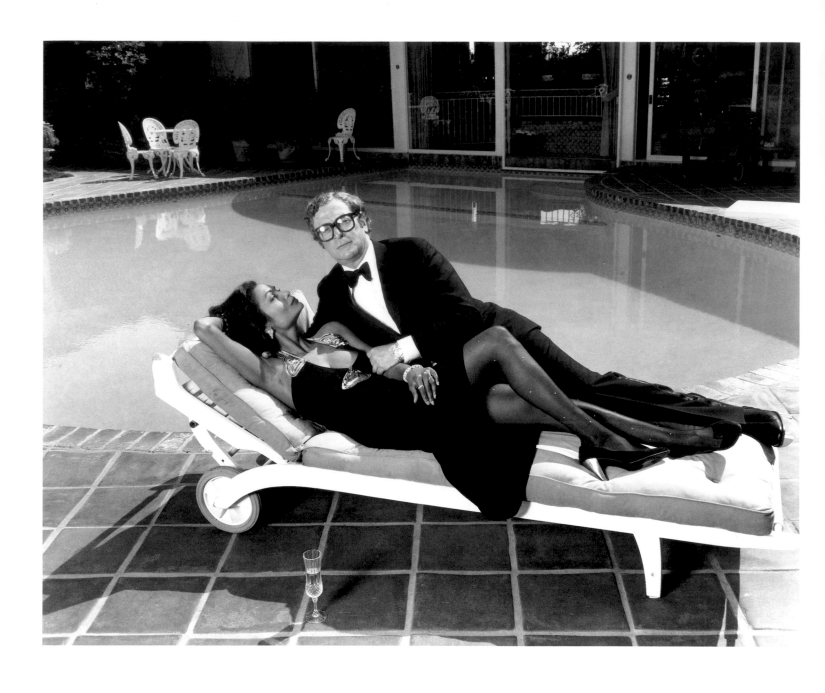

155. Michael Caine and his wife Shakira at their home in Beverly Hills, 1985.

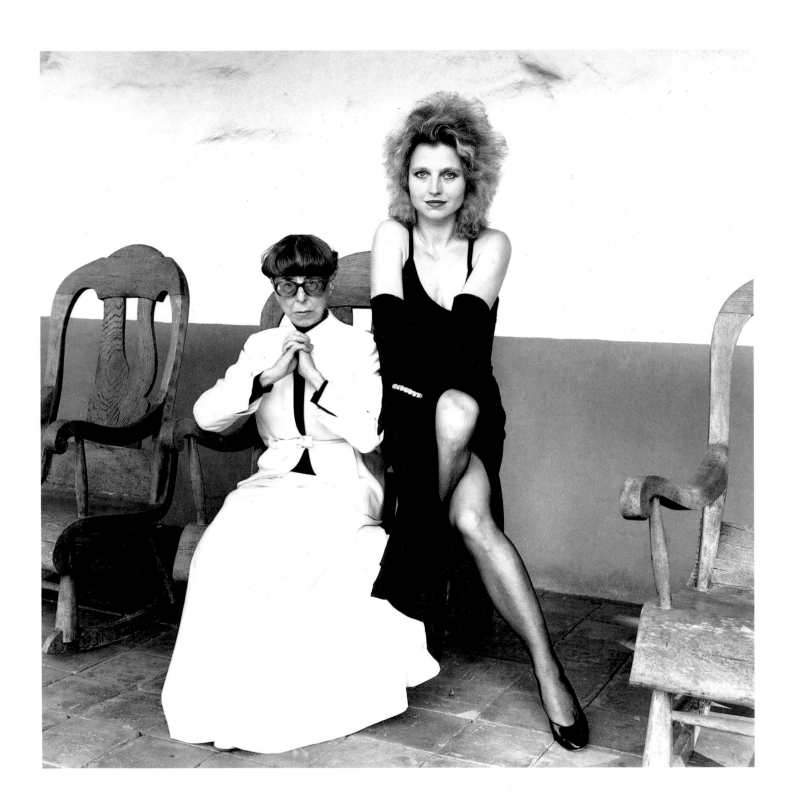

156. Hanna Schygulla and costume designer Edith Head, Los Angeles 1980.

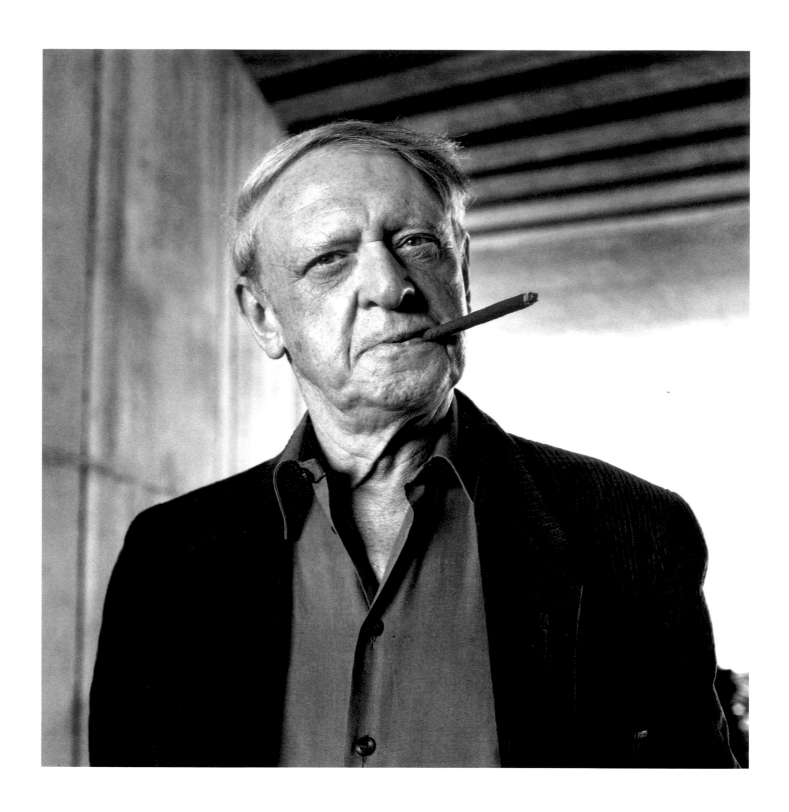

157. Anthony Burgess, Monte Carlo 1985.

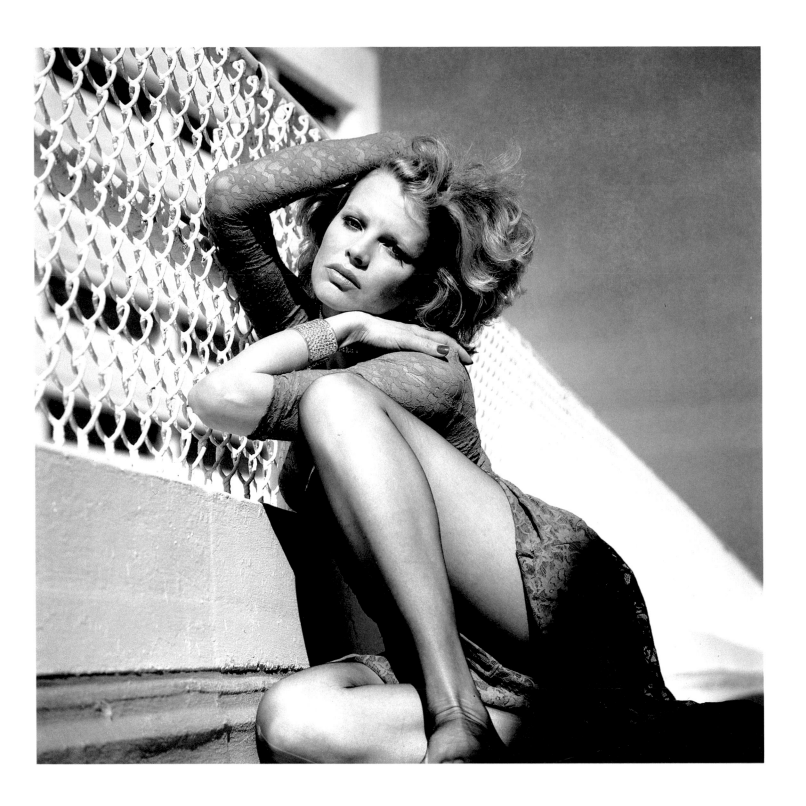

158. Kim Basinger, Santa Monica 1986.

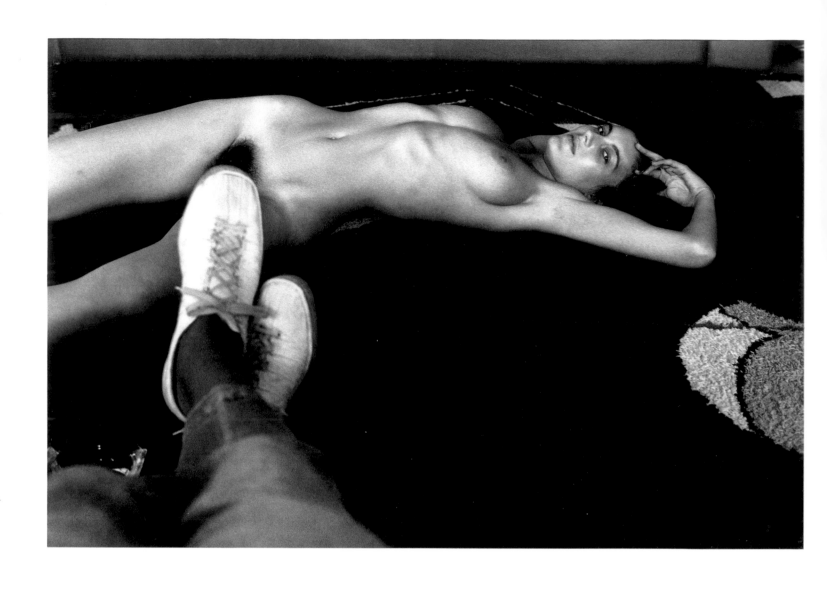

159. Arielle in my apartment, Monte Carlo 1983.

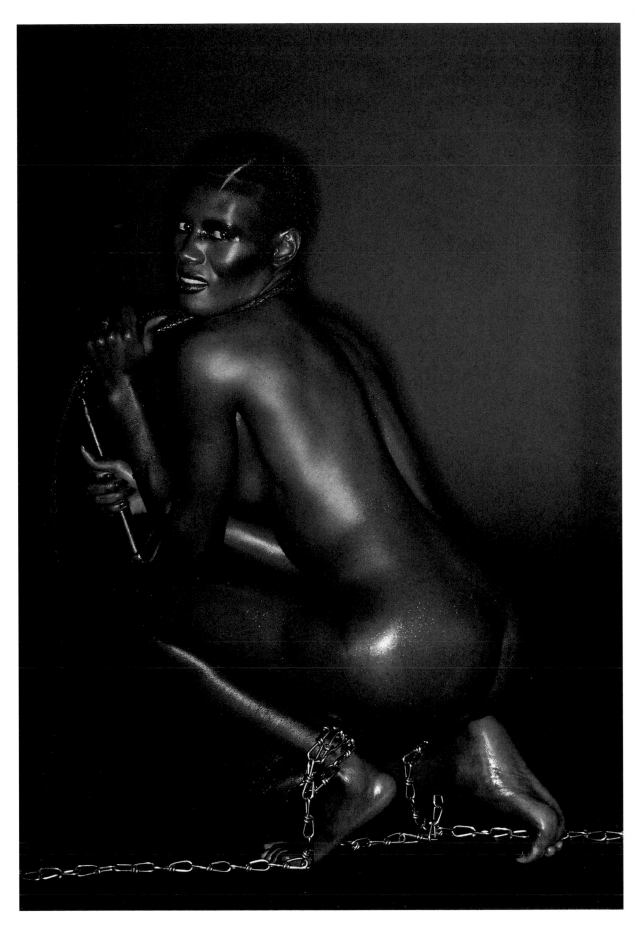

160. Grace Jones, Paris 1978.

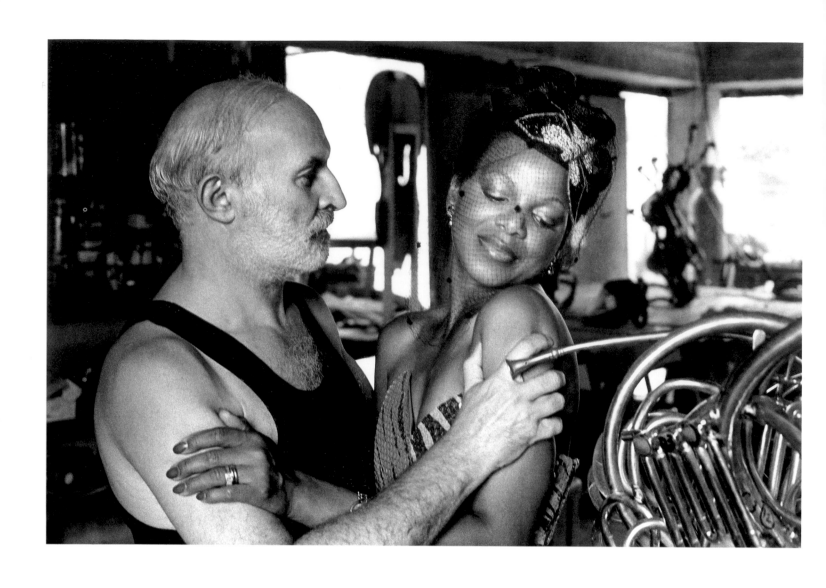

161. The artist Arman and his wife Corise, Vence 1985.

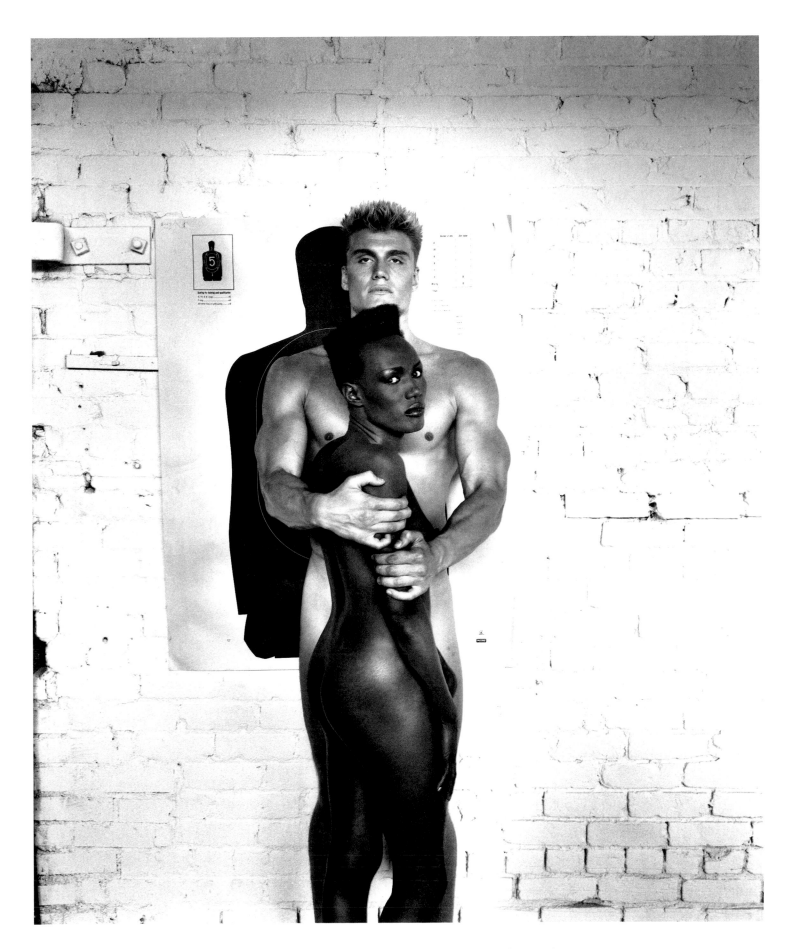

162. Grace Jones and Dolph Lundgren, Los Angeles 1985.

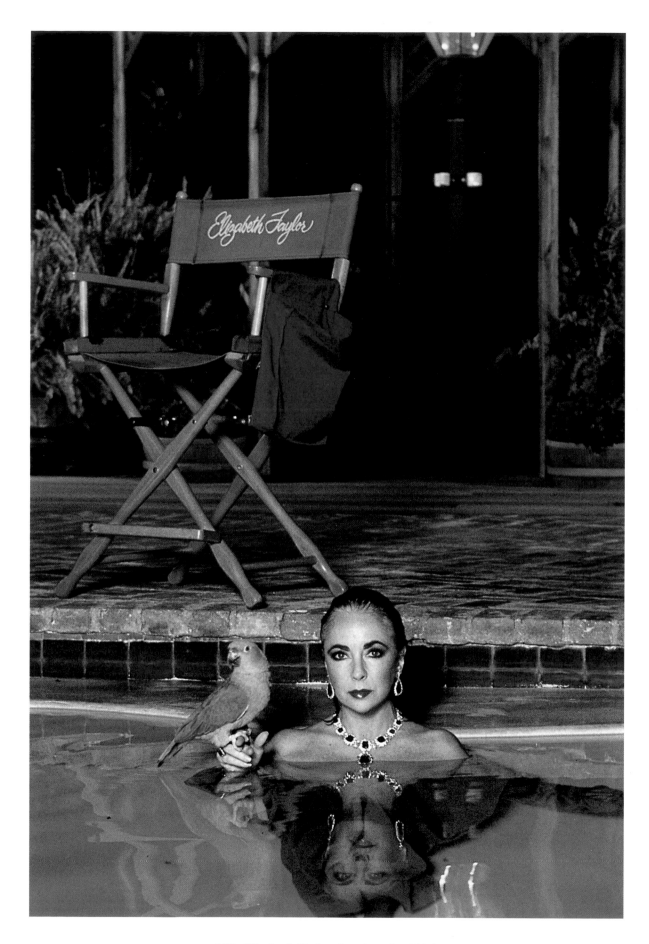

163. Elizabeth Taylor, Los Angeles 1985.

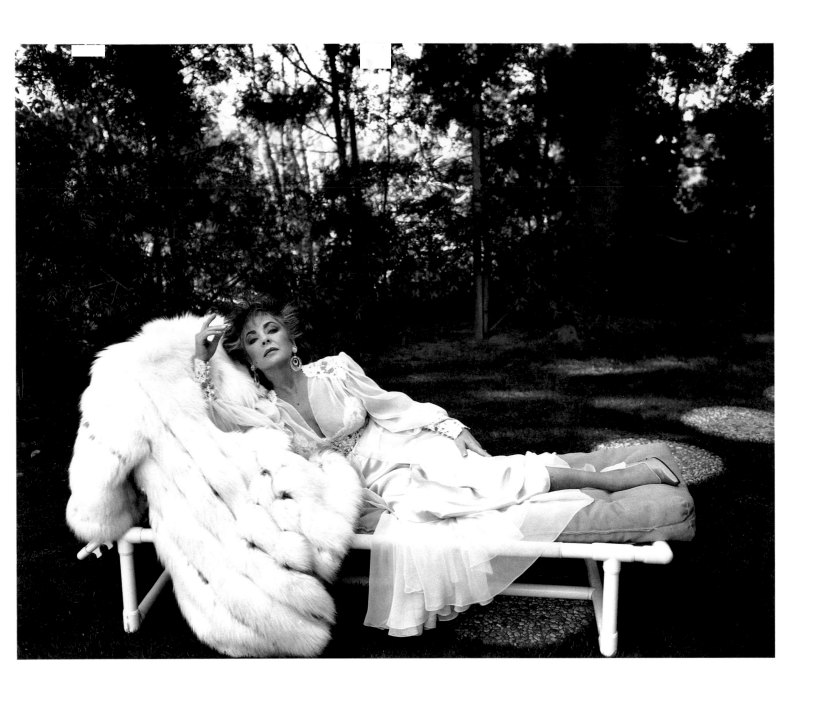

164. Elizabeth Taylor, Los Angeles 1985.

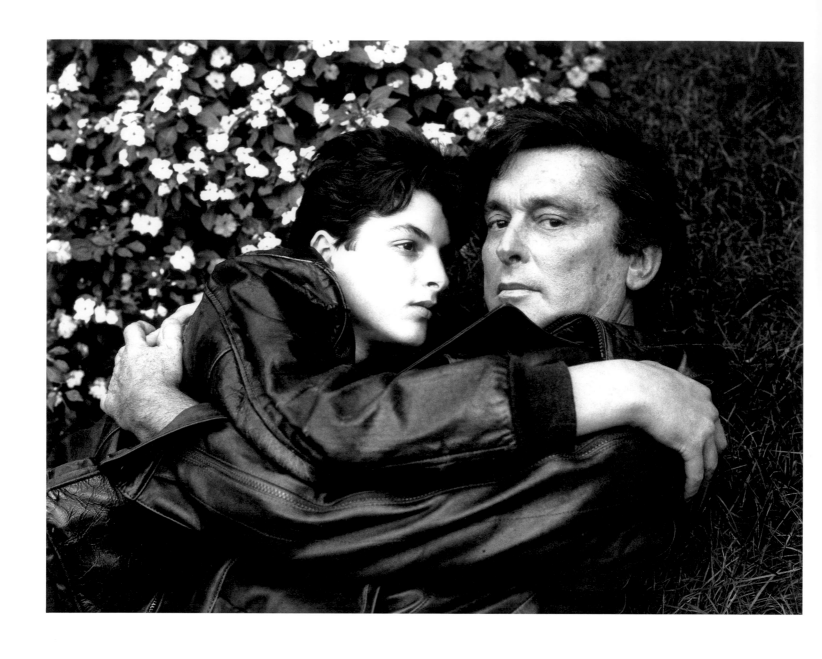

165. Robert Evans and his son Joshua, Beverly Hills 1986.

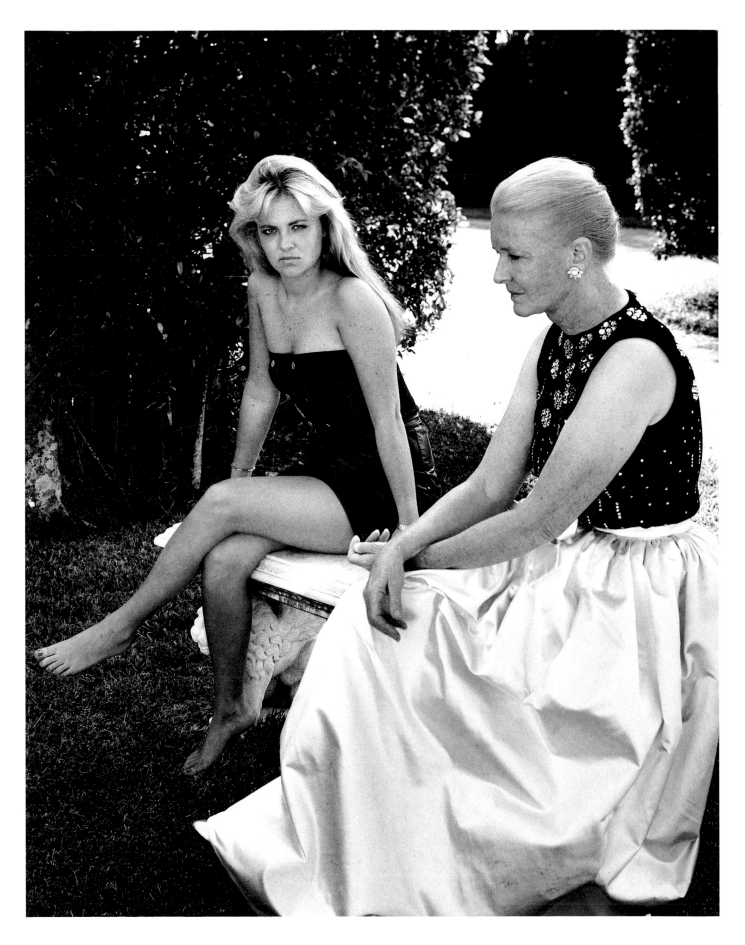

166. Mrs. Winston Guest and her daughter Cornelia, Palm Beach 1986.

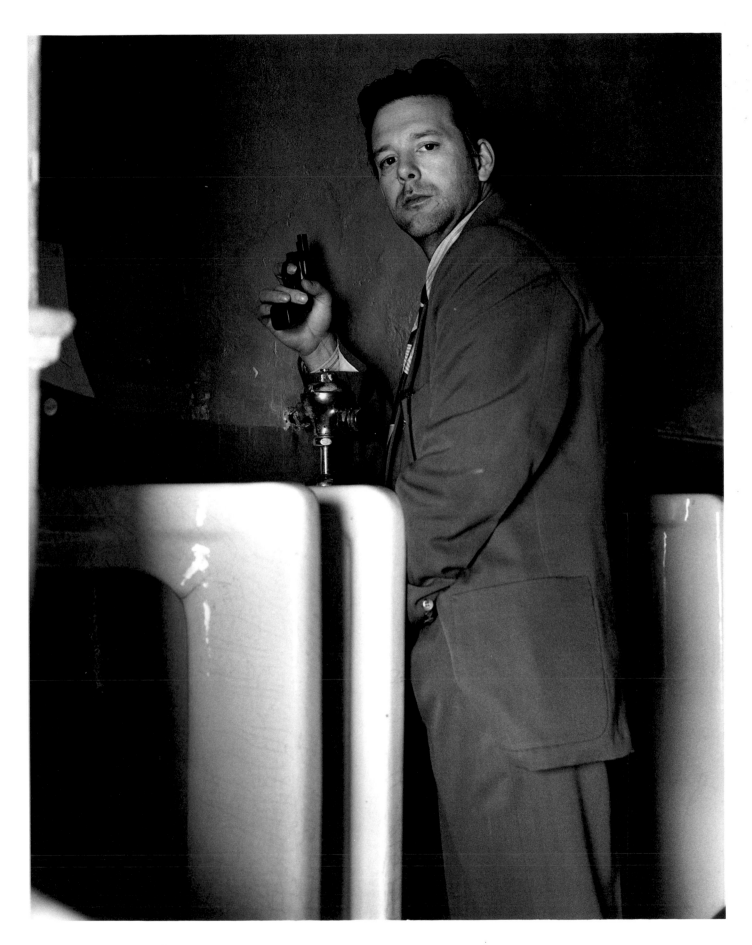

167. Mickey Rourke as private eye Angel Heart, New York 1986.

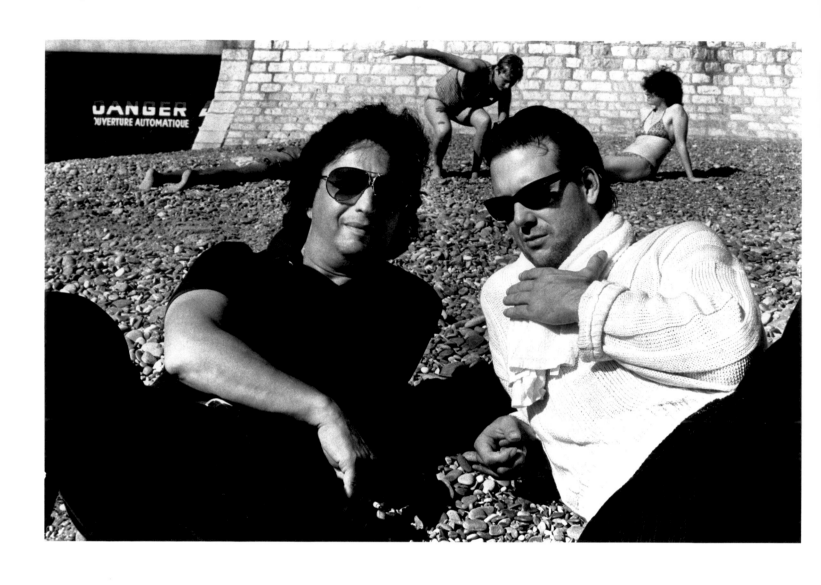

168. Michael Cimino and Mickey Rourke, Nice 1985.

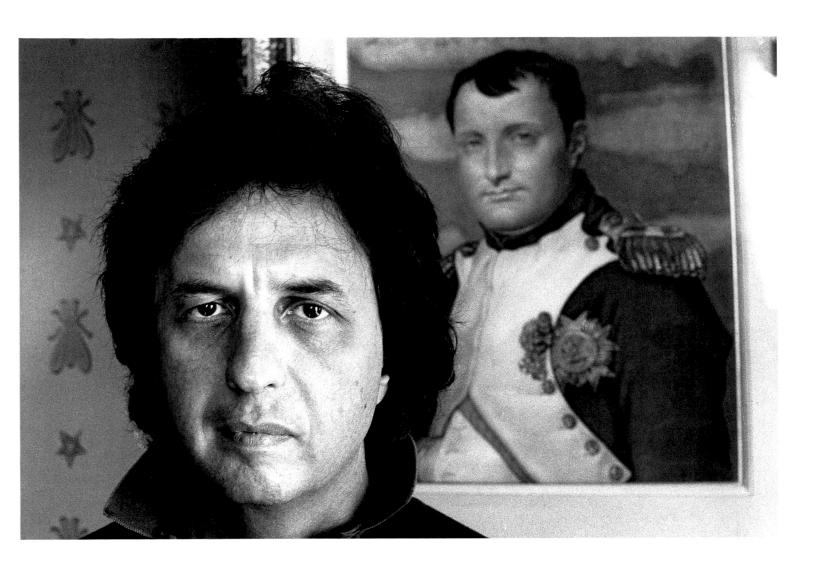

169. Michael Cimino, Nice 1985.

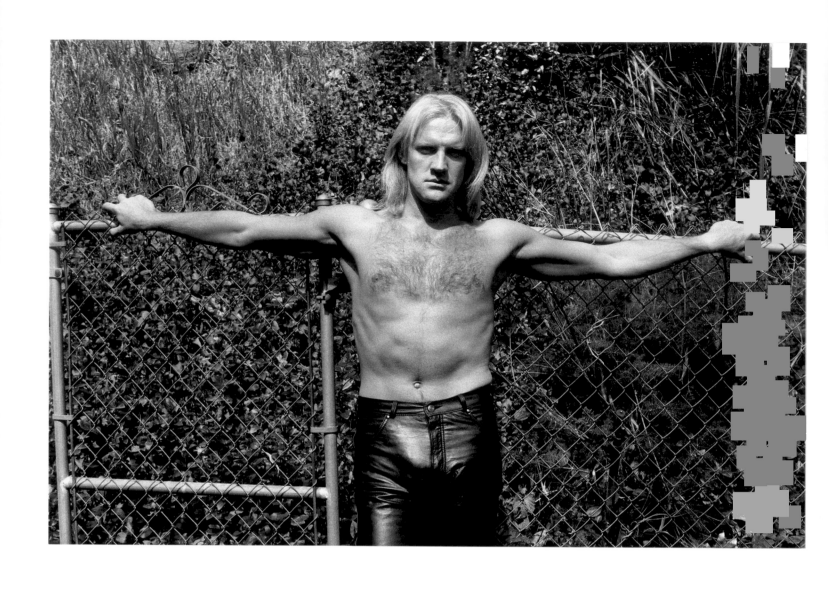

170. The dancer Alexander Godunov, Beverly Hills 1984.

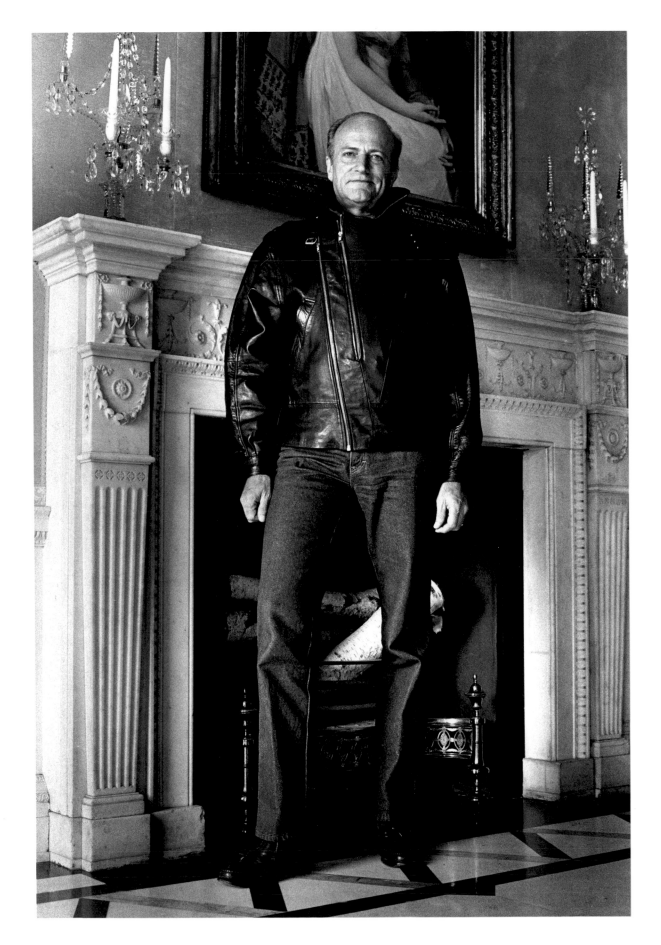

171. Claus von Bülow, New York 1985.

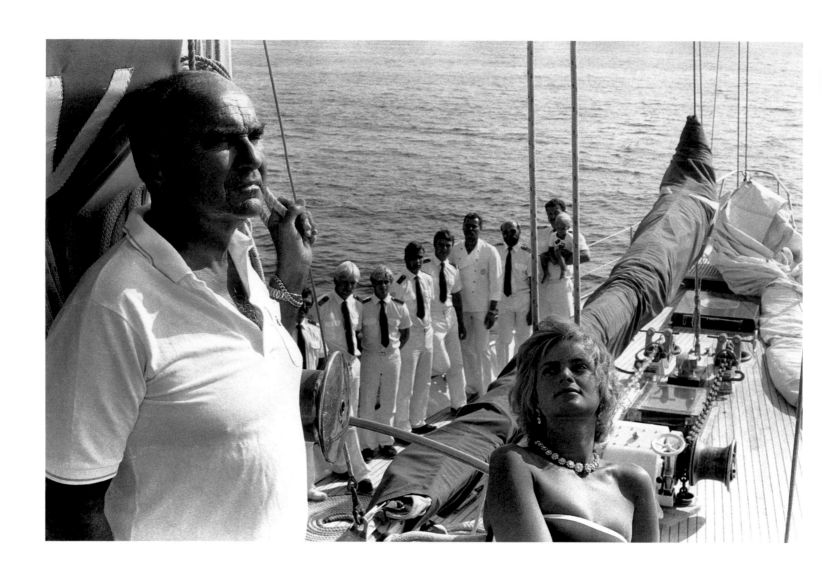

172. Prince Johannes and Princess Gloria von Thurn und Taxis on their yacht *L'Aiglon* off Ibiza, 1985.

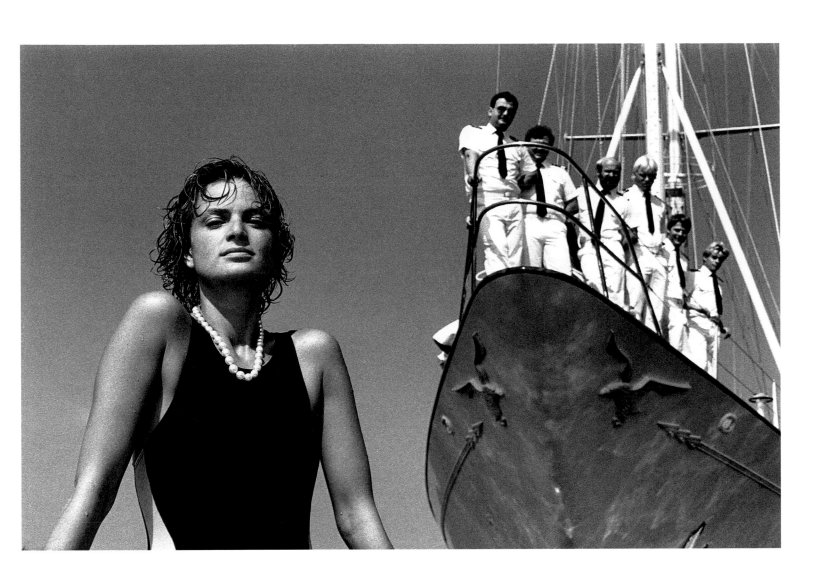

173. Princess Gloria von Thurn und Taxis and her crew on the yacht off Ibiza, 1985.

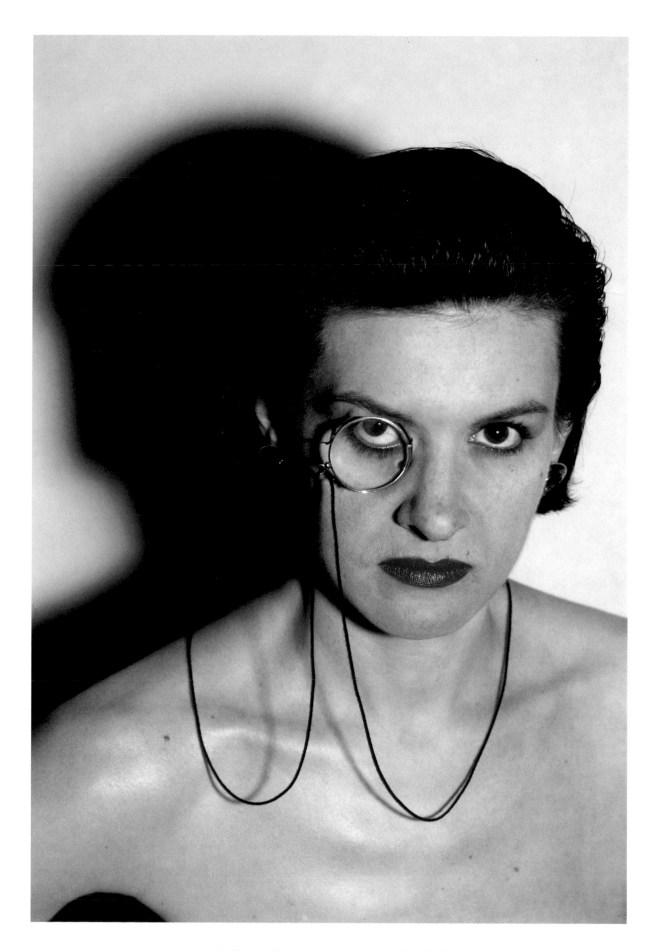

174. Paloma Picasso with monocle, Nice 1983.

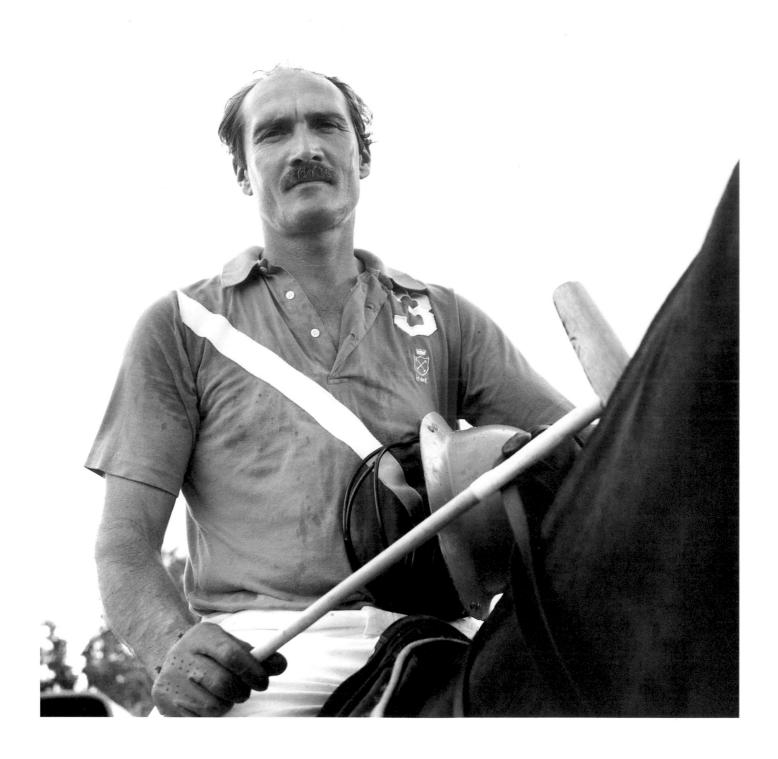

175. Julian Hipwood, captain of the English polo team, Palm Beach 1986.

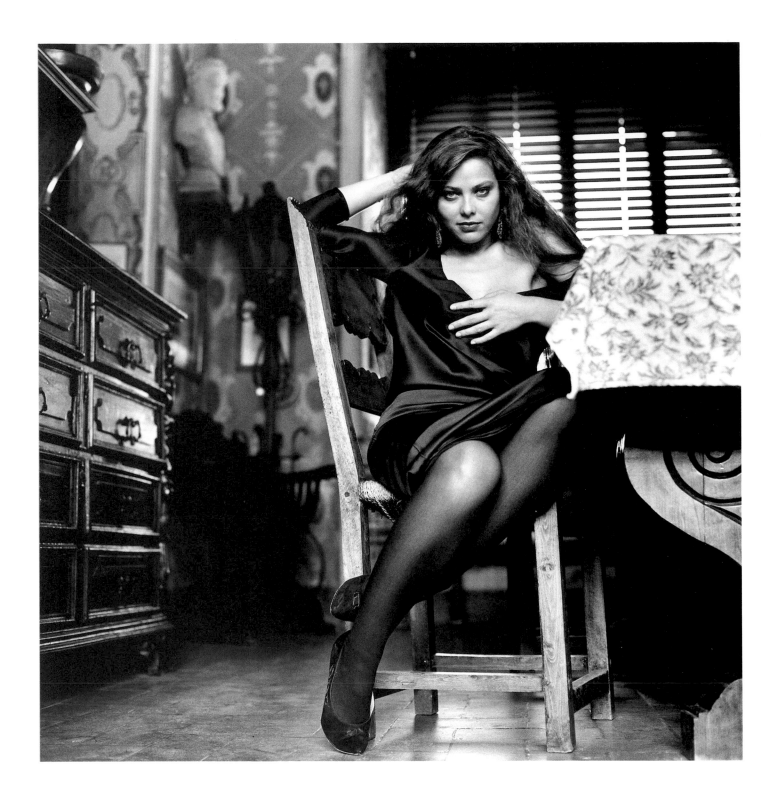

176. Ornella Muti, Como 1986.

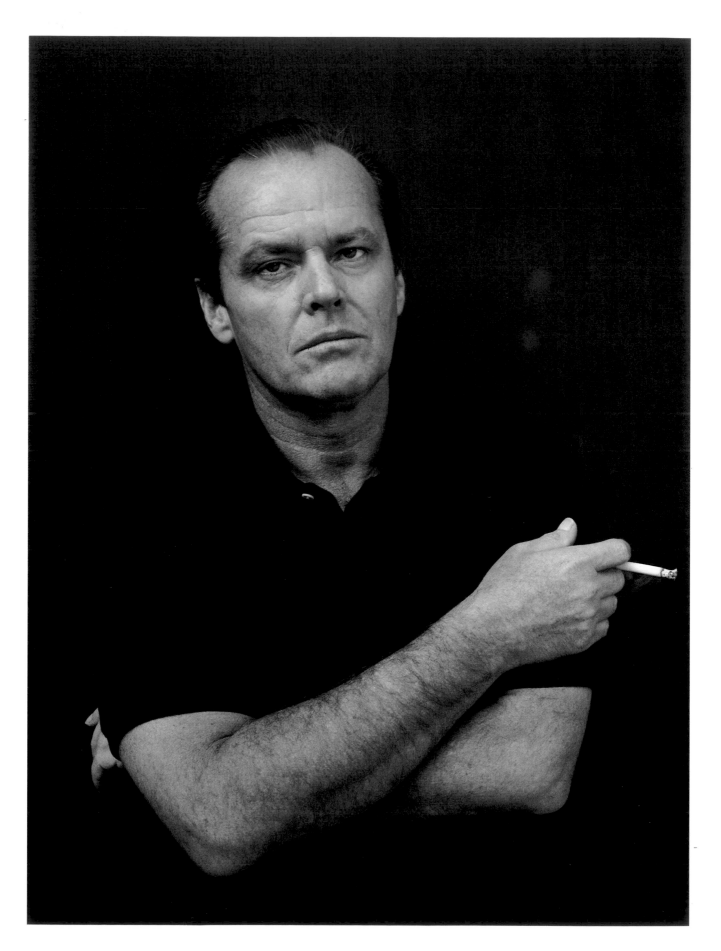

177. Jack Nicholson, Los Angeles 1985.

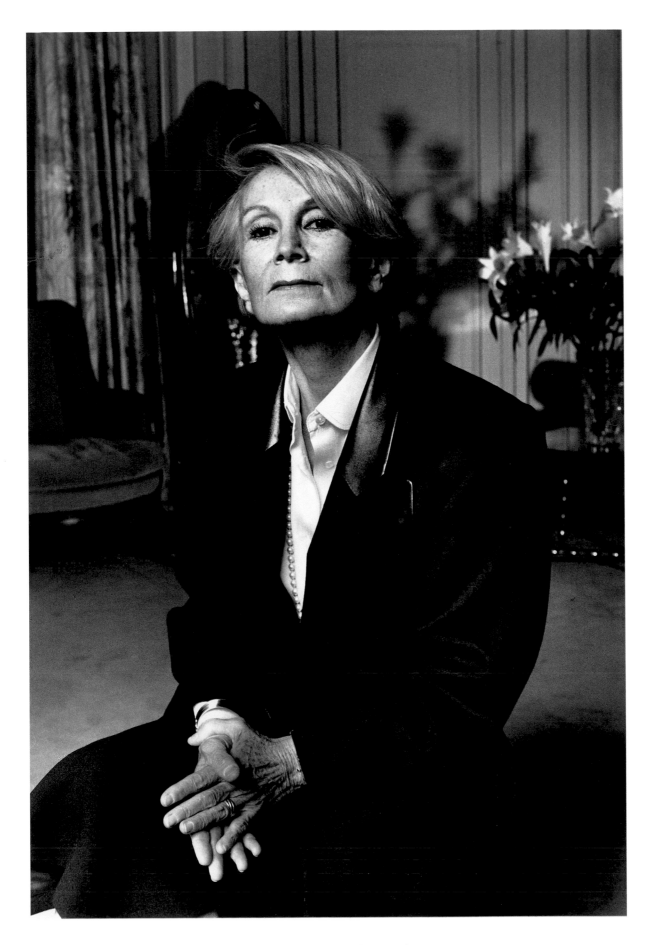

178. Madame Claude, Paris 1986.

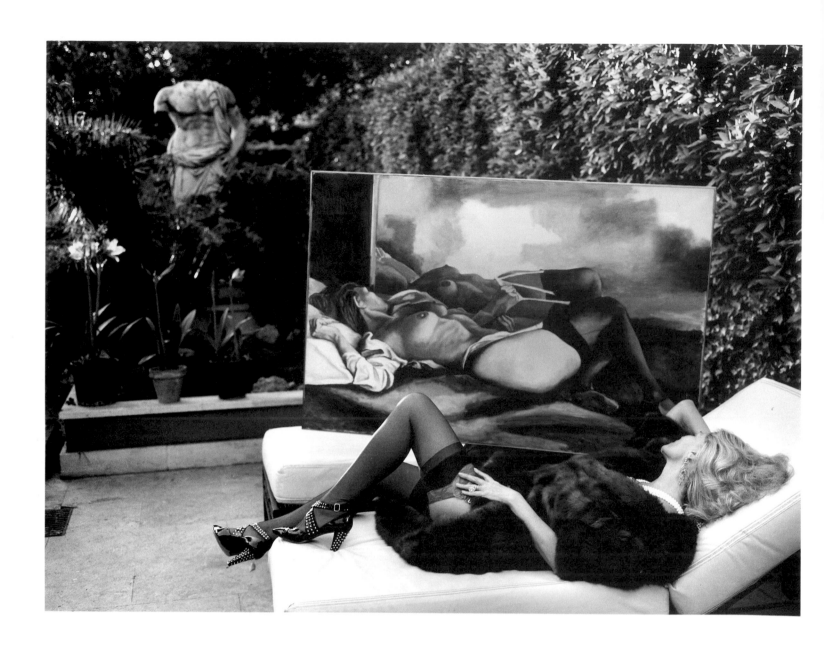

179. Countess Marta Marzotto in her garden with her portrait by Renato Guttuso, Rome 1986.

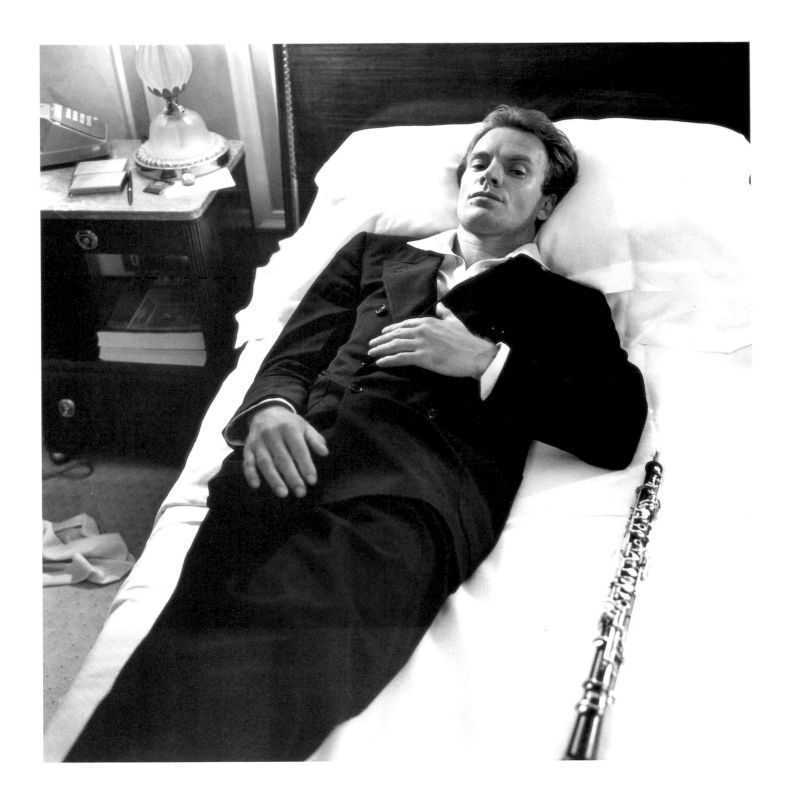

180. Sting, Milan 1986.

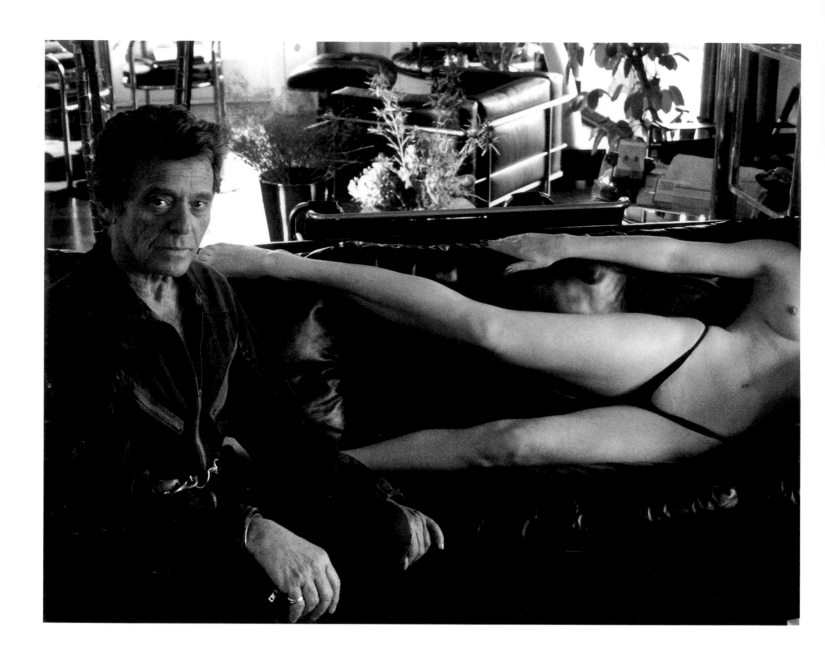

181. Rudi Gernreich with the "pubikini," his last creation, a few days before his death, Los Angeles 1985.

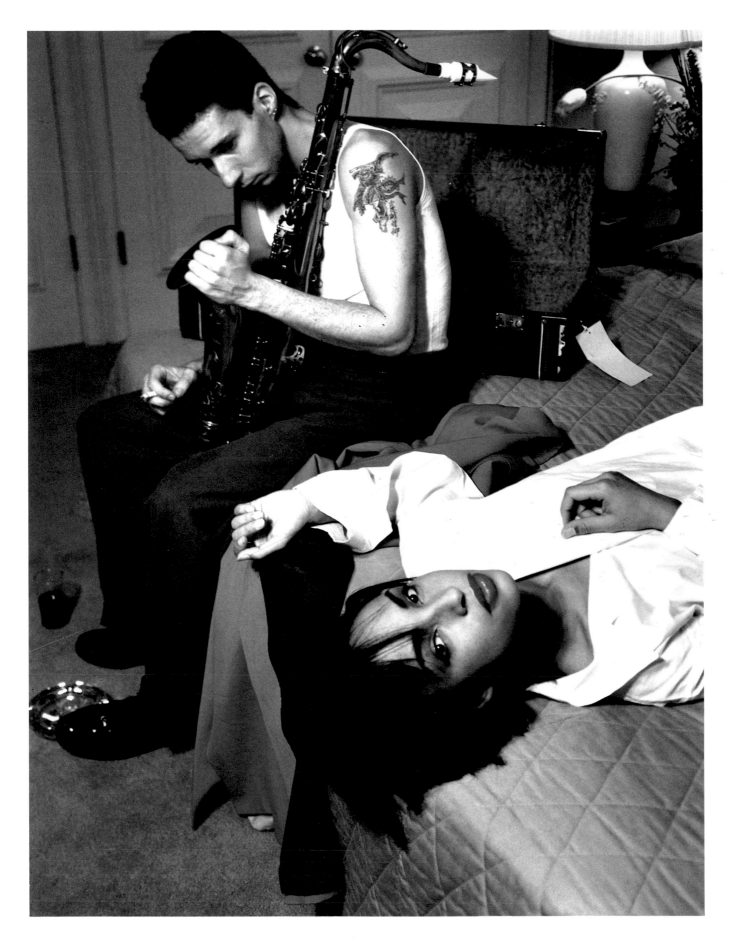

182. The singer Sade, Beverly Hills 1985.

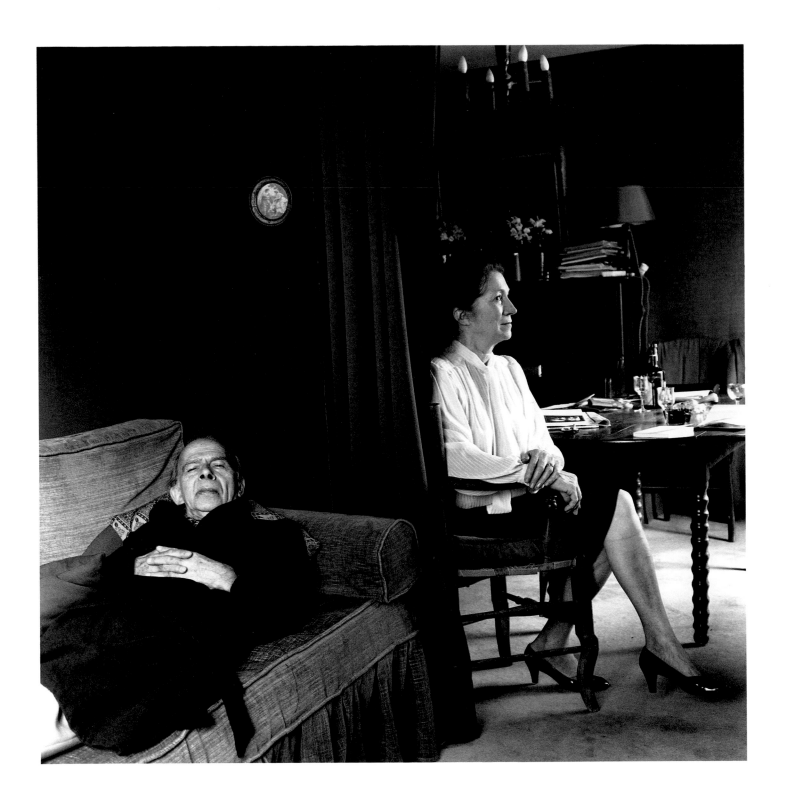

183. Pierre Klossowski and Roberte, Paris 1986.

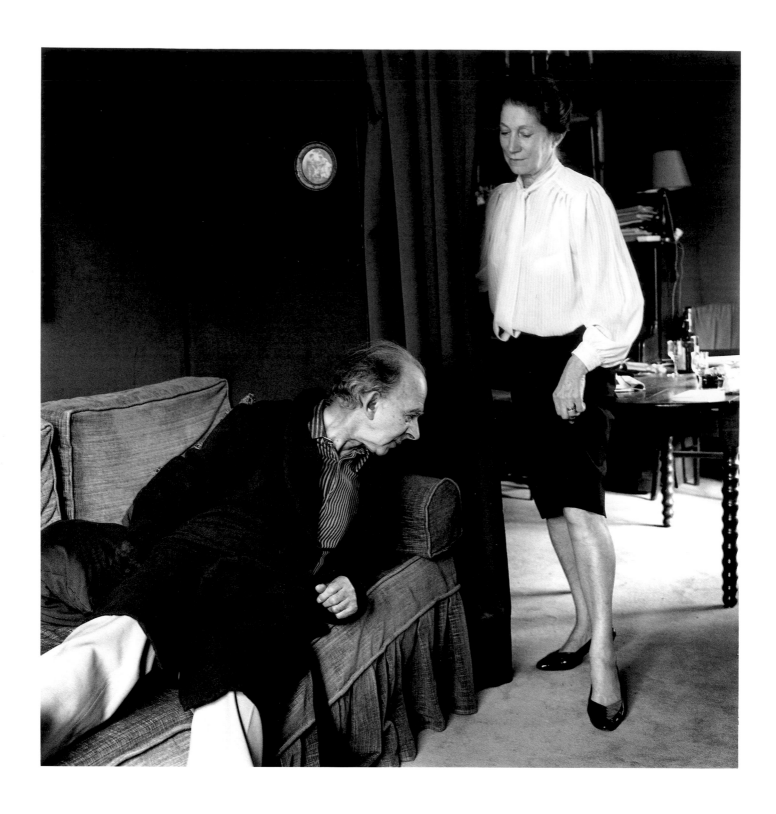

184. Pierre Klossowski and Roberte, Paris 1986.

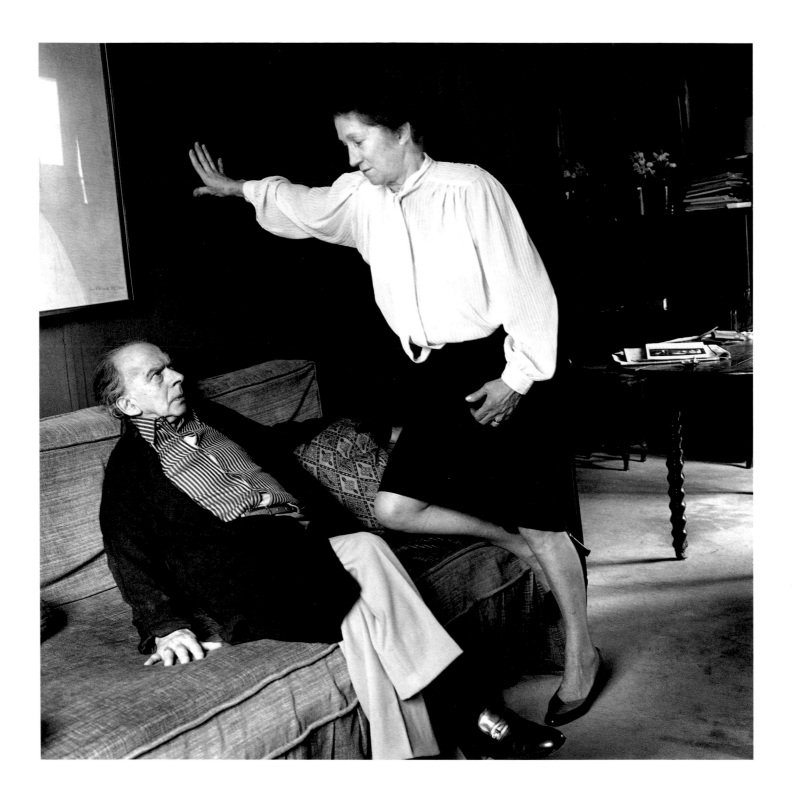

185. Pierre Klossowski and Roberte, Paris 1986.

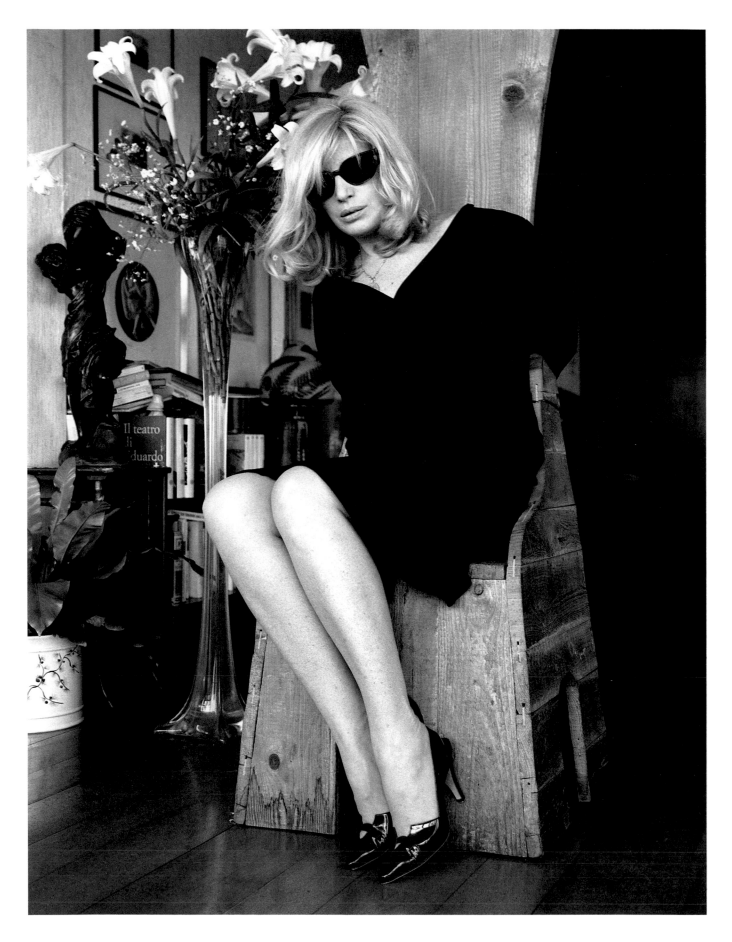

186. Monica Vitti, Rome 1986.

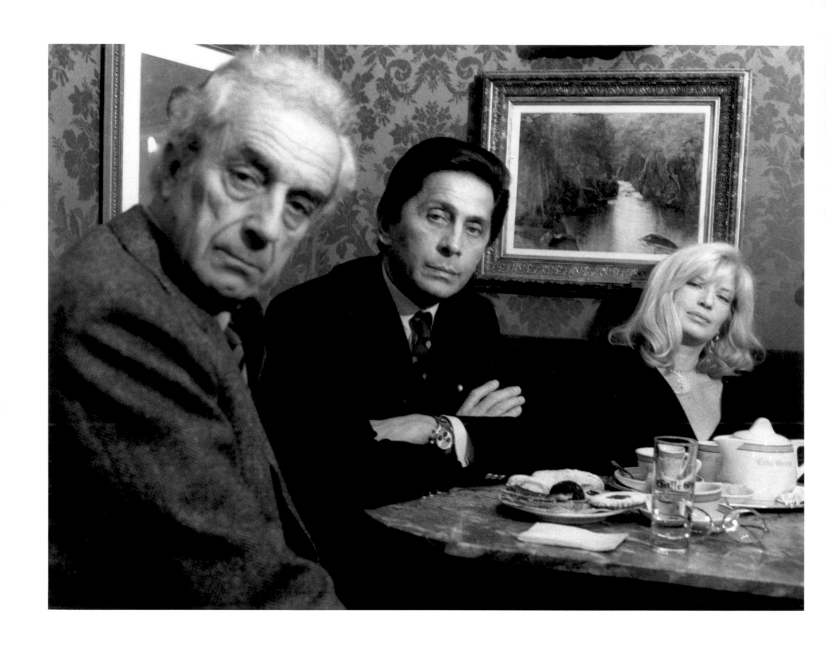

187. Michelangelo Antonioni, the fashion designer Valentino, and Monica Vitti in the Café Greco, Rome 1985.

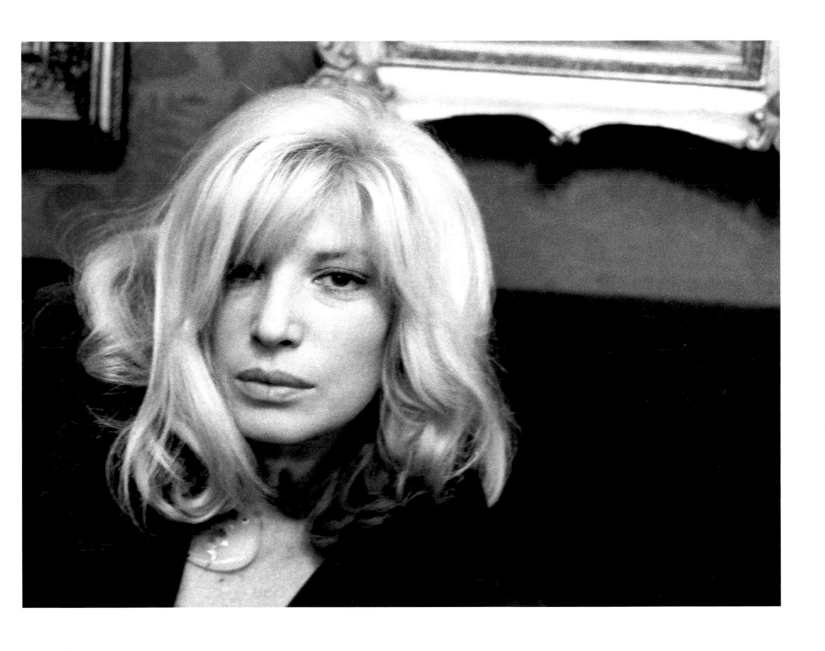

188. Monica Vitti, Café Greco, Rome 1985.

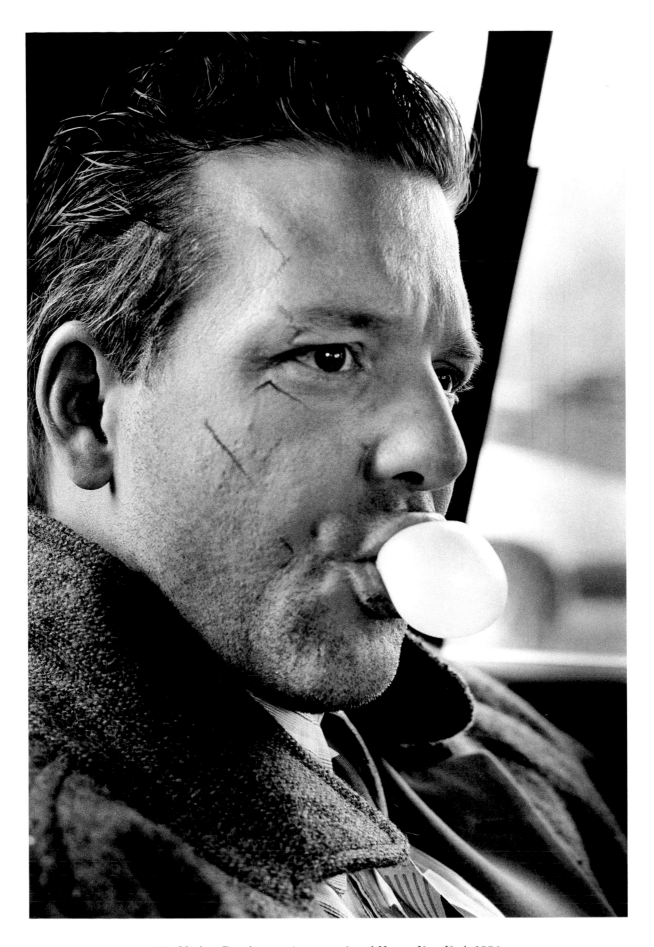

189. Mickey Rourke as private eye Angel Heart, New York 1986.

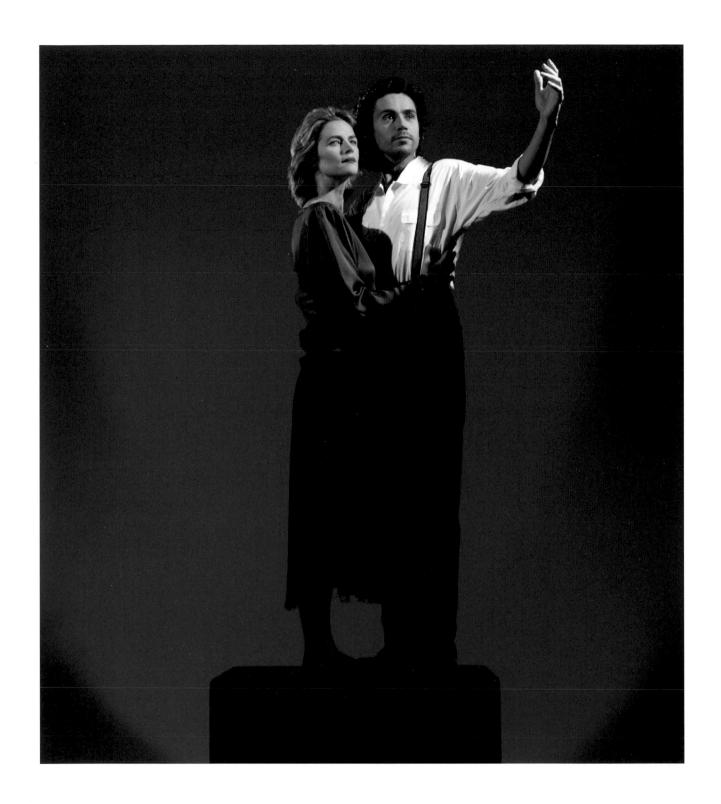

190. Charlotte Rampling and Jean-Michel Jarre, Paris 1986.

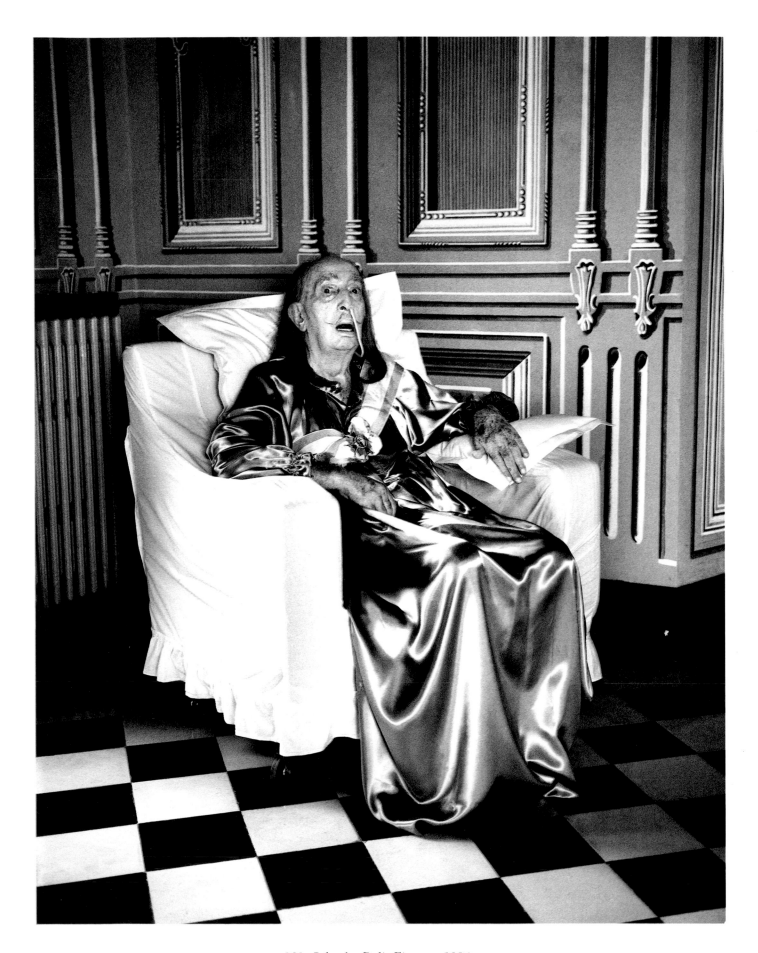

191. Salvador Dali, Figueras 1986.

Biographical Note

Born: 1920, Berlin. Nationality: Australian. In 1936, Newton was apprenticed to Berlin photographer Yva, who was well known for her fashion shots, portraits and nudes. He then spent several years in Singapore and Australia, followed by twenty-five years living and working in Paris. From the early sixties through the seventies, Newton contributed photos regularly to French, American, English, and Italian *Vogue* and to *Elle*, *Marie Claire*, *Jardin des Modes*, *Playboy*, *Nova* and *Queen*, and photo essays to *Stern* and *Life*. Since 1981, Newton has lived in Monte Carlo.

Bibliography

Publications by Helmut Newton

White Women, with a foreword by Philippe Garner. New York, London, München, Paris, 1976

Sleepless Nights, with a foreword by Edward Behr. New York, London, München, Paris, 1978

24 Photo Lithos — Special Collection. New York, London, Paris, München (with a foreword by Brion Gysin), 1979

Big Nudes, with a text by Karl Lagerfeld. New York, Paris, München *(Helmut Newton)*, London, 1982

World Without Men, with a text by Helmut Newton, New York, Paris, München *(Welt ohne Männer)*, London, 1984

Helmut Newton — Portraits, catalogue of an exhibition at the Musée d'Art Moderne de la Ville de Paris, with a foreword by Françoise Marquet. Paris, 1984

Helmut Newton — Portraits, catalogue of an exhibition at the Foto Foundation. Amsterdam, 1986

Helmut Newton, selected photographs, in the 'Photo Poche' series, Centre National de la photographie. Paris, 1986; New York, 1987

Double Elephant Portfolio, portfolio of 15 photos in a limited edition of 50. New York, 1981

Private Property, portfolio of 45 photos in a limited edition of 75. New York, 1984

Selected Publications with Material on Helmut Newton

Design & Art Direction 1968. London, 1968

Design & Art Direction 1969. London, 1969

Cecil Beaton, *The Magic Image.* London, 1975

Georgina Howell, *In Vogue — Six Decades of Fashion Photography.* London, 1975

Chenz and Jeanloup Sieff, *La Photo.* Paris, 1976

Time-Life Photography Year Book 1976. New York, 1976

Charles Castle, *Model Girl.* London, 1977

Peter Tausk, *Geschichte der Photographie im 20. Jahrhundert.* Köln, 1977; London, 1980

Claude Nori, *La Photographie Française.* Paris, 1978

Nancy Hall-Duncan, *The History of Fashion Photography.* New York, Paris, 1978

Die Welt der Photographie, catalogue, Photokina. Köln, 1978

Lee D. Witkin, *The Photograph Collector's Guide*. Boston, 1979

Polly Devlin, *Vogue Book of Fashion Photography 1919–1979*. New York, 1979

Jain Kelly, ed., *Nude Theory*. New York, 1979

Max Kozloff, *Photography and Fascination*. New Hampshire, 1979

Peter Weiermair, *Photographie als Kunst 1879–1979* and *Kunst als Photographie 1949–1979*, exhibition catalogue, 2 vol. Innsbruck, 1979

Ralph Gibson, ed., *SX-70 Art*. New York, 1979

Philippe Garner, *The Contemporary Decorative Arts from 1940 to the Present Day*. London, 1980

Sotheby Parke Bernet Inc., *Art at Auction 1979–1980*. London, 1980

Techniques of the World's Great Photographers. London, 1981

Fotografie 1922–1982, exhibition catalogue, Photokina. Köln, 1982

Pat Booth, *Master Photographers*. London, 1983

Sammlung Gruber, catalogue, Museum Ludwig. Köln, 1984

Catalogue of the Musée de la Mode. Paris, 1986

Television Documentary

Michael Whyte, *Helmut Newton*, Thames Television. London, 1978 (55 min.)

Exhibitions

Photos in Public Collections

American Friends of the Israeli Museum, Jerusalem
Baltimore Museum of Art, Baltimore, Maryland
Brandeis University, Waltham, Massachusetts
Bucknell University, Lewisburg, Pennsylvania
Chamber Opera Theatre, New York, New York
College of the Holy Cross, Worcester, Massachusetts
College of William and Mary, Williamsburg, Virginia
Corcoran Gallery of Art, Washington, D.C.
Fashion Institute of Technology, New York, New York
Michigan State University, East Lansing, Michigan
Musée d'Art Moderne de la Ville de Paris, Paris
Musée Chéret, Nice
Musée d'Epinal, Epinal
New York State University, Albany, New York
San Francisco Museum of Fine Arts, San Francisco, California
University of Michigan, Dearborn, Michigan
University of Pennsylvania, Philadelphia, Pennsylvania
University of Wisconsin, Milwaukee, Wisconsin

Solo Exhibitions

Nikon Gallery, Paris, 1975
The Photographer's Gallery, London, 1976
Nicolas Wilder Gallery, New York, 1976
Marlborough Gallery, New York, 1978
American Center, Paris, 1979
G. Ray Hawkins Gallery, Los Angeles, 1980
Daniel Templon, Paris, 1981
Studio Marconi, Milan, 1982
Galerie Hans Mayer-Denise René, Düsseldorf, Milan, 1982
Marlborough Gallery, New York, 1982
Galerie Tanit, München, 1982
Photokina, Köln, 1982
Ascher-Faure Gallery, Los Angeles 1983
Musée Chéret, Nice, 1984
Palazzo Fortuny, Venice, 1984
Musée d'Art Moderne de la Ville de Paris, Retrospective, Paris, 1984/85
Museo dell'Automobile, Turin, 1985
Galerie Artis, Monte Carlo, 1985/86
Amsterdam Foto Foundation, Amsterdam, 1986
Palais de L'Europe, Menton, 1986
Rheinisches Landesmuseum, Bonn, 1987

Selected Group Exhibitions

Fashion Photography—Six Decades, The Emily Lowe Gallery, Hofstra University, New York, 1975 (travelling exhibition)

The History of Fashion Photography, The International Museum of Photography at George Eastman House, Rochester, New York, 1977 (travelling exhibition)

Die Modephotographie, Photokina, Köln, 1978

La Mode Française, Zabriskie Gallery, Paris, 1979

20/24 Polaroid, Zabriskie Gallery, Paris, 1980

Aspects de l'Art d'Aujourd'hui, 1970–1980, Museum Rath, Geneva, 1981

Hans Bellmer, Helmut Newton, Alice Springs, G. Ray Hawkins Gallery, Los Angeles, 1981

50 Années de Photographie de Vogue Paris, Musée Jacquemart-André, Paris, 1982

Photokina, Köln, 1982

Shots of Style, Victoria & Albert Museum, London, 1985

Index of Plates